THE WORKS OF
JAMES McNEILL WHISTLER

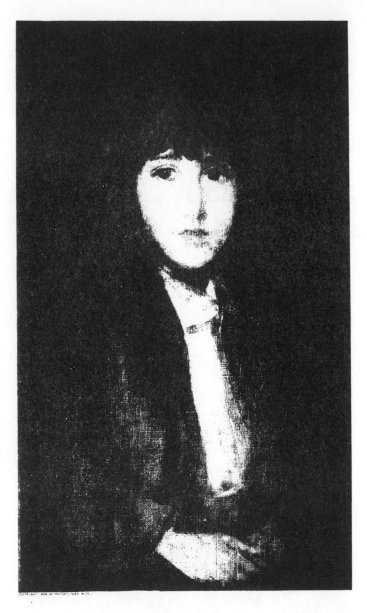

Pretty Nellie Brown
reproduced by kind permission of
Frank Lusk Babbott, Esq.

THE
WORKS
OF
JAMES McNEILL
WHISTLER

BY

ELIZABETH LUTHER CAREY

LONGWOOD PRESS
BOSTON

Library of Congress Cataloging in Publication Data

Cary, Elisabeth Luther, 1867-1936.
 The works of James McNeill Whistler.

 Reprint of the 1913 ed.
 1. Whistler, James Abbott McNeill, 1834-1903.
I. Title.
[ND237.W6C3 1977] 760'.092'4 77-6969
ISBN 0-89341-217-1

Published in 1977 by LONGWOOD PRESS INC.
P.O. Box 535, Boston, Massachusetts 02148
This Longwood Press book is an unabridged
republication of the edition of 1913.
Library of Congress Catalogue Card Number: 77-6969
International Standard Book Number: 0-89341-217-1

Printed in the United States of America

TO

GEORGE MARTIN LUTHER

CONTENTS.

————

LIST OF ILLUSTRATIONS

LIST OF ILLUSTRATIONS—*Continued*

PREFACE

PREFACE

My aim in writing about Whistler has been a very simple one. I have wished merely to express the kind of pleasure in his work that may be taken by an un-technical observer, believing that no special vision is required to get from it the satisfaction given by any genuine form of art. I have tried to follow a general chronological sequence, but have made no great point of this, as the chronology of his works is very imperfectly determined in published sources, to which alone I have had access. Many of his critics no doubt are more familiar with his art than I am, yet they have not, I think, placed enough stress on those expressive and "human" qualities in it that seem to me most obvious. Of course, such qualities may be in my imagination only, but through the kindness of the owners I have been able to verify and strengthen impressions of a much earlier date by review of a considerable number of his works in various mediums. I shall feel entirely rewarded if by discussing them from my own point of view, I may have the good fortune to stimulate a somewhat more general, a somewhat less esoteric, interest in an art that seems to me

peculiarly to appeal to the æsthetic instincts of the American mind, if not to the superficial side of American taste. I am aware that no discussion of Whistler's art, however simple, is without its perils. It was Montaigne who said "Je reviendrois volontiers de l'autre monde pour démentir celuy qui me formeroit autre que je n'estcis, fut-ce pour m'honorer." Whistler's art, however, lives to contradict those who misrepresent it "even to honour him."

I have to express my warmest thanks to those who have, frequently at no little inconvenience to themselves, made it possible to see their pictures, and particularly to the collectors who have permitted reproductions to be made. I must especially acknowledge a great obligation to the friends who have read my manuscript and have helped me by suggestions and corrections; and I must also acknowledge the assistance of Mr. David Kennedy, who has put me in communication with foreign owners of Whistler's works, and in many other ways has facilitated my task.

For such data of Whistler's student years, surroundings, etc., as I have used, I have depended upon M. Duret's *Life* and M. Léonce Bénédite's articles in the *Gazette des Beaux Arts*.

WHISTLER'S BEGINNINGS

CHAPTER FIRST.

Whistler's Beginnings.

WHISTLER already was an artist when, at the age of twenty-one, he went to study in Gleyre's Paris atelier toward the end of 1855. Of this we have more than one proof. He not only had etched the now famous marginal designs on the Coast Survey plate which commemorates his brief career as a servant of the United States Government; he had produced a number of drawings and paintings that went much farther than merely to foreshadow his later accomplishment. Fromentin said of Rubens: "He is asked for his studies and he has nothing to show, as it were, but works." Almost the same could be said of Whistler, so little is there of the tentative and groping in his first essays in art. Two pen-and-ink drawings (made with brown ink or possibly sepia) were recently on exhibition in one of the rooms of the Albright Art Gallery at Buffalo, to which they were loaned by Dr. Roswell Park. According to the description accompanying them, they were made by Whistler when a boy in the school of Dr. Park's father at Pomfret, Connecticut, between 1850 and 1852.([1]) He was not more than sixteen or seventeen years old at that time, but the drawings might well be

([1]) Miss Mary Park (the owner of the drawings) writes that she thinks their date was 1851 or 1852, that it could not have been later than 1852 as the school was then given up.

the work of a trained hand. In one a man is playing a fiddle, while some of his companions dance and others look on. The naturalness of pose and gesture and the reserve in the artistic expression of the rather complicated subject speak of anything but immaturity, and show that the characteristics of the later style were natural to Whistler and not formed by outer influences. Each line tells its essential fact in the composition; there are no foolish accessories, there is no uncertainty of handling. Apparently the impression was formed in the mind with entire precision before the pen began to translate it. The graceful action of the fiddler's hand and his quiet, relaxed attitude are in pleasant contrast to the abounding energy of the dancing figures, in which sheer abandonment to the joy of their motion is indicated with the utmost delicacy and vivacity, and by a method quite as synthetic as that of any of the Venetian etchings. The whole spirit of the little scene is conveyed with the discrimination and humour to be expected as the fruit of experience and slow time, not at all as the quality of a youthful talent; nor is the artistic simplicity shown in it the naïveté frequently found in the work of children and always so astonishing there. The mind and eye had gone a step farther than that, but had not lost the *instinct* of selection.

The other drawing is of a man sitting with crossed feet and folded arms on a barrel. This solid little figure, sitting firmly, is also a complete statement and the execution, more elaborate than in the first draw-

ing, is neither loose nor fumbling, but crisp, certain, and without flourish.

Two water-colours, also dating back to the Pomfret school-days, were shown at the London Memorial Exhibition, and one of these, catalogued as *Sam Weller's Lodging in the Fleet Prison,* was reproduced in the volume by Messrs. Way and Dennis on Whistler's work, with the title *Sam Weller's Landlord in the Fleet.* It gives even in the reproduction an idea of the remarkable command over his material with which Whistler was endowed from the first. The fat shrewd face of the cobbler, the excellent construction of his figure, the delicacy with which the difficult effects of the smoke from his pipe and the flame of his candle are rendered, show an observation already adequate to grasp pictorial values and a hand prompt and obedient to the dictation of the mind. A still earlier achievement, a little bust portrait of an elderly aunt, introduces the text of M. Duret's *Life.* It bears the date 1844 and although it has a childlike quaintness and awkwardness, it betrays a very definite concern on the part of the young artist with modelled line and significant light and shade.

Other very early drawings and sketches were shown at the Boston Exhibition in 1904, and the public has had a reasonable opportunity to recognize what hardly can be called Whistler's precocity, what is rather the innate sensitiveness to æsthetic truths that all through his life kept him from seeing things in any but a pictorial way. All these early drawings convey

the sense of its having been out of his power to render a thing crudely or without an instinct for the right choice among the multitudinous possibilities offered by his material. Apparently he was born with the capacity for which many a painter strives unsuccessfully throughout his career, the capacity to ignore whatever did not serve the purpose of his art. In a word he never saw too much. And the very characteristics which frequently are described as distinctively those of the later periods, are found from time to time in the earlier work, so that the observer is never safe from having an assumption based upon incomplete knowledge suddenly overturned by the appearance of some little drawing or painting which, like those of the Pomfret school, must be assigned to an unquestionably early date, and which nevertheless wears the peculiar charm of the mature style.

This unexpectedness, this freedom from the steady march of an orderly and measured development, gives an inexpressible freshness to the various performance. Not to be able to say of a man that he worked this way in youth and that way in age, not to be able to pin him down to stiff classifications and convenient sequences, to have him escape catalogue and criticism at every point, means that his genius was vital throughout and that it possessed the classic merit of elasticity. This quality of elasticity is revealed constantly in Whistler's accomplishment; in his transitions from one medium to another and from one scale to another; in his ability to preserve in each medium its appropriate

and especial character, and in his swift response to the inner sentiment and mood of the scene before him. Neither in his youth nor in his age, if we may judge from his art, did he ever know an insensitive or unobservant moment.

It would be easy to assume that such a temperament would prove extremely susceptible to influences from without, and would pass through more than the common number of modifications by other minds. Much has been written, indeed, of Whistler's debt to certain contemporaries and forerunners, but it is difficult to find that these did more than lightly to sway his fancy toward a manner of composition at one moment or a choice of subject at another. They have not robbed his work of its individuality even where most is to be said for their share in it. Nothing, however, is more interesting than to try to trace in any complex human performance the psychological gravitation that keeps each personality, however strong, from dropping out of its place in the system, and Whistler's environment during his early years as an art student provided him with many contacts, of which a few seem to have affected his art to a greater or less degree, and others to have exercised no influence whatever upon it. It was a critical moment in the history of modern painting. It was the moment at which it might be said that the purely modern impulse toward uniting art with science came of age and claimed freedom of action. The conflict between the old ideas and the new ideas had begun in earnest and it was

already obvious that the cause of the younger generation was to be the gaining cause, in spite of the inflexible attitude of those who felt themselves the guardians of the old tradition. Only the most stolid intelligence could have come into a field so crowded with personal interests and adventures and failed to range itself either tacitly or openly on one side or the other; or to receive impressions that demanded to be tested before the final choice was made.

FRENCH ENVIRONMENT

CHAPTER SECOND.

French Environment.

THUS Whistler, going to Paris for an education which turned out to be perhaps chiefly a self-education, found himself surrounded by a group of combative, industrious, clear-headed, inquiring and talented young painters, whose minds, if sometimes acrobatically inclined, were in the main incisive and orderly, and bent upon interrogating artistic problems at first hand, preparing the way for the revolution in standards of which Courbet was the boisterous herald.

M. Duret, in his account of Manet's life, has drawn a vivid picture of the difficulties under which painters with a personal vision and a fresh ideal were obliged in the late fifties and early sixties to struggle toward recognition. Manet began his formal study of painting in the atelier of Couture whom he left in 1856, not long after Whistler arrived in Paris. Couture had identified himself with the Romantic School of which Delacroix, who died in 1863, was the acknowledged leader, and which, despite its several great disciples, encouraged a false and bombastic sentiment opposed both to nature and art. Historical painting was in its full vogue and Couture was conventional and academic in his management of historical subjects, although, looking back across nearly half a century of very different æsthetic aims, it is possible to find him

at least soothing in his measured application of a distinct philosophy to his rather dull canvasses. "He believed, with a majority of the artists of his time," says M. Duret, "in the excellence of a fixed ideal, opposed to realism, as it was termed with horror. Only certain subjects were then believed worthy of art. Scenes from antiquity, the representation of Greeks and Romans, were given the preference as having in themselves the character of nobility; the men of the present, on the contrary, with their frock-coats and every day apparel, were to be avoided as offering only realistic motives in contradiction to art. Religious subjects were held proper to great art, but first and foremost came the nude, which herein was *et principium et fons*. Next, in a somewhat lower grade, but still acceptable, came compositions drawn from countries having an exotic charm for the imagination, such as those of the Orient. An Egyptian landscape was worthy in itself, an artist enamoured of the ideal might paint the sands of the desert, but to paint a Normandy pasture with cows and fruit-trees was to be sunk in realism and degraded." It was against such theories that Manet's independent temper revolted. He was the drastic innovator in French painting; the man who overturned old traditions, or to speak more truly, ignored them and made others which were in harmony with the still older past of the great masters, but he was not, of course, the first iconoclastic spirit of his time. Courbet was earlier in the field of sheer realism which

he so intensely though more or less brutally conceived, and about Courbet circled the ardent ones who proclaimed their love of reality and their detestation of Academies.

Whistler was well prepared to take his part in the discussions of the day. During some years of boyhood spent in Russia he had learned to speak the French language as though it were his own. This saved him the tedious effort of translating into a new vocabulary the thoughts and feelings of those about him. It gave him practically another tool which he understood as he understood his etching needle; it made it easy for him to enter at once upon the life of a French student without any preliminary knocking at the door and fumbling with the latch. The life of a French student still included the practice of copying at the Louvre, the old masters being not yet discredited as guides to new mastery. Fantin-Latour, Legros, Manet, Bracquemond, were among those frequenting the galleries, and Whistler also copied there such curiously diverse painters as Ingres, Boucher, and Velasquez.

It was at the Louvre that he met Fantin-Latour, according to M. Bénédite's account of the friendship that presently sprang up between the two young men who represented radically different types of mind and temperament, but who found in one another a common impulse toward sanity and sincerity of artistic expression.

Fantin-Latour was one of those in whom as in

books, in the Bishop of Durham's phrase, "we find the
dead, as it were, living." His youth was spent almost
exclusively in disengaging from the pictures of the
past the spirit and method of those who painted them.
"Rubens and Veronese discovered him to himself,"
one of his critics says, and his long apprenticeship to
the humble task of copying masterpieces, undertaken
as it was in a mood not of literalism but of poetic analy-
sis, resulted in a facility and felicity of handling little
short of marvelous. As true to himself as to his great
models, he developed his own style while searching for
the secret of theirs. Technically accomplished, dedi-
cated to the old, yet sensitive to new excellence, he
must inevitably have exercised a mild and harmoniz-
ing influence on the turbulent forces encircling him,
and it is easy to believe that Whistler derived from the
sobriety and measure, the good taste and intelligence
of his works, a degree of profit not lightly to be esti-
mated; and that to the end he felt the effect of his wise
example.

M. Bénédite, at all events, sees definite traces of
Fantin in Whistler's first important composition, en-
titled *At the Piano,* painted during a visit to England
and exhibited at the Royal Academy in 1860. He has
described the picture with reference to this influence
as follows:

"In a softly lighted interior a woman, seated at the
left of the canvas, is playing on the piano, at the right
stands a little girl, leaning on the piano and listening
in an attentive attitude. These are his (Whistler's)

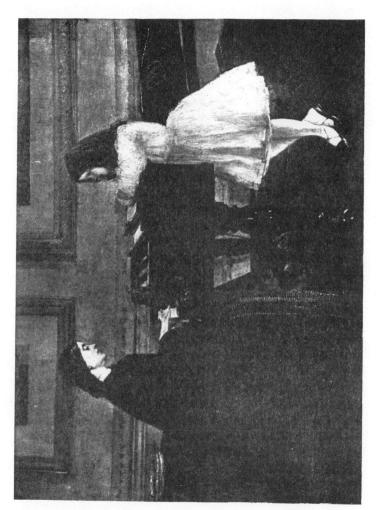

"AT THE PIANO."

sister, Mrs. (now Lady) Haden, and his niece Annie, already made the subject of a delicious etching. The mother is wholly in profile, in a black dress; the little girl is all in white with blonde hair falling on her shoulders. Under the piano, violin and violincello cases repeat the black note of the dress. On the floor is a covering of plain red which corresponds to the red covering of a round table behind Mrs. Haden, on which is placed a Chinese cup decorated in blue and gold. The background, very light and soft, is of grayish-white with bands of water-green and gold; the wall is adorned, as always in Fantin's pictures, by the lower portions of two great picture frames, the gold of which gleams dimly. The just agreement of these sober discriminated tones, these reds and russets, these blacks and whites, these grays and golds; the relation of the figures to the background from which they detach themselves quietly, bathed in atmosphere; the flesh-tones suffused with a limpid brilliancy as though softened by the glow of light; the transparency of the shadows; the caressing vibration of the lights; the whole precious canvas, of the rarest sensibility, evokes the memory of those *Brodeuses* and of that *Liseuse* with which it went to the combat in that *Salon* of 1859, the first to which the two friends had dared adventure."

The two friends were both defeated, sharing the fate of all who attempted to produce art that fell outside of academic custom and formula, and it was on this occasion that Bonvin, a painter a number of years

the senior of Whistler and his companions, threw open his studio for an exhibition of their rejected works, and brought to this little *Salon des Refusés* Courbet and other artists who marked Whistler for their particular praise.

In Courbet also M. Bénédite finds an influence that makes itself felt in Whistler's early pictures, more especially in his pictures of the sea. Such an assumption involves an adaptation of Whistler's vision to a vision, absolutely unlike his own, that saw the outer wrappings of nature where her delicate inner forms were revealed to his subtler observation. It is hardly contestable that between certain pictures by Whistler and certain pictures by Courbet a clear likeness exists, but it seems to be confined to qualities held in common with others, with Manet, for example, whose direct vision already had enabled him to produce masterpieces. It is true that *The Blue Wave,* painted by Whistler at Biarritz in 1862 (now owned by Mr. Alfred Atmore Pope of Farmington) is extremely like a painting of the open sea by Courbet which recently has hung in the Cottier Galleries in New York, but Courbet's picture which apparently is a study for his great picture of *La Mer Orageuse* (now commonly called *La Vague*) of 1870, cannot have been painted as early as Whistler's of 1862, so what influence can be traced logically must be traced to Whistler. Each is the portrait of the ocean in an angry mood. The sound of the rollers booming toward the shore almost can be heard in Whistler's picture; the forms are even

bolder than in Courbet's, the advance of the waves is more irresistible, the sky domes with a vaster curve, there is a clearer conception of elemental force and majesty. "The sea here is terrible," Whistler wrote from Biarritz in a letter describing a narrow escape from drowning, and it is precisely the terrible aspect of the engulfing waves that he has rendered. He has rendered also the liquid quality of the water more fluently than Courbet and his churning foam shows less tormented brushwork. Courbet's characteristic brown is in the foreground, but the blue is that of Whistler's own especial palette; intense and vital. Some subtler resemblance than a mere account of technical likenesses could show, dwells, however, in the two canvases and it is not surprising that the older man is held responsible for it by those who have not followed the work of the two with regard to chronological sequence. In Whistler's picture, as in Courbet's, we see a bluffness of temper, a vigour of description that suggests a man of action rather than a fastidious discriminating observer. How differently Whistler was to paint the sea, with how much more reticence and mystery, is revealed by another picture in the same collection, the *Symphony in Blue and Violet,* a masterpiece of noble eloquence compressing into a few elements all the poetry of whipping spray and driving clouds, of unquiet powers and thick salt air.

This picture also shows us the open sea with billows advancing, their blanched crests driven forward by

the wind—not near us as in *The Blue Wave* but far off on the horizon where their smallness makes us realize the immensity of the space they must traverse to reach us. This space is filled with the restlessness of the heaving water that rolls and rocks with perpetual change of colour and form. Across the sullen deep skims toward us a sharp light edge of foam, and on the horizon a small white sail calls to it with another note. Two other boats are riding the billow, the larger a soft gray shape against the low gray sky which breaks into a pale turquoise at the top, and across which ragged clouds are passing. The horizon line dips and rises like a melody and its irregular curves are echoed in the forms of the clouds. The merits of the execution are great even for Whistler's brush, but the fine imagination that pervades the canvas, that fills it with a sombre splendour and wraps it in an austere poetic sentiment, is greater. It tells us that the artist in laying aside the realism of *The Blue Wave* became only a still more subtle realist. In the *Blue and Violet* if he has eliminated everything that could interrupt the breadth of the effect he has kept everything that contributes to the essential truth of the scene. The difference is simple. It is not the observer but the maker who has set his seal upon the canvas.

We must, however, continue to beware of sharp divisions. In *The Blue Wave* also, despite its thicker skin and more matter of fact realization, we find the generalization that makes the least poetic of Whist-

Blue and Silver

THE BLUE WAVE—BIARRITZ.

By kind permission of Alfred Attmore Pope, Esq.

ler's pictures something more than realism, and it is interesting to ask ourselves at this point, if in his association with Courbet he did not modify the older painter's point of view as much as he was modified by it, if not more. There seem to be indications that he did. One of Courbet's most enlightened critics, M. Paul Mantz, writing in 1878, says of *La Vague* (painted eight years later than Whistler's *Blue Wave*): "It is an impassioned effort that does Courbet much honour. The painting in this case is complicated with that subtle and intangible element that makes it impossible not to believe that the artist has intended to make a synthesis of the wave, he has added abstraction to its concrete phenomenon; he has, so far as it lay in his power, submitted to the fatality of the ideal." It is not entirely fanciful, I think, to read in this a suggestion, too slight for serious emphasis yet quite distinct, that Whistler's way of looking at nature reacted upon Courbet and led him after his gusty burial of romance toward an art of eliminations and refinements foreign to his habitual processes. There are other signs as well, that fix more exactly the moment of this relenting. The summers of 1865 and 1866, according to M. Duret, were spent by Whistler in Courbet's company at Trouville, the two living and painting side by side. One of Whistler's pictures of this period (now in Mrs. Gardner's collection) has Courbet's figure in the foreground. It is painted rather more dryly than most of Whistler's sea-pictures, but there is much of Whistler and little

if any of Courbet in the treatment, the wan sands and
the silvery shimmer of the blue showing unmistakably
his own feeling for colour and his discrimination in
rare tones. We think of it as having been the same
had he been alone at Trouville. But in Courbet's
painting of these two summers, M. Mantz finds a new
sensitiveness to subtleties of nature not before inter-
rogated by the master's sturdy vision. Without re-
ferring to the companionship of Whistler, perhaps
ignorant of it, he traces in Courbet's canvasses pre-
cisely the qualities that are evoked by the thought of
Whistler's attitude toward the visible world. ([1])

"Among these views of sky and sea," he says,
"many are superb, speaking to the eye and to the
mind by visual characteristics, the charm of which
had long been disregarded by Courbet, for they have
depth óf distance, vital air, luminous atmosphere."
And in another reference to the work of these sum-
mers, he frankly announces his amazement that Cour-
bet should have sought to refine upon nature in draw-
ing from his model for the *Baigneuse* of 1866. "Cour-
bet seized with a fervour for elegance very curious
to note in him," he says, "wished to make his bather
slender."

In these comments as in the one or two canvasses

([1]) Mr. August F. Jaccaci tells me that none of Courbet's "waves,"
which are numerous, has been traced to a date earlier than these years
spent with Whistler at Trouville, and that *La Vague* now in the
Louvre did not get this name until after 1870, its first title being *La Mer
Orageuese*. Therefore, it is not possible that Whistler's "wave" of 1862
owes anything to similar subjects by Courbet, the earliest of which must
have followed *The Blue Wave* by at least three years.

by Courbet painted at about that period, which have
been accessible to the present writer, it is at least pos-
sible to read admissions rather touching than other-
wise and as creditable to Courbet as they are flatter-
ing to Whistler, that the exquisite talent of the latter
was not lost upon his companion who for the time of
their close companionship became anew the pupil of
nature, of a more charming nature than he had
hitherto known, a teacher who set him difficult tasks
which he bravely accomplished and won from him
recognitions which he gave with delicacy. If Whist-
ler lent synthesis, daintiness, an ambient air to Cour-
bet and Courbet emphasized in Whistler the force of
primitive nature and the joy of the obvious, it was per-
haps an equitable exchange that should not be re-
gretted for either, but that should not be held respon-
sible for any of the "realism" of Whistler's art. His
respect for reality was too deeply ingrained to be in-
fluenced by the practice of other artists, whatever at-
tention he may have accorded to their theories.

It seems to be only in the earlier, perhaps only in
the earliest canvasses by Whistler that we may look
with any degree of confidence for the signs on his part
that he was in the neighbourhood of the *"maître
d'Ornans"* and where these signs exist they do not
convey the idea of imitation nor are they unwelcome
as a feature of his art. They show an attitude of
hospitality to experimental ideas, of freshness of
thought and of enthusiasm pleasant to find in any art
so remote as Whistler's, so selective, so fastidious, so

personal. In 1862 he painted *The Last of Old West-minster,* now owned by Mr. Pope, in a mood of down-right statement which at least makes us remember that Courbet at the same time was painting in a mood as downright. The picture represents the demolition of the old Westminster Bridge and the building of the new. The great structure is drawn with the boldest yet the most specific definition of form. Nothing has been omitted or attenuated in its long stretch across the canvas. Workmen are engaged on the new bridge of which one span is seen, there are scaffoldings and heavy piles and little boats; on the Surrey side of the river are buildings and trees,—all are rendered with fidelity and an apparent delight in the power of art to reproduce the actual without much picking and choos-ing, with merely the quick grasp of handsome bold effects well within the reach and with a use of blonde brown in the water that recalls Courbet's. It is not an artistic temper that a painter with Whistler's tendencies and prepossessions would be expected to retain for a lifetime, but as the ebullient note of youth it was in place and cheering. In such a picture a part of our satisfaction with it comes from its intangible suggestions that the painter was young, was in love with his art, was knowing joyous days, was compan-ionable with other minds.

This special quality may, of course, have been in-spired by contact with Courbet's own limitless youth-fulness; but it is not probable, as this painting also pre-ceded the period of close association between the two

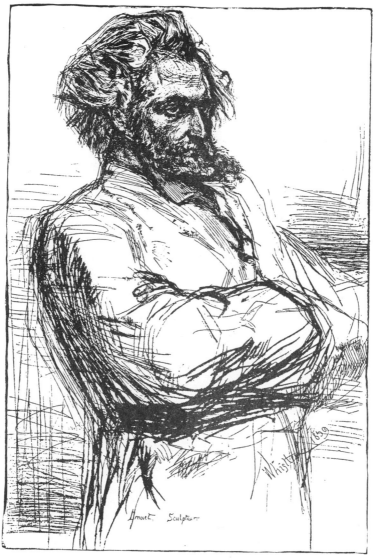

DROUET.

(From the Etching.)

artists. It should be remembered that so far as
the spirit of Whistler's art goes, his Thames etch-
ings show much the same kind of realism as ap-
pears in *The Last of Old Westminster* and *The Blue
Wave,* the same structural richness and frank scru-
tiny of the external world, and in the etchings no
accent but his own can be distinguished. As M.
Bénédite has pointed out, he had no national tradi-
tions and school prejudices and therefore was not so
deeply concerned as his companions with the question
of masters and limiting allegiances. His appreciation
of Rembrandt in his youth left, for example, hardly
a trace on his student work. Although he copied
effectively enough at the Louvre, as his copy of the
Andromeda by Ingres, exhibited at the Keppel Gal-
leries in New York, sufficiently testifies, he did not
excel his companions as a copyist. Nor is he reported
as having been an industrious student at Gleyre's.
The point with him was not so much his industry in the
ordinary sense of the word, it was his energy of pur-
pose. He himself declared that what he began he did
not leave, and having begun to be an artist he never
for a moment was anything else. If not working in
the studio or gallery he was working in the street or
on the shore or the banks of the river, observing,
making deductions and comparisons, training his
eyes, storing his memory, and, by the constant taking
of notes, giving to his hand that indispensable manual
memory without which an artist is at loss to record
his knowledge. Even at the first there was no osten-

tation in his method. There was no bravura. He applied his art to the average material about him with such simplicity that it is sometimes difficult to realize how steadily he must have bent his eyes upon the truth of nature to present it with such perfect proportion and in such a clear light. The visible world seemed to him interesting, not because it was like pictures he had seen of it, but because it was itself, and in itself pictorial.

This gave to his work a vitality of utterance independent of his artistic vocabulary. If he chose, like Courbet, to use a forcible and slightly rough speech at one moment or another it was still his own emotion that he expressed with it. His mind was concentrated on nature as he saw it, not as anyone else saw it, and this concentration led naturally to the stately synthesis of his most expressive moods. The facts of life as they unrolled themselves before him remained in his memory. In his later years when he had long passed beyond whatever influence Courbet may have exercised upon him, he needed no reminder that the ocean was an element of might and of potential cruelty. One has only to observe any one of his paintings of the sea as they are reproduced in the London Catalogue or in the various books upon his art to see how even in poor translations of his beautiful technique the quality of truth to the essential facts of nature persists. In the smallest drawings as in the largest canvas it is present. Mr. Howard Mansfield owns a bewitching water-colour bearing the title

Green and Silver: The Photographer, which shows within a few square inches of space a lovely sky with sweeping clouds above an ocean the waves of which break on a beach where three or four figures are placed, one of them, the Photographer, busy with his instrument. The reality, the life of nature, is as perfectly revealed in this as in *The Blue Wave.* The sky domes, the floating clouds have their characteristic texture, the ocean is a ponderable element with mass and power, the figures, tiny spots in the encompassing atmosphere, move and breathe. And thus it is with so many others that it is safe to assume it true of all.

Therefore, it is not strange that Whistler did not lay undue, or perhaps, as M. Bénédite thinks, not even due stress upon his debt to Courbet. He was not long in finding that his path did not lead him to an *impasse* of superficial realism which is what the word too often implies in Western art. The quintessential realism of the Orient was another matter; with this he was instinctively in sympathy, and seeking its appropriate expression in his personal accomplishment, he passed quite beyond the gates at which both the Realists and the later Impressionists stopped.

As early as 1867 he seems to have been in complete revolt against all that Courbet represented in art. In a letter of that year, written to Fantin, he inveighs against the education he has given himself, or rather the "terrible lack of education" which he feels. He assures his friend of the regret, rage and hatred with which he thinks of Courbet, not of the poor man him-

self or even of his works, but of his realistic doctrines and that cry of *"Vive la Nature!"* prompted by the assurance of ignorance in defiance of all traditions. He declares that cry of "Nature!" to have been his great misfortune, leading him to paint what he saw before him complacent in the notion that fidelity to the obvious was the only thing needed. He depicts himself with furious whimsy as having been "a blackguard swelling with vanity at being able to show the painters his splendid gifts, gifts only requiring a severe training to make their possessor at the present moment a master and not a perverted pupil." He mourns, furthermore, that he could not have had Ingres for a teacher, though liking his pictures only moderately. "I find many of his canvasses which we have looked at together," he says, "very questionable in style, not at all Greek as they are said to be, but very viciously French. I feel that there is a much greater distance to go, that there are much more beautiful things to do. But I repeat, had I but been his pupil! What a master he would have been! How sanely he would have guided us!"

This letter M. Bénédite interprets as marking the close of what he calls the "preparatory period" in Whistler's development. A further passage exalts lineal beauty and decries colour except as the accompaniment of firm design, and it was, no doubt, with reference to this emphasis on the virtue of beautiful line that Ingres came into Whistler's mind as the master above all others who knew its resources and

could impart his knowledge. M. Bénédite finds that from this time (1867) onward Whistler became more austere and gave to the element of design in his work a more and more preponderant place, if by design is understood the expressive value of line, the arabesque, the placing and disposition of the subject. Such a separation of the "early" and the "late" periods has in it, however, a precision of statement of which the baffling and flexible truth does not in this case wholly admit. Whistler's art was so integral that thus to divide it up even with the wise moderation of this learned critic, tends to banish from the mind the close web of consistency by which all the periods were held together. If we examine merely for the lineal pattern, the picture called *The Music Room* which followed *At the Piano,* with an interval of perhaps two years between them, and the portrait of Lady Meux in rose and gray which is placed by Mr. Way among the work of the early eighties, twenty years later, we see in both the same preoccupation with the placing of the figure and the refinement of the line. The standing figure in *The Music Room,* a girl in a riding habit, presents an arabesque, the curves of which flow naturally, without exaggeration and in perfect harmony, balanced and offset by the straight lines of the curtains, the picture frames and the mantel shelf. In the Lady Meux the figure stands in a very similar position but there are no accessories. Beyond the rippling edge of the light curtain meeting the dark floor, there are no lines of composition save in the

figure itself. This is very clearly shown in Mr. Mansfield's pen and ink drawing of the subject which gives the outline with every other element abstracted. In regarding it one thinks instinctively of Whistler's own charming instruction as to the artist's method of using nature, when "in the long curve of the narrow leaf, corrected by the straight, tall stem, he learns how grace is wedded to dignity, how strength enhances sweetness, that elegance shall be the result." It is a wonderful piece of drawing, but the sensitiveness to decorative pattern and linear eloquence is hardly greater in it than in the earlier picture with its less perfectly discriminated values and less complete though more detailed statement.

The letter to Fantin, then, would seem to signify a mood rather than a definite change of thought or aim, a mood more or less of discouragement and self-distrust that reappears frequently in the correspondence and lifts only as he sees himself realizing his own ideal. "Always the same story," he complains, "always such painful and uncertain labour! I am so slow." It may be doubted if Ingres, had he laid upon him the detaining hand of classicism, would have hastened his approach to his goal. The energetic and intelligent effort toward self-discipline kept him steadily critical of his processes and accomplishment, while leaving him free to seek the expression of form in his own way with silvery floating lights and quivering shadows that define without insistence, model without intrusion, and express nature and art equally.

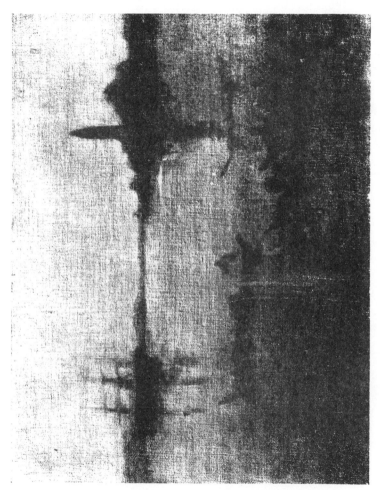

Nocturne in Blue and Silver.
"THE LAGOON"—VENICE.

His picture of *The Music Room*, like the piano picture, was painted during one of his visits to his sister in England, and curiously mingles the charms of two nations. The subject is an interior with three figures, one the girl in a riding habit, the second a little girl reading, the third a lady of middle age, seated at a piano and seen only by the reflection of her figure in a mirror. The young "Amazon," as Whistler called her, gathering her long skirts into heavy folds, holding her whip and glove lightly in her small hand, and smiling a little as she looks intently toward some scene or object out of the canvas, absorbs the attention. Her youth and suppleness and strength, the rich silhouette of her gown against the light background, her easy poise carrying the suggestion, not too strongly emphasized, of arrested motion, place her among the most enticing visions of English girlhood. As the creation of an individuality we think of her as in the same category with Rose Jocelyn and Diana Warwick. The whole group in its pleasant environment has a kind of frank lovableness rare enough in any art and in modern art increasingly rare. The spirit of the subject, not merely its pictorial aspect, has been so completely grasped that we are greatly fortunate in having it a subject of intrinsic charm. The little girl, delightful Annie Haden again, dainty and fresh in her crisp white frock, dreams over her book without a trace of self-consciousness in attitude or expression. The woman's face seen in the mirror is delicate and tender, that of the Amazon of peculiar beauty and

sweetness, and the flowered chintzes, the reading lamp, the elegant homliness of the softly lighted room, add to the effect of a painting affectionately wrought, a sense of the psychological value of the scene blending with that care for ingenious composition and exquisite colour-harmonies already apparent as dominating characteristics of Whistler's art.

It is a temptation to linger over this picture, to class it with the portrait of the artist's mother as an expression of something so sweet and fine in his perception of life that it cannot be put with his other pictures but remains a perpetual benediction and perfect in its kind. Many others give a more purely æsthetic joy, but has Whistler ever revealed more intimately his conscience and his love of his craft? The very fact that it is less wisely executed than his later work, that the signs of labour are not so successfully banished from it, allows the patience of the workmanship and the love of the maker for what he has made more clearly to be felt. How purely English the scene is! Yet do we find such distinction, such reticence, such absence of even a breath of sentimentality in any English picture of the time, or, for that matter, of any time? It is England touched by French reasonableness and American sentiment. It is England at once spiritualized and rendered scientifically. Never has her simplicity and unassumingness and pleasant humanity been shown with more impeccable taste, with more severity of conception. Subjectively and ob-

jectively lovely, *The Music Room* is a priceless record of that fleeting instant in Whistler's career when, in sympathy with his friend Fantin, he painted domestic scenes.

French influences as he gained in mastery of his medium, sank more or less into the background with him, but it is not too much, certainly, to grant to his French friends to own that their influence was all in the direction of developing in an orderly fashion the "beautiful qualities" as he frankly called them, which he had received from nature. If he resented Courbet what would have happened had he chanced to begin his career as a member of the Pre-Raphaelite Brotherhood! After eight years in Paris, with many journeys thence, to be sure, but with the Paris standards continually before him, and with the clear acute criticism of the informed French mind always at his service, he was at least protected, notwithstanding his own avowal to the contrary, from thinking himself wonderful before he *was* wonderful.

In addition to his sojourns in England, he had been during these eight years in Alsace-Lorraine (in 1858) whence he brought some charming etchings that are grouped with the so-called French Set; at Perros-Guirec in Brittany (in 1861), at Guethary on the borderland of Spain (in 1862) and finally at Amsterdam (in 1863), a trip which he has commemorated by the etching of the Tolhuis. There he paid tribute to Rembrandt's *Night Watch*. He had dreamed also of a journey to Madrid, and crossing the frontier on one

occasion, he wrote to Fantin with emotion, "Yesterday we were in Spain; yes, my dear fellow, in Spain!" This pilgrimage, however, was not accomplished, and M. Bénédite urges that the much discussed influence of Velasquez upon Whistler's art was only the influence due to kinship of vision.

ENGLISH ENVIRONMENT

CHAPTER THIRD.

English Environment.

IN 1863, after returning from Amsterdam, Whistler decided to settle in London, putting an end to the frequent travels which involved the interruption of breaking in new models and the detaining adjustment to new environments and conditions. He established himself in Cheyne Walk in the near neighbourhood of Rossetti, who, not yet a recluse, moved in a circle of interesting and prosperous people, deeply engaged with art. It is inconceivable that even the most independent mind could come into contact with Rossetti's varied, complex, and magnetic personality and with that painting which carried the torch of Italian romance through the fogs of England, without feeling and showing the effect of such contact. Whistler did not escape, although he succumbed to a less degree than frequently is assumed by his critics.

Rossetti was at the height of his accomplishment. His work was freed from the archaistic tendencies of his Pre-Raphaelite youth, it had richness and splendour and imaginative charm, and it was not yet infected by the morbid qualities that, most unjustly, have come to be considered its chief characteristics.

Between 1860 and 1865 he had produced, among an astonishing number of subjects, the water-colour *Dr. Johnson at the Mitre,* unique both in conception and treatment, the *Joan of Arc,* also unique in type

and unusually fine in tone and colour, the *Lucretia Borgia,* the first *Regina Cordium,* painted from his wife, and the original sepia study for a stained glass window, *Sir Tristram and La Belle Yseult drinking the Love Potion,* from which was painted the beautiful water-colour now belonging to an American collector. In 1863 he was painting the *Beata Beatrix* and the sumptuous but inexpressive *Helen of Troy,* which elicited Mr. Swinburne's exuberant admiration. To that year also belongs the delicate little study of Ruth Herbert owned by Mr. Bancroft and more sensitive and tender than any work of Rossetti's that followed. A mere glance at the accessible reproductions of these pictures is sufficient to show their entire unlikeness to Whistler's art. Where Whistler was deft, clear and discerning, Rossetti was weighted with his idea, laborious in his execution, and too introspective to see his subject with impersonal distinctiveness. It was characteristic of Rossetti that he applauded Keats's toast to the confusion of Newton "because he destroyed the poetry of a rainbow by reducing it to a prism." It would be difficult to imagine Whistler's saner attitude toward science thus expressed. Rossetti agonized over his poetry but frankly owned that he found painting a more or less mechanical process. Whistler's continual joy in the exercise of his art and his unwearying research that leaves no trace of the mechanical in his methods are obvious in his slightest work.

Nevertheless, before Whistler became Rossetti's

neighbour he had painted a picture that reflected Rossetti's evocations of expressive physical beauty, and passive revery. The *White Girl,* which bears the date 1862, differs completely from the "piano picture" and *The Music Room* both in conception and execution. It hung for a time in the Metropolitan Museum in New York, arousing very little interest on the part of the general public, according to the former authorities of the Museum, but making an indelible impression upon a few. It is a portrait of a soul struggling with early conditions, an ideal of beauty completely modern, yet steeped in the spirit of wonder and awe belonging to the world of old romance, the world in which Rossetti moved as a native and patriot but to which Whistler was a stranger. A young girl in a quaint high-waisted gown of low-toned white, is standing on a fur rug, in front of a white curtain. The face is self-conscious, subtle, enchanting, yet vaguely repelling; the figure has an indefinable frailty, a light, appealing girlishness and awkwardness of pose, the hint of moral and physical angularity never beyond Whistler's reach and never quite within Rossetti's. The low-toned flesh, the dark red hair, the creamy and grayish-white draperies, the fur rug, the pattern of the carpet, suggest in the colour-scheme which they compose, Rossetti's *Lady Lilith,* painted two years later, and it is suggestive to remember that Rossetti prior to his acquaintance with Whistler, seems to have painted but one important picture—the very early *Annunciation*—which could be described

as in the key of one colour, while afterward, he frequently made references to conscious efforts toward colour-harmonies, speaking of "a gradation of grays" in the *Proserpine,* a "lovely effect" of white drapery, white marble and white roses combined in *The Roman Widow,* and a "study of varied greens" in *The Day Dream.* Whistler's colour sense and Rossetti's were so different, however, that even in the pictures where these come closest to one another it would be difficult to establish anything worthy the name of a resemblance, and Rossetti was even less than Whistler open to any outer influences as his experience with Ruskin clearly shows. In its technique, *The White Girl* has a very distinct likeness to Rossetti's characteristic brush work. We see in it almost none of Whistler's light, beautiful control of his pigment. A little tormented and hard, the paint is put on with a quite thick impasto, and is moulded rather than brushed into a texture that is not fully life-like in the flesh painting or supple in the robe.

For M. Bénédite, the picture has souvenirs of Millais, but it is impossible to think that the essentially commonplace gifts of Millais's mind gained even a momentary sway over Whistler's always distinguished art. Millais, like all the Pre-Raphaelites, had passed under Rossetti's spell and had produced pictures that fitted into the mosaic of poetic imagery and mediæval sentiment formed by the corporate brotherhood. Even Holman Hunt had not failed to contribute to the romantic spirit animating the little

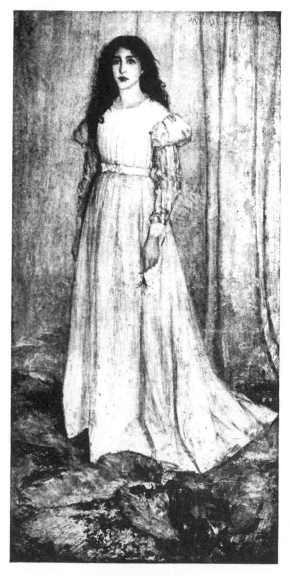

Symphony in White, No. 1.

THE WHITE GIRL.

group of innovators while Rossetti was still among them and of them. When they went their separate ways all trace of romance gradually vanished from their works, save in the case of Rossetti himself. In his art it was an essential, inalienable element, and its potency is seen in its transforming effect upon the more prosaic imaginations of his fellow painters of the Brotherhood. Whistler, whose imagination was infinitely poetic, could resist it better. *The White Girl* is the beginning and end of its influence upon him. Of Rossetti's companions none was so little subjugated by his imperious vision. Slightly as Courbet entered into the work of Whistler's youth, he is more harmoniously a part of it than Rossetti in *The White Girl's* spiritual drama; while Fantin has more in common with it to the last hour.

Nevertheless this picture is a most interesting product of Whistler's brush. It shows how adequate was his intelligence to realize a purely psychological idea. Although inspired from without, it is a true, not a false spirit of mysticism, enveloped in a very worldly beauty, that looks out of those questioning ghost-seeing eyes, and is deepened by the droop of the rich young mouth, the slightly startled poise of the beautiful head on the long neck, the straight-hanging arms and slim sensitive hands. The mood is one of ecstasy. Deep, dim meanings seem to be half revealed, not with the opulent confidingness of the Italian Rossetti, but with the reticence, the racial shyness, of Whistler's transcendental countrymen. The

Joan of Arc of Bastien-Lepage has almost the sa
look of bewildered exaltation, with the differen
that the French girl is listening to voices from a
other and superior world, while the girl in Whistle
picture listens to a voice of her own acce
speaking from her own individuality. No clear m
sage can be read in the puzzle of her brow. S
was painted from an Irish model, and if this was
artist's period of painting only what he saw bef
him, as he declares it was, he must have seen all
outward signs of the haunted Celtic soul. The delica
with which he realized them constitutes the pictur
special charm. It is not nearly so fine in arrangem
or so subtle in its play of line as *The Music Room.*
forms are less designed to bring out the rhythm
the figure and even the colour, though rich and h
monious, is a little heavy. The idea has loaded
vehicle, but the idea is exquisite. Had Whistler c
tinued on this road, we feel the opportunity of
artist to communicate poignant secrets of the sp
would have been fulfilled as by no other modern.

Nothing, however, could long have held him to
story-telling art; story-telling in the most appropri
and pictorial sense, but nevertheless intensely expr
sive and literary. Even while under Rossetti's shac
he could not give to his picture a title revealing a
thing but the painter's point of view. He had
painted an Undine or a Psyche or Eurydice or B
trice; he had painted a girl in white against a w
background, a very difficult feat to accomplish s

cessfully, and nothing could be better than to call her *The White Girl* thus indicating to the public the problem with which he as a painter was concerned. What the public wished to read in her face of her past or her future or of the fears infesting her soul, was their affair; it was his affair to place tone against tone and colour against colour in a way to achieve a true relation, and he was free to challenge the observer on that ground alone.

It is hardly necessary to recall the fact that this was not the temper of the English painters in 1862 or long after, and M. Duret goes so far as to attribute to the titles chosen by Whistler for his pictures, particularly the musical titles which he later adopted, much of the misunderstanding that presently arose with his English public. The terms "harmonies," "symphonies," "nocturnes," were not at first used by him even for the pictures to which they were most appropriate, but after he had thought of them he seems to have liked them so well that he affixed them to many of these as secondary titles or even as primary titles giving the original name the secondary place. Thus *The White Girl* was *Symphony in White Number* 1 and *The Music Room* became *Symphony in Green and Rose*. The peculiar fitness of such a terminology to Whistler's tone compositions no longer needs explanation, but it is interesting to note in M. Bénédite's references to the melomania of Fantin-Latour and his particular circle and the inevitable discussions of the laws of music in which it is reasonable to suppose that

Whistler joined, the suggestion of a closer study on his part of the analogy between accords of sound and accords of colour than the mere choice of a musical nomenclature would indicate. How far Whistler went in his investigations; how far he founded himself on science in applying the principles of music to his harmonic arrangements; how far he joined the Impressionists in their study of Chevreul and Rood and their analysis of light, must be a matter of conjecture. He himself felt that he plunged very deeply into the whole matter, writing as late as 1871 that he believed he had made progress at least in the direction of the science of colour, that he had almost entirely sounded it and reduced it to a system. In a somewhat earlier letter to Fantin (1868) quoted by M. Bénédite, he goes more explicitly into his theories of colour arrangement with reference to some flower-painting upon which Fantin has asked his criticism.

"First," he says, "it seems to me that, given the canvas, the colours ought to be, so to speak, embroidered thereupon, that is to say the same colour should reappear continually here and there, like one thread of an embroidery, and thus with the others, to a greater or less degree, according to their importance, the whole forming in this way a harmonious pattern. . . . Behold the Japanese . . . how well they understand this. It is never contrast that they seek, but, on the contrary, repetition." He then points his moral in the friendliest way with one of Fantin's studies:

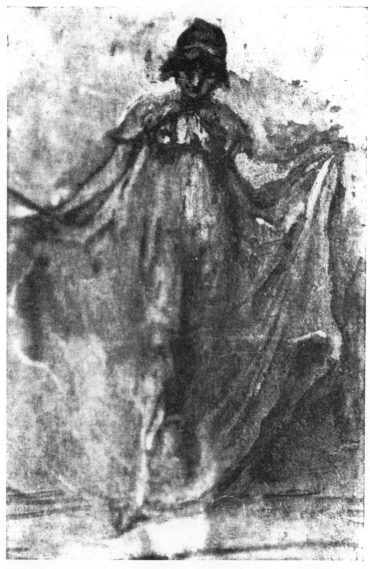

Green and Blue.
"THE DANCER."
(Water-Colour.)

"In your second canvas the whole is first of all a charming pattern, and as for the rest, there is no one who could render it like yourself. Faith, how perfect it is!—the background is repeated in the bouquet and the table climbs up through the ruddy grapes and is found again in the similar tones among the flowers! The reds of the fruits are repeated in several places and the green grapes—how delicate and fine in colour they are!—seek other greens in the leaves. It is a ravishing pattern and delicious in colour!"

It requires little discernment to find in his own works the application, firmly and clearly made, of this colour-theory. An especially delightful example of a rich and intricate yet delicate colour scheme displaying the principle of repetition in the fullest degree, yet escaping entirely the dryness of a formula, is found in a little pastel owned by Mr. Mansfield and called *The Japanese Dress.* It is a full length drawing of a girl in the Japanese garb indicated by the title. She is standing, holding a Japanese umbrella back of her head with her right hand, and with her left hand she holds up the outer robe of her gorgeous raiment. The principal colours might be described as pink, blue, red and yellow but the complete originality of their effect depends upon the certain taste and knowledge by which their action upon each other has been foreseen by the artist and a crude statement of their separated qualities fails entirely to suggest the picture. The outline is in black on brown paper. The colours of the umbrella are deep orange-yellow, pale blue and white.

There are touches of yellow on the cheek and chin, the hair is yellow, and the outer robe is lined with the orange-colour of the umbrella. The cap is of flesh colour with a band of peacock blue and has crimson and pink balls hanging at the left. The under-robe is of dark gray-blue with touches of bright rose and the light blue of the umbrella in the pattern. Beneath this is seen a white skirt that repeats the white of the umbrella. The pattern of the outer robe is in the peacock blue and flesh-colour of the cap with flecks of the light blue. The butterfly is a strong note of peacock blue, the background is flesh-colour merely brushing the surface of the brown paper, and the sash is of brilliant vermilion. This web of interlaced colours with its alternate exciting and soothing of the optic nerves, so far from producing an appearance of motley, of "bariolage" to use an expressive Gallicism, blends in a tone as homogeneous as the flushed gray of the mists at dawn. Owing to Whistler's choice of a low key even where the colours seem to be light and gay, it has none of the sparkle of the Impressionist colour-schemes, but, on the contrary, is distinctly sober in effect.

A much simpler pastel also belonging to Mr. Mansfield, illustrates the same principle within a more limited arrangement. It represents a little girl (probably Florence Leyland) with fair hair, bending over a book. The outline again is in black on the brown paper used in order to avoid a ground that required killing, which, he said, was a waste of time and a

handicap. (¹) The contrast between this black line
and the touches within it of fresh pale colour in itself
conveys a prompt æsthetic pleasure. At first glance
the colour seems to be little more than the pale yellow
of the hair falling over the face and the rose-colour
of the sash. Upon closer examination it is seen that
the rose of the sash has been repeated in a much
lighter and slightly yellower tint in the stenographic-
ally indicated ruffles of the dress and that under this
delicate rosiness of tone plays a faint blue; a stronger
note of the blue emphasizes the sleeve and it enters
also into the white of the cuff increasing its cold bril-
liancy. The rosy tone appears again with modifica-
tion in the mere suggestion of flesh-colour on the
hand. In these simple and few elements we have the
picture. The colours are not only present but are
present exactly in their relative importance and value,
each playing accurately the part assigned to it in the
charming dim drama, the whole uniting like the soft
humming of a chorus in subdued rehearsal.

Such undisguised examples of the scientific combi-
nation of colours and tones (scientific at least in the
sense that the effect is known and calculated upon
from the first) are precious both in themselves and
from the clear light they throw upon the deliberation
of the artist's plan. They show him neither impetu-
ous nor vague, but reflective and definite, bringing to

(¹) "He never worked upon a ground that required killing. That was
a waste of time, he said, and a handicap: one could not procure clean
crisp tones—it was necessary to go over them so many times." *"Whist-
ler as I Knew Him,"* by Mortimer Menpes, p. 75.

bear upon these little works that in many instances would seem to the eyes of the inattentive observer the merest sketches, the acuteness and force of a disciplined intelligence each act of which in the domain of art had its logical explanation. It is not always easy to distinguish the underlying plan of his colour combinations in such works as the *Nocturnes* for example, where the values are close and the tone mysterious to the last degree, but it is perfectly safe to assume that he never worked from a haphazard or an unstudied palette.

To return to *The White Girl,* this composition of a single figure placed on a long narrow canvas, without accessories and with a symphonic colour arrangement heralds the larger canvases of a much later period, and thus, despite its suggestions of Rossetti, is an essentially original work, marking indeed a distinct step toward the realization of a strictly personal ideal.

For its author it appears to have been of rather unusual interest. M. Bénédite relates that it plays an important part in his correspondence where he shows much concern for its exhibition and its effect upon the public. He sent it to the *Salon* of 1863 with entire confidence in its rejection, arranging with Fantin to have it placed elsewhere in such case. It was, however, a fortunate year for the rejected ones. Their numbers were many and the outcry against the decisions of the Beaux-Arts administration was great. The Emperor, Napoleon III, intervened, and upon his order the unsuccessful artists were permitted to

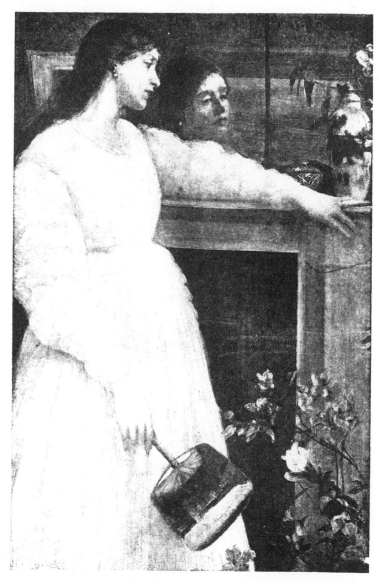

Symphony in White, No. 2.
THE LITTLE WHITE GIRL.

show their canvases to the public in a certain part of the same building in which the official *Salon* was held. This little exhibition was called the *Salon des Refusés* and has become famous in the history of French art. It contained, in addition to Whistler's *White Girl,* works by Bracquemond, Cals, Cazin, Chintreuil, Fantin-Latour, Harpignies, Jongkind, Jean-Paul Laurens, Legros, Manet, Pissarro, and Monet. Whistler found the whole affair, the official repulse and the Emperor's decision, most inspiriting. "It is charming," he wrote to Fantin from Amsterdam, "it is charming for us—this matter of the exhibition of the *Refusés!*"

The White Girl proved the special feature of the exhibition, and the critics were almost unanimous in discovering its psychological charm, a charm that in the case of M. Bénédite has been somewhat dissipated by time. He notes that the very characteristics which seemed so novel and interesting forty years ago, the unusual shape of the canvas, the placing of the figure in the background of the picture, the relations of the tones, have been so often repeated in recent art that they no longer are surprising, and he finds himself frankly rather bored by "that ecstatic personage with the great beryl-tinted eyes, who pauses, flower in hand, with the aspect of a ghost and the wild regard of an Ophelia, affecting vague pretensions to a symbolic meaning."

Of these white schemes Whistler painted several, of which two, at least, are well-known to the public. The

second is called *The Little White Girl: Symphony in White Number 2,* and represents the same charming model, standing with one arm resting on a mantelshelf above which is a mirror in which her face is reflected. Her right arm is hanging at her side and she holds a Japanese fan in her hand. A Japanese vase is on the mantel and a spray of azalea is seen in the lower right hand corner, breaking unexpectedly in upon the diagonal of the composition. This picture was exhibited at the Royal Academy of 1865 and bore upon its frame a poem (after the familiar fashion of Rossetti) written by Mr. Swinburne and emphasizing the absence of any message in the young face depicted. The last verse runs:

> I cannot tell what pleasures
> Or what pains were,
> What pale new loves and treasures
> New years will bear,
> What beam will fall, what shower,
> With grief or joy for dower,
> But one thing knows the flower, the flower is fair.

Symphony in White, Number 3, has no other title and is dated 1867. The composition comprises two figures, one half-lying, half-sitting, on a divan, the other sitting on the floor at the foot of the divan with one arm stretched over it.

With this third symphony certain studies of nude and half draped figures are frequently associated by Whistler's critics as sharing its suggestions of classic inspiration, which, M. Bénédite thinks, came to Whistler largely by the way of the English painter

Symphony in White, No. 3.
WHISTLER. 1868.

Albert Moore, whose work, of a pseudo-Greek manner, he is said to have admired, but with which his own has nothing more than an inspiration in common.

Whatever the source of their first conception may have been, these drawings and paintings, made perhaps as preliminary studies for pictures, perhaps as pictures in themselves, for they need nothing added to complete them, reveal a side of Whistler's art that would be in comparative obscurity without them. We have his expression of the human form, often quite freed from the glamour of his colour, and rendered only with a black chalk outline, or again fully modelled in colour and with a degree of relief that would surprise an observer familiar only with *The White Girl* or *The Music Room*. They emphasize in him the qualities that most often have been denied him, concern for tactile values, to use Mr. Berenson's convenient phrase, and close attention to construction. A number of them represent the model lying on a couch, the figure half turned, giving the twist of the waist so easy to caricature if the precise value of the fold in the flesh has not been felt or if the outline has the least suspicion of rigidity. Nothing could be farther from such rigidity than these supple little figures, so instinct with the movement of life that were they to change their position before your eyes you would hardly be more astonished than the Japanese artist who complacently watched his men and women walk out of his picture.

Others are standing with truly Greek simplicity of

pose, embraced in a large, sweeping outline within which the sensitive contours of their lovely forms betray the same quickness of life and subtlety of modelling. These also could move, could turn and walk and smile and speak. They are, moreover, creatures of a big mould though so dainty in their lightness of poise and grace of proportion. They have the deep chests and rounded limbs of the ancient Aphrodites and Ceres. Where they are slender and young as in the instance of the exquisite water-colour entitled *The Forget-Me-Not* (owned by Mr. Mansfield) they are still strong and normal in type with none of the bony frailness of youth, with, on the contrary, a richness of outline that requires the utmost refinement of realization to endow with that elegance characteristic of Whistler's representations of the human form.

One of the nudes (owned in America) has been on exhibition on three occasions at least, at the Comparative Exhibition, held in New York in 1904, at the Boston Exhibition of Whistler's works and at the Pennsylvania Academy Exhibition in 1906. This is *The Little Blue and Gold Girl,* a painting in which both colour and form have an arresting force and a mysterious beauty that make it one of the most delightful of his works. The figure of the girl ivory-tinted with warm shadows, is relieved against a blue drapery that pales into ashen tones and deepens into purples. Back of the figure is a window through which is seen a river-view wrapped in blue mists. A gray vase of beautiful proportions is at the

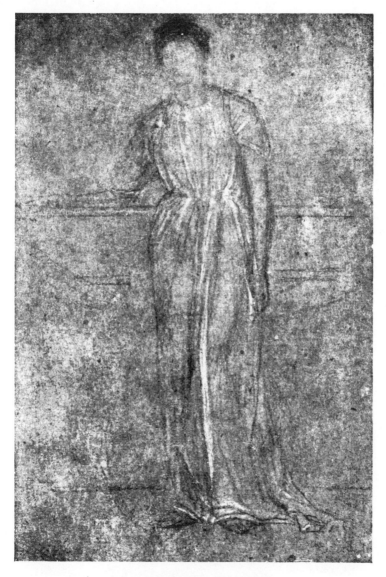

DRAPED FIGURE STANDING.

(Pastel.)

Reproduced for the first time by kind permission of Howard Mansfield, Esq.

right of the picture and holds a spray of clem-
atis. The girl's reddish hair is gathered into a yellow
kerchief with a blue band. Nothing could exceed the
firmness and lightness of the little creature's poise
upon her slim legs, or the grace with which she lifts
her round long arms. The rhythm and vitality of her
contours show the highest sensibility to the suppleness
of the human body and to its beauty of structure. It
is a modern form and by no means a classically per-
fect one but it is young, it has grace, it is alive, and
these facts are stated in the picture with explicit nota-
tion of all its refined and poetic aspects. The bloom
of an exquisite adjustment of values is over it. It
stands as the full expression of Whistler's study of the
nude.

The pastels give, however, a better impression of
how closely he has observed the significant modelling
of the human figure for the reason that in these he
frequently uses only a single touch of the chalk to
express the roundness of a limb, the projection of a
shoulder or back, the plane of a chest. He isolates
the few indications of light and shade necessary to
make us know that his figures have backs when you
see their faces, as Fromentin said was true of the
drawings of Franz Hals, and we realize the precise
muscular stress called out by their movements and
gestures. One of Mr. Mansfield's drawings repre-
sents a woman of great nobility of form, whose classic
drapery does not disguise her classic proportions, and
who stands leaning with one arm resting on a shelf or

ledge. The effect is rendered by the slightest means, but the disposition of the weight, the swell of the arm supporting the pressure of the body, the relaxation of the other arm, the capacity of the whole strong, buoyant figure to move with energy and lightness, are perfectly felt. These are the facts assential to our enjoyment and they are not obscured by any irrelevances. They keep alive the spirit in which ancient art realized the nude by their consistent rejection of all but its life-enhancing and æsthetic attributes. They touch idealism on the side of this rejection, but they have all that is artistically important in the real.

Through them we seem to see the artist's own poetic vision of his beautiful art in concrete form as "a goddess of dainty thought—reticent of habit, abjuring all obtrusiveness, purposing in no way to better others." Without the due appreciation of them it is impossible to do justice to Whistler's interests in the things which have interested all great artists. The qualities personal to him have been naturally the qualities most stimulating to his critics but they are wholly significant only in their connection with the qualities that unite him to the artists of the past. Detached from these they suggest an eccentricity not to be found in his art even at the moments of its greatest originality.

One of these moments is, curiously, that of his frank representation of the art of the farthest East.

THE ENTRANCE OF JAPAN

CHAPTER FOURTH.

The Entrance of Japan.

IN 1862, according to the date fixed by M. Chesnau, a little shop was opened in Paris on the Rue de Rivoli, by a man and his wife who had lived in Japan and who had brought back with them embroideries, lacquers, prints and porcelains which they offered for sale.

The way to their success had been prepared by the enthusiasm of the French etcher, Félix Bracquemond, who in 1856, had discovered a part of Hokusai's *Mangwa* in the hands of Delâtre, the printer of etchings to whom it had come incidentally wrapped about some porcelains, but the charm of its wonderful little drawings was promptly felt by him and Bracquemond did not succeed in persuading him to part with it. Later, however, Bracquemond found it in the hands of the wood-engraver, Lavieille, from whom he obtained it by giving in exchange for it the rare and curious volume on wood-engraving by Papillon which Lavieille on his side coveted. This incident shows with what power the Japanese master's "drawing as it comes spontaneously" appealed to the Western student of pictorial realities. Japanese art, especially the art of the prints, was practically unknown in France at this time. The passion for lacquers, porcelains, jades and bronzes marking the reign of Louis XIV, had died out, leaving many precious objects in the col-

lections of the great amateurs, but little or no trace upon the public taste. When Bracquemond had acquired his volume of the *Mangwa,* therefore, he felt that he held the key to a new world, and he passed it about among the artists of his acquaintance with an enthusiasm which they were not slow to share.

Thus the opening of M. de Soye's *"Porte Chinoise"* was the signal for an infatuation for its wares that invaded the studios, to quote M. Chesnau, "like a flame running along a powder trail." Tissot, Manet, Fantin-Latour, Degas, Carolus Duran, Monet, Solon, Jacquemart, Barbédienne, Christofle, Falize, artists and artist-artisans, trooped to the little shop and exulted over the beauty and novelty of the objects found there with an emotion very different from that of the mere seeker after new things. Each recognised in the decorative qualities of the prints, the colour and glaze of the porcelains, the patines of the bronzes, a source of inspiration for his own work, and each took away with him suggestions which he embodied in his technique.

Whistler, M. Bénédite tells us, was of the group and not the least ardent. He bought stuffs and porcelains for his studio, but while he at once made use of an occasional vase or fan or rug in the composition of his pictures, it was not until after he had taken up his residence in London that he produced the series of so-called Japanese pictures which have become famous in his art. It is difficult to fix the chronology of any but his dated works and it is impossible to be sure that

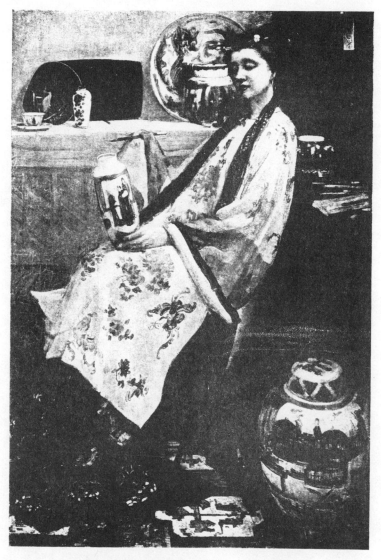

DIE LANGE LEIZEN, OF THE SIX MARKS.

a dated picture is the first of its kind without a complete and authentic record of his art to serve as a guide. No such record is accessible at the present time, but M. Bénédite considers *Die Lange Leizen, of the Six Marks* the first of this series. It must have been begun either late in 1863 or very early in 1864, as in January of the latter year Whistler writes to Fantin of *Die Lange Leizen,* telling him that it is filled with "superb porcelains" from his collection, is good in arrangement and colour and represents a dealer in porcelains, a Chinese girl engaged in painting a pot.([1])

This picture, which now belongs to Mr. John G. Johnson, of Philadelphia, is peculiarly interesting as showing how completely Whistler passed from the psychological mood of the first *Symphony in White* to the purely decorative mood appropriate to his new subject.

The colour scheme is in the subdued key of *The Japanese Dress* already described. There is not one shrill note. The primitive colours are present sufficiently to give fullness and resonance to the harmony, but the general tone is soft and grave, and the exquisite surface is to the ordinary oil-painting what the true Japanese lacquer is to the lacquer of commerce. The richness of the effect is composed of many elements making an intricate but unconfused pattern in which the local colours and contrasted surfaces play into a unity of impression without losing their indi-

([1]) The model was Miss Leyland,

vidual clearness of shape and texture. The superb
porcelain jar by the girl's side has the brilliancy of
porcelain and the pattern on it is reproduced with as
much precision as the artist used in his illustrations
for Sir Henry Thompson's catalogue of Nankin por-
celains made many years later. The other vases and
the cup and platter are drawn with equal care the pat-
tern on each having its special character scrupulously
defined. The girl wears a gray robe over a dark blue
skirt. Its decoration consists of pale red bands and
an embroidered floral pattern in red with spots of
green and blue, a pattern so delicately and precisely
indicated that it might serve as an embroiderer's
model. The red and green pattern of the rug on the
floor is also clearly defined. A darker red is in the
table cover and the yellow of the table at the left and
the background above it has a golden quality. There
is no strong modelling by light and shade, although
the forms of the girl's handsome little face are by no
means cursorily suggested and her figure is round
and supple under its long draperies. The delicious
rhythmic line that runs from her head to her feet and
the flowing brushwork emphasize the sense of tran-
quillity produced by the quiet tone and softly polished
surface. This inner harmony of design and colour
penetrating the apparently diverse and separated
items in the picture speaks more eloquently of Whist-
ler's instinctive sympathy with Japanese ideals in art
than any of its incidental features.

The picture, *Rose and Silver: La Princesse du Pays*

de la Porcelaine, dated 1864, has a more exclusively decorative aspect and brings into the mind a composite vision of Utamaro and Yeisen and Shunsen. In this superb canvas Whistler's brush plays with ease and fervour performing miracles in the way of indicating widely diverse textures and carrying the lightest films of paint with the airiest suggestions. The princess stands in a sinuous pose emphasized by the sweeping lines of her robe, against the background of a tall folding screen, an iridescent wonderful figure, painted with a gaiety and delicacy, a daring and vivacity, that would overwhelm an observer familiar only with Whistler's portraits of the sombre backgrounds and restricted range of colour. The lovely gray of the under-robe, the poppy-red sash with its lines of gold, the pale purple drapery back of the·figure with its impalpable veil of shimmering light; the gray tone, filled with air, against which the dark head is relieved, the creamy pallor of the skin, the warm transparent shadow of the hair upon the forehead, the soft surface of the pottery jar, all combine in an effect of splendour, curiously subdued to a matchless refinement of tone

The model for the Princess was Christine Spartali, a younger sister of the Marie Spartali (Mrs. Stillman) who posed for Rossetti's *Fiammetta*. William Rossetti, speaking of her in connection with her sister, says, "she also was a beauty, but in a way less sympathetic to Rossetti who did not, I think, ever draw from her." Her beauty, strange and penetrating, ap-

pears in the Princess, but it is odd to think of it as not appealing to Rossetti, for as Whistler painted her, she resembles the *Proserpine* and *Pandora* painted by Rossetti from Mrs. Morris, rather more than she resembles the *Fiammetta* or the figure in Dante's dream which were painted from her sister. The deep brooding eyes, the dusky hair, the ripe lips and long neck, inevitably bring to mind the distinguished model of Rossetti's later pictures and from this superficial resemblance has grown the impression that *La Princesse* also shows Rossetti's influence, but M. Duret rightly argues that it does not. No one familiar with Rossetti's painting could see in this brilliant example of technical dexterity any sign of him. The line alone, vibrating and losing and finding itself in its swift flow is enough to make the essential unlikeness manifest, but there is no trait or touch to suggest an external or inner likeness.

Two other important pictures of this Japanese series are *Caprice in Purple and Gold: The Golden Screen* (1864) and *Variations in Flesh Colour and Green: The Balcony* (1867). The latter represents four women on a balcony with the the Thames beyond. The women are dressed in Japanese costumes but there is no attempt to realize a typical Japanese scene. The title *Variations in Flesh Colour and Green* indicates the colour scheme so far as Whistler's colour can be indicated by a title—the flesh colour is different from other flesh colours, the green is a kind of robin's egg.

These were direct results of Whistler's admiration for the art of Japan. The colours are entrancing, the planning of the spaces and accents is most beautiful and interesting, the light and shade and modelling are kept decoratively subordinate, all that is lacking to make the observer feel himself in the presence of the purest art is a deep personal sentiment. "In the majority of cases," writes the Japanese critic Sei-ichi Taki, "what is called 'a poetic sentiment' in art is determined to be such by some point of hackneyed tradition, be it historical or literary, and often it has been so clumsily expressed that it is entirely out of harmony with the very ideas which the artist intends to portray. Such sentiments cannot but exert conventional effects, sometimes ending in meaningless allegories. Such was not the case with Sessû, for by his masterly touch the most commonplace scene was enlivened with an enthralling sentiment which insensibly makes the beholder a captive to the poetic charms of his art." This sentiment which Sei-ichi Taki attributes to his great master, less clearly felt in the *"Chinoiseries"* above referred to, invests Whistler's nocturnes with poetic charm.

In these, in his river-views and in many of his paintings of the sea, he reached a point of expression which a Japanese critic would probably have felt was the highest to which he could aspire. He reached the point, that is, of gathering all his impressions and memories of the beauty of a scene into a synthetic statement of its essential reality, eliminating all that

was trivial or extraneous. He represented in these dusky nights and veiled mornings the appearance of reality and not the facts of science. He filled them with the "painter's poetry" of which he speaks in his famous lecture, and this painter's poetry he tells us is "the amazing invention, that shall have put form and colour into such perfect harmony, that exquisiteness is the result . . . the nobility of thought that shall have given the artist's dignity to the whole." A Japanese painter might have spoken just these words. This mood in which the painting of nature becomes a matter of suggestion, of simplification, of obedience to æsthetic laws rather than imitation or even close representation of any but the largest truths, we find in those few examples that have reached us of Japanese art in its higher forms. His sensitiveness to the characteristic sentiment of a scene forms a closer link between Whistler's art and that of the Japanese great masters than even the much-discussed decorative quality of his arabesques and colour schemes and his sympathetic rendering of this sentiment with the utmost restraint and economy of means is in the true Japanese tradition so far as we can trace it. The *Nocturne in Green and Gold,* recently acquired by the Metropolitan Museum, exhibits to the fullest degree his power not only to select from nature the elements of art but to make a beautiful notation of an intrinsically beautiful fact. The scene is Cremorne Gardens at night, with coloured lights and gaily dressed people dancing or gathered in groups

at little tables. An illuminated kiosk is at the right of the picture, and waiters in red coats are here and there in the foreground. It does not require especial energy of imagination to summon to the mind an impression of some not unlike scene, and gather from it suggestions of the beauty held in the vaporous darkness of sky and foliage, the contrasting brilliancy of fireworks and lanterns, and the strange mingling of the night's austerity and the crisp bright gaiety of the human crowd. All this he has conveyed by means of a design which subtly extracts the dominant quality that pervades the whole and appeals to our imagination. We have only to follow the pattern made with infinitely delicate and close values, by the masses of the trees against the luminous dusky blue of the sky and the rippling line of varying light and colour that runs along the populous garden to realize how entirely the mystery of that visionary beauty is supported by a knowledge of the fundamental principles of art and how subtly he interpreted the doctrine of Ingres, that "even smoke should be expressed in line." An accident to the canvas also serves the purpose of the student curious as to the character of Whistler's colour. A little break that has been repaired has necessitated retouching in one spot, and the tone used contains a certain amount of purple obtained by the mixture of red and blue pigment. In ordinary light it is almost indistinguishable except as a spot from which the atmosphere seems suddenly to have dropped out, but seen from one standpoint it emphasizes in the

surrounding gray dusk the absence of the red and blue so often combined to express darkness in pictures of night. There could hardly be a better object lesson for the practical worker, in the value of a neutral tint without definite colour in which colour is called out by the opposition of the orange, or rose, or yellow, which determines the character of the colour design. This is what the fireworks and the little lanterns and the light green of the little booth near the kiosk mean to the picture; they fill the gray atmosphere with the colour of the night.

Another nocturne of the Gardens and fireworks belongs to Mrs. Samuel Untermyer of New York. It is called *Nocturne in Black and Gold: The Falling Rocket*, and is a much more dramatic arrangement. In the Metropolitan's Nocturne the general quiet tone of the picture is hardly interrupted by the flecks of brilliant colour. In Mrs. Untermyer's a concentrated blaze of light fills the scene with splendour and there is a double line of rising and falling fire. Here again is the reproduction of a beautiful visual image by the abstract means familiar in Japanese art and only recently familiar in Western art. The dark masses of blackish gray foliage, the dusky blue sky, the smoke irradiated against it and cooling and graying in colour as it rises, the yellowish gray foreground, make a pattern of line and colour lovely in itself, that would still be lovely if the orange and yellow of the fireworks were stains of blood and carnage, if the smoke rose from a battle-ground, if the dark hulks of the trees

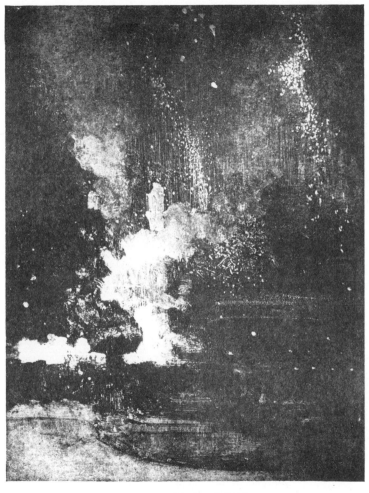

Nocturne in Black and Gold.
THE FALLING ROCKET.

Reproduced by kind permission of Mrs. Samuel Untermyer.

were heaps of slain. The beauty is absolutely inde-
pendent of the subject and the sentiment of the scene
is strictly the pictorial sentiment. The exclusive pro-
priety of this sentiment in works of art is what Whist-
ler strove to impress upon his hearers in his "Ten
O'Clock," and what Ruskin was instinctively com-
batting when he called the *Nocturne in Black and Gold*
"a pot of paint flung in the public's face."

In certain of his pictures Whistler introduced an
obviously Japanese device, a branch of leaves or blos-
soms that is sharply cut off by the frame, as the
azaleas in *The Little White Girl,* and the spray of
leafage silhouetted against the water in one of the
nocturnes "in blue and silver," and this not always
fortunate detail has many times been mentioned as a
proof of his affinities with the Japanese. In order to
realize how little this accidental arrangement has to
do with the truly Japanese spirit of a composition it
is only necessary to observe the pictures by Rossetti
in which a part of a rose-bush strays irresponsibly
into the composition, or the decorative cherry-branch
in Lotto's *Christ Taking Leave of His Mother,* to
name but two masters of many who have served them-
selves with a similar decorative idea. One swallow is
far more adequate to make a summer than one arti-
ficial feature to make a Japanese picture. It is not,
perhaps, putting it too strongly to say that Whistler
was never so thoroughly in harmony with the higher
Japanese ideals as when nothing in his picture directly
suggests them. The exquisite nocturne (the *West-*

minster) owned by Mr. Johnson, is Japan itself passed through the artist's own sensitive personality. The picture is little but air and light. There are pale tones of turquoise blue and a gray shadow resting on the land, two squares of yellow light in the tower and a reflection in the water at the right. Out of these elements he has made the transparent dusk and the pale summer heavens. What classic model of the Middle Kingdom might he not have followed, hand in hand with a Japanese disciple, to gain this "sublimity of tone" this "far-off effect," this "calm and reposeful expression," this organic relation between the parts that together constitute for the Eastern world the soul and spirit of landscape art.([1])

His touch also in those of the nocturnes that are known to me is precisely what one would imagine the Japanese touch to have become had it been developed in the medium of oil-colour, "feathery light" as Mr. Cox happily calls it, and of a gentleness that heightens the effect of tranquility. This subtle and complete harmony of the touch with the colour-scheme and the tenderness of the hour, is it typical of any race so much as of the Japanese? If it is not, we are safe in assuming that Whistler's art was not merely externally affected, as was the art of Bracquemond, for example, by his introduction to the applied arts of Japan, but was similar in essence to the pictorial art of such painters as Kano Motonobu and Sesshu,

([1]) See *The Kokka* No. 184 ("Characteristics of Japanese Painting") and No. 191 ("On Chinese Landscape Painting").

whose work we are only just now beginning to know and care for, and to whose artistic race Whistler belonged in the sense that he himself recognised when he declared "there is no nationality in art."

CHARACTERISATIONS

CHAPTER FIFTH.

Characterisations.

DURING the latter half of Whistler's life he painted many portraits and made many records of character that were in the nature of portraits, though not identified as such. In these his art was put to the final test. Could he read the poetry of human nature as unerringly as he read the poetry of the sky and air? Did he live up to his own definition of what a portrait painter should do and "paint the man as well as his features?" It would seem superfluous to make such inquiries of ourselves when three of his masterpieces in portraiture were produced over thirty years ago and have been before the public in multiplied reproductions, were it not that the notices of the Memorial Exhibitions of his work frequently recurred to the old charge made against him that he lacked interest in humanity and therefore was not the greatest type of artist. If he did lack interest in humanity, his portraits are certainly not convincing evidence of such a failure. On the contrary, they seem definitely to prove the opposite. If we refer them to their origin in human types we find them singularly explicit in what they tell us and true to the human nature we know. So far from being lay figures on which to drape an arrangement of a scheme of colour and line they are as various as life. In fact, the artistic arrangement, frequently similar enough

in general character if not in special development, is
all that any of them have in common. There may be
two harmonies in gray and black or rose and gold,
there are never two subjects alike in temperament and
personality. That this is not universally recognized
in spite of the fact that many a critic or commentator
has insisted upon it, is probably due to the artist's pur-
suit of the same ideal toward which the nocturnes led.

In portraiture it is the ideal of a quintessential like-
ness from which all accidental effects are abstracted,
and which is lodged so deeply within as to be inde-
pendent of the fluctuating emotions. "The expression
of the face," said Carrière to his pupils, "is but a mask,
distinct from the permanent character which it modi-
fies." No one has realized this more completely than
Whistler. Burne-Jones had the same idea in mind
when he said with unwonted violence, "Paint a man or
a woman with the damned 'pleasing expression' or
even the 'charmingly spontaneous' so dear to the 'pho-
tographic artist' and you see at once that the thing is a
mask, as silly as the old tragic and comic mask. The
only expression allowable in great portraiture is the
expression of character and moral quality, not of any-
thing temporary, fleeting, accidental." The reason
that Burne-Jones in following out this theory obtained
an ideal rather than an abstract likeness may be
traced, perhaps, to the fact that his mind was full of
preconceived ideals which he liked to impose upon
nature; Whistler, on the other hand, again like the
Japanese, put nothing into his pictures that he did not

learn from nature itself. His analysis of a character was done in his mind, his synthesis appeared upon the canvas. Where the character is clearly marked and one that we are more or less accustomed to analyze for ourselves it is generally greeted with understanding. In the portrait of the artist's mother, for example, although it is said to have met with opposition when it was offered at the Academy of 1872, is so simple a rendering of character that the little children of the schools where reproductions of it are given as a subject for description, recognise its dominating sentiment and the appropriateness of the quiet room to the quiet figure. It is a type known to us all in its general aspect, touching in the most hardened of us the source of tears, the type of serene age, reconciled to its renunciations and calm with resignation due to noble schooling of the stubborn mind. The frail shoulders, the head somewhat heavy for the relaxed muscles and drooping a little forward, the delicate hands clasped quietly over the thin handkerchief; the smooth hair, the daintiness of the lace cap, the far-seeing eyes that seem to look into the past, all combine to make a lovable impression on the mind before the eye has distinguished the subtle division of the spaces, the distribution of the masses, the placing of the accents, the grave beauty of the values in the shadowy wall and black dress, the decorative charm of the dark curtain with its intricate pattern. No one has painted with more respectful observation the beauty of an old age respectful of itself and free from

the suggestions of relaxing will. Without that reference to the identity of the sitter by which Whistler was inspired to one of his most widely quoted sayings, we are still at liberty to recognize an interpretation of a personality which adds to the pictorial beauty of the "arrangement" the beauty, equally rare and equally magical, of character written in art.

In the contrast between the portrait of his mother and that of Carlyle Whistler passes with the subtlest of gradations to an almost opposite type. The differences are so subtle that even Mr. George Moore, who saw in Whistler's art much beside the obvious, considered it merely as "the attempt to repeat a success." Both portraits are arrangements in black and gray, in each the figure is seated in profile among surroundings indicating that the room is the same in both pictures. But the arabesque made by the outline of the old philosopher silhouetted against the wall is forcible where that of the mother is calm and flowing. The large hat perched on the knee, the right hand resting on a cane, the coat bulging violently at the breast and the more erect carriage of the head contribute to an angular effect quite at variance with the long easy sweep of line in the earlier portrait. Even the angles of the chair are more sharply defined, and this ruggeder outline is in harmony with the more furrowed face, the more anxious expression, the querulous brow and obstinate mouth. There is a suggestion of pose in the arrangement that does not appear in the portrait of the mother. It is not quite

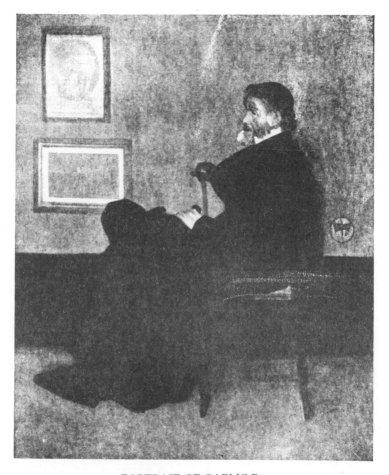

PORTRAIT OF CARLYLE.

Courtesy of H. Wunderlich & Company.

simple and frank, and fits thereby its subject whose own absorption in the "picturesque" has been noted as a mark of his mind's perversity. Yet the effect in general is of dignity. The head especially has an element of grandeur in its craggy contours. It has struck Mr. Moore that the picture shows an absence of intimate knowledge and of respect and reverence for the illustrious sitter, and therefore fails to show the frame of mind in which great portraiture is done. Great portraiture, however, is among other things the placing of a subject according to its relative importance, and when we look at Whistler's Carlyle it may fairly be argued that we see the world's Carlyle, mentally as well as physically a little ailing, impressive but not imposing, not reticent or sustained by spiritual peace; not representative but sharply individual. Whether Whistler intended to convey this impression is quite beside the question. We cannot assume that he did or did not. The point is that the impression is conveyed and that it seems to be the one nearest to the truth. "What the canvas under consideration tells most plainly is that Mr. Whistler never forgot his own personality in that of the ancient philosopher," says Mr. Moore, but that is hardly a fair charge. In one sense there could be nothing more impersonal than a critical vision unconcerned with the great reputation before it, concerned only with the essence of the man. That the man was one who could sympathetically quote the objurgation "may the devil fly away with the fine arts" has in-

spired no malice in the presentation. And the presentation is purely within Whistler's definition of art as something that should "stand alone and appeal to the artistic sense of eye or ear, without confounding this with emotions entirely foreign to it, as devotion, pity, love, patriotism, and the like." Upon nature, forever young, the past writes no hieroglyphs and the artist is able to ignore a scene's associations in painting it. The human face permits no such freedom. Character and personal history mould it to a greater or less degree and the artist who distinguishes significant details of surface, and complex relations and correspondences in the organic whole must perforce reveal character. If he reveals the essential and permanent rather than the transitory mood it is not necessarily due to his interest in his sitter but to an imagination which like that of the astronomer or the engineer is able to "body forth the forms of things unknown" from the concrete facts with which he stores his mind. Wordsworth's definition of imagination or explanation of its manner of working, might indeed serve as a description of the kind of art produced by Whistler wherever the question of representation comes in. "When the imagination frames a comparison," he says, "if it does not strike on the first presentation, a sense of the truth of the likeness from the moment it is perceived grows—and continues to grow—upon the mind; the resemblance depending less upon outline of form and feature than upon expression and effect,— less upon casual and outstanding, than upon inherent, internal properties."

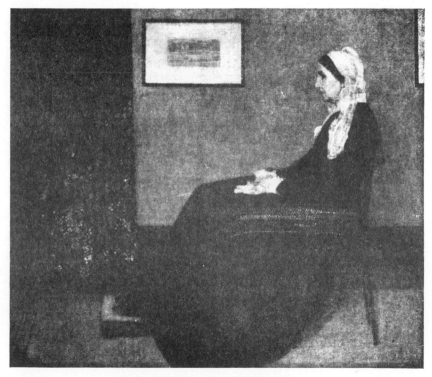

Arrangement in Gray and Black.

PORTRAIT OF THE PAINTER'S MOTHER.

In his portraits of children Whistler has particularly shown his austere quality. He has been as respectful of the rights of childhood as the secondary painters of children have been disrespectful. Compare with Sir Joshua Reynolds's children, for example, Whistler's *Miss Alexander* or *Little Rose of Lyme Regis* or *Chelsea Girl*. Sir Joshua sees the child egotistically in every case, from the point of view of his own pleasure in its pretty attitudes and soft curves. *Little Penelope Boothby* and *The Strawberry Girl* in spite of their charm or because of the cheap and superficial character of their charm have not the slightest interest as individuals. Not one of Whistler's children have that capacity for boring one. The portrait of *Miss Cicely Henrietta Alexander,* to give its proper title, is not only a *Harmony in Grey and Green,* it is an interpretation, conscious or otherwise, of the spirit of childhood, not only its innocence but its pride, not only its fresh spontaneity and charm but its interrogation and knowledge, in a setting as appropriate in its conception to the subject of the portrait as the quiet environment of the mother. How compounded of inner moods and judgments is that buoyant little figure, stepping forward, her hair a luminous blond cloud against a light background, her eyes turned, not wholly without covert resentment, toward the spectator, her beautiful little dress, transparent and crisp, standing out from the slim form, her hat with its trailing plume held in a nonchalant hand, behind her a jaunty spray of daisies, about her head two

fluttering butterflies. M. Bénédite has given a rapturous account of the colour-scheme which harmonizes with all the other suggestions of youth and dainty beauty.(¹)

If the *Miss Alexander* gives us the pride of childhood united to the daintiness and elegance to which Whistler was peculiarly sensitive, we see it no less in *The Chelsea Girl,* owned by Mr. Alexander J. Cassatt, united to quite different attributes. This is a child of the streets, standing legs astride and arms akimbo, her cheeks indomitably rosy, an apron over her dark un-childish dress, a brown hat tied under her firm little chin, a bow of ribbon of exquisite yellow brightening her coarse garb. As a distinguished and sober colour-harmony of inimitable grays and yellows, and as an example unusual in Whistler's art of gay and daring brushwork, this canvas is sufficiently a joy to the beholder, but it is also one of the canvasses that prove the artist more an explorer of the spiritual side of his subjects than his own words, quoted and requoted, would lead the reader not also an attentive observer of his work to believe.

It would be difficult to imagine anything more acutely rendered from the psychological point of view than this initiated little creature, not more than eight or ten years of age, with her grave and bold eyes, her aggressive decision of pose—the pose of one instinct-

(¹) The portraits of Carlyle and Miss Alexander are known to the present writer only in reproductions. The fine coloured prints recently imported are said to give a quite remarkable idea of the colour.

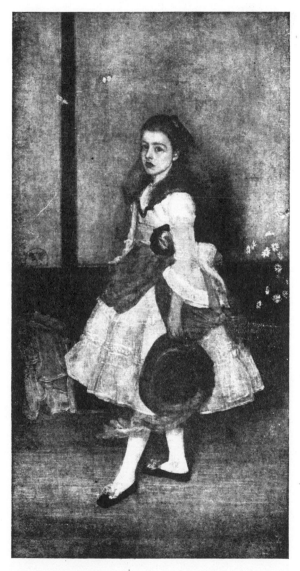

PORTRAIT OF MISS CICELY HENRIETTA ALEXANDER.

Courtesy of H. Wunderlich & Company.

ively aware that only the fighters of her class are the survivors—her whole air of pitiful bravado; even her ugly little costume caressed into loveliness by a tender and reconciling art. A sentimentalist or even a painter a very little less antagonistic to pictorial cant would have been likely to make an obvious appeal to the sympathy of the beholder in presenting a type so touching and suggestive. Bastien-Lepage would have filled the face with yearning and weariness, Sir Joshua would have given her some violets to sell. Whistler selected the outer facts that told the inner truth of her intricate little personality and confused them by no extraneous rhetoric.

Less enigmatic, but not less subtly realized is the *Little Rose of Lyme Regis,* a half-length figure owned by the Boston Museum of Fine Arts and said to have been painted at the village of Lyme Regis in Dorset when Whistler was there in 1895. Nothing could be more unlike the sophisticated arrogance of the Chelsea waif than the tidy simplicity and gentle seriousness of this little Rose on whose face are written in unmistakable characters amiability and the tendency to obedience, whose clasped hands and trusting eyes give the impression of docility. She also may be called a child of the people, perhaps, but of how different a people, with what opposite traditions, surroundings and ideals! Thus to have discriminated between types of the two classes with such perfect lucidity and directness, without a shred of adventitious aid, without a revealing acces-

sory or a suggestion of a typical occupation or amusement, by merely the determining differences of pose. expression and feature, and by the way of wearing a little apron, is in itself sufficient to suggest if not to prove that Whistler took as much as the painter's usual "human interest" in his subjects. Another interpretation of what we may call the competent types is *The Little Lady Sophie of Soho,* a child of the studios, and one of the most vivid of his characterisations. The bold refinement of her bearing, her firm mouth, the superb gesture of her arms, compose an effect of extraordinary distinction.

Quite a different aspect of childhood, less accentuated in character but with the charm of a greater beauty, is shown in the *Pretty Nellie Brown* owned by Mr. Frank Lusk Babbott, of Brooklyn, New York. This enchanting little picture is the quietest and most delicate rendering of a rather fragile grace, a rather baffling personality. Deep mild eyes look out with an unquestioning, unreflective, softly indifferent gaze from a lovely oval face enveloped by a shimmering cloud of light brown hair. The recondite simplicity of the colour scheme is only hinted at in the "rose and gold" of the title. It is a dull rose deepening in the background almost to crimson and of the curious grayish tinge that brings the phrase "ashes of roses" into the mind. The outer garment, of this colour, opens at the throat over a filmy blouse of palest pink, modified by yellow. The flesh tones are warm, but less so than in the *Little Lady Sophie,* which also is a

harmony in rose and gold. The eyes are the dark accent of the face and the modelling about them is definite with sharp touches at the corners. The hair has the neutral quality of raw umber in its dim tones yet it is not lacking in life. The modelling of the face is accomplished as in many of Whistler's later works with the slightest alterations of tone, and the rather coarse canvas everywhere shows through the films of pigment. The brushwork is hardly brushwork at all, but a mere staining of the canvas with a few tones that melt into one another by gradations felt rather than seen and seem to withdraw within a pale twilight that softens without obscuring every form and plane.

The gray ground which Whistler often (though by no means inevitably) used, shows particularly in the hands which are defined by the thinnest possible film of flesh-colour and have the look of extreme frailty not uncommon in the hands of children of ten or twelve.

This picture was painted on as late as 1900, having been many times gone over before its completion. Whistler was then over sixty-five years of age and within three years of his death, but his touch upon the canvas was as sensitive and certain as in his earlier days. It is notable that old age did not produce with him that relaxation of will and nerve that so often accounts for what we commonly call "breadth" in the later style of the great masters. The training of his hand to exquisite precision and the care bestowed by him upon all the details of his workmanship bore fruit

in his ability to keep to the end the precious quality of his art. He could do little things as well at sixty as at thirty,—years robbed him of nothing essential to the close web of his workmanship. He neither drops his stitches nor blurs his page. He is not forced to the pathetic long stroke of a hand that cannot trust itself to make a short one. Almost as though in defiance of the common enemy as age approaches we see him producing numberless little pictures, each one of which is a testimony to the quickness of his sight, the power of his memory, the deftness of his hand, the adequacy of all his faculties to answer to his call. The refinement of old age is as impressive as its coarseness is revolting, and each of Whistler's late works is a monument to his self-discipline. No man has ever died and left behind him a product more evenly free from the accidents of mortality, more purely the emanation of the mind and temperament. So far as his art went the old age he is said to have dreaded never was his.

His interpretations of children, always peculiarly discerning, grew perhaps more comprehending and tender, a number of those belonging to his later years having an especial richness of sympathy with the ardour and reserve of childhood and an indescribable delicacy of interpretation. These little creatures, of which there are many, each unconventional, unpretentious—thoroughly alive, bear striking witness to Whistler's faculty of rendering character, but they are only a small part of all the work that bears such evidence. His full length portraits of men and women

Arrangement in Black, No. 3.

PORTRAIT OF SIR HENRY IRVING AS PHILIP II.
OF SPAIN.

By kind permission of George C. Thomas, Esq.

are both numerous and varied, although the colour harmony in many of them is in the key of black, producing an apparent similarity among them. The types, however, are perfectly embodied and differentiated. The portrait of Miss Rosa Corder, belonging to Mr. Canfield, is a breezy and vivid picture despite its black dress against an almost black background. It shows a woman with a strong profile, in a fur-trimmed jacket, holding her hat, one might say swinging it somewhat, in her right hand. Splendid as pure painting, it is no less splendid in its vigorous individuality, its suggestions of movement and energy and activity of mind. The Henry Irving as Philip II, has precisely the touch of dramatic gesture, not emphasized or to the slightest degree insisted upon, but hinted at in the clutch of the hand at the chain and the lifting of the eyebrow that brings the actor before us in his least exaggerated, most uncaricatured aspect.

In the *Portrait of a Lady*, owned by Mr. Cassatt, the small, beautiful hand, the direct serene gaze, the quiet poise, the severe taste of the arrangement all play into the total effect of extreme elegance. In the portrait of Lady Archibald Campbell (*The Lady with the Yellow Buskin*) the supple figure lightly turned, the small head sunk in the deep furs, the small foot in its handsome little shoe, the droop of the mouth and line of the brow, as delicately indicated as unmistakable in their precision, are eloquent of refined caprice.

Mr. Pope's *Carmen* is the genius of the gypsy race, unique, I think, in Whistler's painting on the side of its rude brush strokes and its arrest of development at the point of powerful realisation where his habit was to proceed to subtle suggestion, and unique also in its bold interpretation of a barbaric nature. It is one of the few pictures that stand out as his experiments in what might be called the athletic type of art, a type demanding force rather than intuition or poetic imagination, and it is especially valuable as showing the artist's ease in handling such an alien subject and his feeling that with it he could dispense with the usual refinements of his craft.

In the portrait of Señor Sarasate, the violinist, the sensitiveness of the musician is noted, not as an independent quality, but expressed with the greatest subtlety in union with the mobility and eagerness of the Latin race. The portrait of Comte Robert de Montesquiou-Fezensac is the epitome of dilettantism.

In none of these portraits which show something of Whistler's range but by no means exhaust it, do we feel that the painter has failed to capture the air that makes his subject different from any other subject, that saves it not only from commonplace in general but from *its* commonplace, that disengages from the every-day familiar aspect the record made upon the features, the gestures, the figure, by habits of thought and feeling, and by inherent traits. Everyone knows the answer he made on the occasion of the celebrated Ruskin trial, to the judge who inquired of him whether

he did not think two hundred guineas a large sum to ask for a picture that had been painted in a day. "I ask it," he said, "for the knowledge of a lifetime." It is obvious that to treat a subject synthetically and yet fill it with suggestiveness and keep in it the unwearied incidental look of a thing done easily involves an amount of labour of mind unknown to the painter who relies chiefly on his joyous enthusiasm to impart the look of ease and happiness to his finished work. Whistler, however, went beyond all usual bounds in his patience and persistent search for the intimate aspect and the appearance of spontaneity in the execution. M. Duret tells us how he produced the little lithographic portrait of Stephen Mallarmé. The portrait was to be the frontispiece of the volume of Mallarmé's *Vers et Prose,* published in 1895. Whistler kept Mallarmé posing, working rapidly, but dissatisfied with one after another of the drawings made, finding himself not yet able to penetrate to the absolute character. Mallarmé became discouraged and lost all hope of a success, when the artist finally achieved a drawing with the charm of swift improvisation but holding all the accumulated observation of the many preliminary efforts. It is only necessary to compare the two reproductions in M. Duret's book, one of the finished portrait, the other of one of the attempts, to see to what depths that observation went, and how the mind and temperament of the poet found their expression in the few touches of the crayon that show the action of the head, the arm, the mobile eye-

brow and flexible mouth. "Those who knew him might believe they heard him speak," M. Duret says, and those who knew him not may believe they see him think.

Whistler also painted M. Duret's portrait and its little history throws much light on the method used by the artist in the portraits of this period. Whistler and his friend had been discussing the portrait of the President of some Society or Corporation who had been painted in the robes of his office of the customary antique cut, but with his hair arranged in the fashion of the day. This appearing to Whistler "in detestable taste," the conversation turned on the proper pose and costume for a portrait. It was agreed that the pose should be determined by the sitter's type, that the dress should be modern, and that it was perfectly possible to paint a man in the evening dress of the period with satisfactory result. Whistler asked M. Duret to pose for him, and a standing pose and light background were determined upon. Then came the question of some accessory that should break the severity of the long black figure. After long thought Whistler bade his friend bring to the studio a rose-coloured domino. M. Duret, astonished but obedient, went in search of the domino, found it at the costumer's of Drury Lane Theatre, and appeared with it on the appointed day. The following is his description of the development of the picture under Whistler's hands:

"He posed me standing before a curtain of grayish

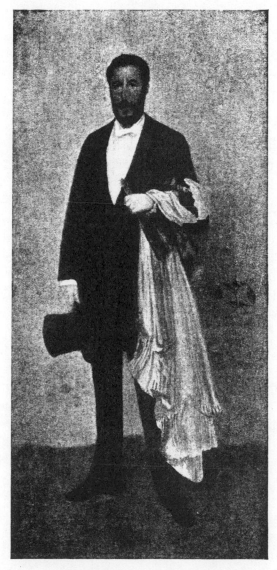

PORTRAIT OF M. DURET.

From M. Théodore Duret's *Whistler*.

rose-colour, the rose-coloured domino thrown over my left arm, bare-headed, with my hat held in my right hand which hung by my side, and he attacked the portrait without any preliminary drawing. He merely made with the chalk on the white canvas, a few marks to indicate at the top the placing of the head, at the bottom that of the feet, and at the right and left the position of the body. He then immediately applied the colours and tones to the canvas as they were to be in the definitive picture. At the end of the pose one already could judge what the general appearance of the work was to be. For the principal *motif,* a man standing, seen full face, in a black suit, then the pink domino had permitted the arrangement of the colours in a decorative scheme such as he introduced into all his paintings, the black of the clothing, the rose-colour of the domino and the grayish rose of the background forming *An Arrangement in Flesh-Colour and Black.* The domino served him also in defining the character of the model who might pass for a gentleman going to a ball. And, finally, hanging as it did, over the left leg and covering it in part, it destroyed the stiff parallelism of the two sides of the body and diversified the outlines. He continued to make me give him long poses. He was painting Lady Archibald Campbell's portrait at the same time with mine. He carried the two works forward together and I was able to observe the degrees by which he kept them parallel. One of his principal anxieties as they advanced was to preserve in them the appearance of

having been produced without effort. In place of adding details, he suppressed them and kept the style large before everything else. Therefore that with which his detractors have reproached him, the painting of sketches only, was not with him the consequence of absence of effort, but came from his very conception of a work of art, and was on the contrary the result of persistent attention and additional labour." M. Duret adds to this valuable account the statement that as soon as Whistler found any disturbance of the relation between the tones from working on any part of the picture he at once went over the entire canvas and brought the whole together again. This happened perhaps ten times before its completion, yet when it was sent to the *Salon* of 1885 it was criticized as being in the nature of a sketch, probably executed in a very brief period of time. This impassioned attempt to cast everything portentous and heroic out of his pictures is perhaps the quality that opens between Whistler and his contemporaries the widest chasm. Manet's work while it does not suggest labour and effort does not on the other hand suggest the absence of it. Whistler's is never without the suggestion that it was done for the sweet pleasure of the doing, and it is in line with this intention that he saved himself unnecessary tasks. In his later work his prepared grounds and his thin medium gave him remarkable control of his material. What helped him most, however, was his deliberate and reasonable foresight. One of his pupils has said that he insisted in the class upon a

thorough mental preparation before the canvas was attacked, a study of the model and the arrangement in the mind of the painting before the first touch was placed. This was no less his own method. He appears always to have referred the image growing under his hand to a clear mental image of the complete effect as he wished it to be. There seems to be no evidence in his pictures of reconsiderations or changes of plan. The repaintings to which they were in many instances subjected seem always to have been the means by which he reached his predetermined goal, not the result of efforts to improve or alter a first intention. This no doubt is what he means by saying that a picture should be finished from the beginning. In such a sense it is finished from the beginning as each time that it is laid aside it is in a condition that shows the precise relation between all the parts.

How different was Manet's attitude M. Duret has told us in his *Histoire d'Edouard Manet*. In 1868 Manet painted his portrait and M. Duret watched the process with the same intelligent interest that fifteen years later he was to show with the portrait painted by Whistler. Manet commenced, he says, with a harmony of grays, but when the picture was finished and seemed to M. Duret entirely successful, he could see that Manet was not satisfied with it. He put M. Duret in pose again and began to add accessories. First he arranged a little table with a garnet cover and painted that. Then came the happy idea of throwing a book with a light green cover under the

table and painting that. Later, a carafe, a glass and a knife on a lacquer tray were placed on the table. Finally a lemon was added. Thus the artist built up a little bouquet of colour in the picture that satisfied his natural instinct as the quiet grays could not. M. Duret has traced in many of his other pictures the same accumulative process by which multi-coloured accessories are added to a general gray tone, as if by an after-thought.

Apparently Whistler and Manet worked in almost precisely opposite directions in the actual treatment of their material. Whistler in his later portraits became increasingly abstract, eliminated detail with a deepening passion for simplification, resolved his varied colours more persistently into a single expressive tone; sacrificed the exquisite accessories of his early work, and finally stood, quite alone in his generation, severe almost to the point of austerity, impressive, learned, and triumphant over all pre-occupations with the by-play of art. Never inclined toward a positively high key, (try a white handkerchief against his lighter pictures and note how low in tone it shows them to be) he was more frequently solicited by closely related grays and variations of black, and posed his models and sitters chiefly in the half light of his studio to secure for them the quiet illumination that made possible his infinitely quiet effects.

Manet, on the contrary, was increasingly inclined toward posing his models in the open air and using vivid colours in juxtaposition. If he, to adopt M.

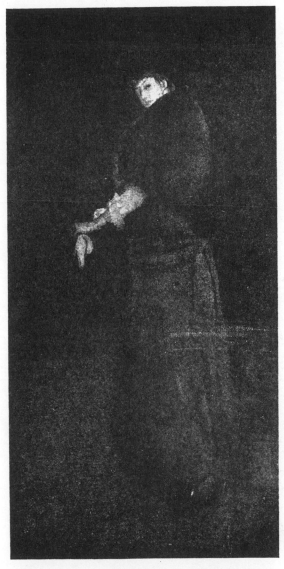

THE LADY WITH THE YELLOW BUSKIN.

In the W. P. Wilstach Collection, Philadelphia.

Duret's phrase, was the hunter leaping every obstacle in his path in his reckless determination to reach his goal, Whistler was the racer, covering his ground steadily, conserving his energy, and achieving his purpose without swerving from his course.

And we are safe to assume that a part at least of his purpose was to realize individual characteristics. There is no sign that he cared to represent in his art the richness of the human world. If his types are various it is probable that he nevertheless took them much as they came, reserving his right not to take them at all if they did not please him. There are many classes of society not to be found in his work, and we cannot by the farthest stretch of imagination call it the "baggage" of a painter for whom the personal experience of men and women is an unfailingly inspiring theme. Nor do we find that human affairs in general have any place in his paintings. "I do not remember," says Mr. Cox, "a single figure-picture by Whistler," in which anybody is doing anything in particular. His figures stand or sit or recline, but they never act." This, of course, is of the essence of his art, and his power to show character in repose is certainly not a mark of inefficiency. But the fact remains that his was not illustrative painting in any sense of the word. We not only learn from it nothing of the events of the time in which he worked, we learn nothing of the feelings, admirations and prejudices of the time. He never painted an *"Hommage"* to anyone; he never chose such a subject as the *Night Watch;*

he celebrated no historical event such as the combat of the Kearsarge and the Alabama, which moved Manet to the achievement of a truly magnificent marine. It is all the more remarkable that he has been able so completely to project himself into the temperament of the individual. There is nothing cheap or coarse in his psychology, therefore it is easy to overlook it. But if we overlook it we have shut ourselves from one of the most delicate pleasures of the many with which he has provided us,

ETCHINGS

CHAPTER SIXTH.

Etchings.

MUCH has been written of Whistler's etchings from both the technical and the untechnical point of view, and only the simple truth that a thing of beauty is a joy forever can excuse bringing the subject forward again with no very new light to throw upon it, with only a personal pleasure in it to record. Simple as it seems, however, to say that Whistler's etchings are beautiful, it is what can be said of comparatively few etchings in the world. Always an interesting process because of its definite and personal character, etching requires a profoundly artistic intelligence to turn its limitations to artistic ends, to make peace with the instrument, as it were, to soften and subdue a certain shrillness in its artistic utterance of the artistic idea without destroying its crispness and decision. In all etching the effect should be of a line made by an inflexible metal point, and scratching a metal plate with a metal point is, of course, of the essence of dry-point work. A true etcher is not tempted to disregard the lineal character of his medium, his problem is to make his line so expressive and musical as to destroy in the mind of the observer all thought of its limitations. If he can so lightly and subtly suggest shapes and distances as to convey the memory beyond them to stored associations and impressions too delicate to be evoked by a

ruder touch, he has made his inflexible point do its
whole duty as an artistic medium. To do more would
be to do less. This apparently is the conclusion to
which Whistler was led by his many years of study
and practice in etching, and, paradoxically, it is the
conclusion from which he started. His earliest plates,
or to speak more accurately, some of his very early
plates, show his innate tendency to make a single line
express twenty, to select the one line exclusively ap-
propriate to his subject and to concentrate attention
on the object most interesting to him which consti-
tutes his theme. The *Isle de la Cité,* dated 1859, is
quite as perfect a description of the given scene as we
could find among his later works. It speaks quite as
concisely, the form is quite as elegant and as in-
tently observed as in, for example, the *Upright
Venice* of more than twenty years later. The
little group of clustered houses, the buildings
shown with less and less detail toward the edges
of the plate, the riverside and bridges with their
minute little figures, the open placid sky, all indicated
with exquisite restraint of expression, contain the
essential charm of his method. His later renderings
of similar scenes in a similar mood carry perhaps
more of the courage of his conviction, but they reveal
no different conviction. Not all the etchings of that
period, however, are thus wholly comparable with the
later ones. Many are rich and beautiful portraits of
places in which every detail of picturesque value is
elaborately worked out, in which the sense of light

and dark in extreme contrast is somewhat insisted
upon; in which, in fact, the mood of the etcher might
be considered as one of emphasis arguing with
slightly excessive eloquence for the beauty of what he
sees. The quality of such eloquence is not, indeed, to
be denied. Only one thing could be more expressive
—the statement unadorned of a fact of beauty so
moving as to make adornment superfluous. To this
Whistler in his later etchings proceeded, not chang-
ing his artistic intention, but refining his method until
it became so distinguished as to be almost negligible.
By a perfectly natural evolution he more and more
came to substitute expressive spaces for expressive
detail. But it could only be through mastery of detail
that he could learn when to ignore it, and the individ-
ual results of his early work are delightful in their
kind with values of association that persist in appeal-
ing to the untechnical careless world.

His first dated series of etchings, published in
1858([1]) and called the *French Set,* includes thirteen
plates, some of them made on a trip into Alsace, Lor-
raine and Germany, and others in Paris. The subjects
are from the life about him and show him in a sense off
guard as he was not in his early paintings. He was
using a medium, that is, with which he had gained
familiarity in the mechanical task of engraving plates
for the Coast Survey. He knew precisely what his
hand could do, and he was thus free to use his eyes
as an artist immediately and independently, without

([1]) 1858 is the date given by M. Duret. Mr. Wedmore has it 1859.

the perplexing undercurrent of wonder as to how he should render the thing seen. He began with this part of his initiation behind him, and could at once devote himself to the refinements of the technical process necessary to produce the exquisite results for which he sought. Had he learned to engrave on copper with the direct intention of making pictures by that means he might have found it more difficult to avoid that habit of which he has told us, so often formed by students in schools, the habit of making pictures of pictures instead of making pictures of nature. No accident of education could have made him individual if he had not started so, but this lucky accident may have kept him from falling into the imitative ways of a student by giving him a means of adequate expression for his pictorial ideas before he had mastered the craft of painting. In the *French Set,* for example, is an etching of *La Mère Gérard.* an old French woman who fell by degrees from the proud estate of keeper of a reading room, to the humble occupation of selling flowers at the door of the Bal Bullier, where Whistler was attracted by her picturesque figure and claimed her for a model. She wears a dark tippet and a bonnet tied under her chin, her face is keen with a sensitive mouth and clear-cut nose, her brow is marked by the bar of Michael Angelo. Not a line of the dainty little plate but shows the fine discrimination of Whistler's taste and the costly simplicity of his execution. We have only to compare this quite perfect etching with the portrait in oils of

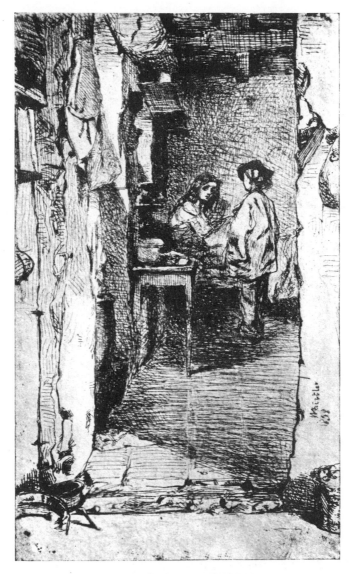

"THE RAG GATHERERS."
(From the Etching.)

the same model, which was one of his earlier achievements, to realize how much it meant to him to "know how." The oil-colour is laborious and holds reminiscences of commonplace ways of handling the brush and the pigment. If the embryo of Whistler's style is there it is formless and indistinguishable as his.

We may therefore consider it a piece of extraordinary good fortune for ourselves as for him that his frank youthful vision of Paris and London was not obliged to wait for a single night to be translated into his characteristic idiom. A *Thames Set* of sixteen etchings followed the *French Set* and the two groups with the detached subjects of the same early period, are records of localities that vie with those of Balzac in their precision of representative statement. The plate called *The Rag Gatherers,* for example, shows a hovel in the *Quartier Mouffetard.* The doorway frames the scene, a device of which Whistler made frequent use, and which contributes to the effect always in his mind to obtain—the effect of seeing objects not as though they stood out from the paper or canvas or other material on which they are drawn, but as though they were a little back of it. We perceive two figures, a boy and a girl or woman, within the room at long range as if we were peering into a rather deep enclosure from some distance beyond the threshold. The girl is bending forward with an appealing aspect of frailty in her small face surrounded by a fall of heavy hair, the boy is erect and wears his cap and blouse with jauntiness. And there

is the inimitable revealing touch of a master upon accessories, showing by a few objects, a heavy wallbeam, a little table, some irregular boards in the flooring, the precise character of the squalid interior. In an earlier state in the Avery collection(¹) there are no figures. "The scene is then," says Mr. Wedmore, "in its silence and squalor almost as suggestive as the *Rue des Mauvais Garçons* of Meryon."

The famous plate *The Kitchen* shows another characteristic interior, tidy this time and comfortable, with a woman's figure at the end of the room in a deep recess on the walls of which the sunlight pours through a little window. Vines make charming patterns on the window-pane and shadows on the wall. The figure of the woman is very dark and most of the room is in heavy shadow. We see the details of its furnishing, however, and the textures and surfaces of the different objects are scrupulously defined. They are not, that is, partially obliterated by the shadow, their specific appearance is not merged in a single tone, as so often is the case with Rembrandt's rooms in which the light and shade are thus strongly contrasted. Even at this date Whistler had his individual way of treating chiaroscuro, a way that is fully developed in such paintings as *The Yellow Buskin* and the *Rosa Corder*. He kept his darks distinguishable from one another, although casting them into a

(¹) It is catalogued as the first state, but the whole question of states is still so shifting that one hesitates even to quote a positive statement.

common shadow. The background does not blend with the figure and the darks of the curtain and the dress are as different in value as red and green are different in colour value. We find this all through the etchings even where the shadow becomes positive blackness as in *La Vieille aux Loques,* another French habitation with a delightful old woman nodding in the doorway and an extraordinary amount of cross-hatching all over the darker parts of the plate. Not until the printing of the Venice Nocturnes does he adopt a chiaroscuro which grows without interruption from darkness to light so that critics uncontrollably impelled to compare his etchings to those of Rembrandt must go as far as this to discover any real correspondence in vision or rendering and by this time the etchings in all other particulars have become so unlike anyone else's that to search for correspondences is a thankless task. One little plate of the early period, however, (the *Little Arthur,* Wedmore 13) does afford an opportunity for direct reference to Rembrandt. It is etched with a different line from that usually chosen by Whistler from among the innumerable possibilities of line. Even where his lines are minute as in *La Mère Gérard* they are seldom abrupt or scratchy. They convey a sense of tranquillity not only in the mood of the etcher, but in the atmosphere surrounding the subject of the etching. It is the same tendency that led him away from noonday effects in his open air pictures and from the use of a high key in his colour schemes. He had not—in his

art—the dramatic note. This *Little Arthur,* however, is etched with a crisp almost crackling line, that gives the figure the appearance of being seated in pulsing shimmering sunlight. The air vibrates and tingles with little sharp accents. How often Rembrandt used this effect in his small portrait heads and little early compositions is a matter of common knowledge, but there is an especially striking likeness between the *Little Arthur* and his *William II* (Blanc, No. 177). In each we find the same modelling of the face with cross-hatched shadows, the same discrimination of texture in the hair and dress without special definition of planes, the same breaking up of the background with the little staccato lines already referred to, and in this one instance we find a shadow connecting the figure with the background more extended and "Rembrandtesque" in Whistler's plate than in Rembrandt's. The suggestion is clear that in that subject and at that moment Whistler, whether or not with Rembrandt in mind, was making his picture out of light and shade with less attention than usual to the pattern made by line and surface.

Another early plate (1859), *The Landscape with the Horse,* has also its reminiscences of Rembrandt which are not, however, enough to dilute the strong personal character of the design. They show most in the state where it is a landscape with two horses. The meadow dipping and rising, the little fence marking the sharp elevation of the ground in the distance, the foliage light without fuzziness, the shapes of the trees

"JO'S BENT HEAD."
(From the Etching.)

against the sky, are all in Rembrandt's tradition of representing in a landscape great solidity and distance with a few structural lines and just as much realism as will leave wholly unimpaired the indispensable attribute of vitality in the drawing. But they are also in Whistler's tradition as he shows it throughout his work in all its forms, and it is probable that the choice of a landscape subject—a choice so rare with him as to seem in itself a mark of some outside influence—is chiefly responsible for the thought of Rembrandt that inevitably comes to mind at sight of this beautiful and in no way uncharacteristic etching.

The very fact that one example or two permit a reference to forerunners throws into striking relief the originality of Whistler's work as a whole. In noting here and there a resemblance one is forced at the same time to note its isolated character and the infrequency of opportunities to trace influences or even relationships. A few of the *French Set* remind the observer acquainted with Meryon's majestic portraits of old Paris that Whistler had been etching ten years before Meryon died and no doubt had felt the inspiration of his rare and passionate genius. There is the *Street at Saverne* in which a street lamp casts a broad illumination over the walls of houses on the opposite side. The large flat surfaces on which the light rests uninterrupted by accidental shadows, the simple imposing masses of strong dark, the solid dignified architecture, have just such beauty as the artist of the *Rue de la Tixanderie* sought and found unceasingly.

There is also the *Liverdun,* a farmyard of Lorraine, in which the distribution of light and shade produces the effect of massive structure, almost of solemnity, with which Meryon invests the simplest scene. A few other plates, among them *The Miser* and *Wych Street,* have this effect—it might crudely be called the flat wall effect, as it depends upon the flooding of a large unbroken surface with light,—and wherever it occurs we are assailed by the thought of Meryon, so that we could say with a certain amount of justification that Meryon more than any other etcher influenced Whistler's etched work. But if we say this we must remember that it is an influence audible because of the silence in which it speaks. To lay special stress upon it or to extend it beyond occasional examples, would be to exaggerate it. Still less can we afford to emphasize the influence of any contemporary. Beside his brother-in-law, Sir Seymour Haden, his friend Legros and Félix Bracquemond were expressing very definite temperaments and ideals through the medium of etching; but their work only serves to emphasize the independence of Whistler's. Sir Seymour Haden was probably most intimately his companion as an etcher. There is at least one plate which they etched in collaboration, (it is called *The Wood*) and it is obvious that in a number of instances they were drawing the same subject at the same time. These plates made side by side are the best evidence possible of the degree of artistic relationship between the two artists. Its negligibility is not to be mistaken. If we take for

a single example the etching by Whistler of *Greenwich Park*, in which the trees, seldom found as a prominent feature of his compositions, afford an opportunity for comparison, we see at once how he made a distinct pattern of the foliage with clear-cut edges where Sir Seymour Haden reproduced instead its depth and blurred its silhouette. The sharpness and fineness of Whistler's vision and of his translation of his vision were much more in harmony with the methods of his French friends than with those of any contemporary English artist and the mid-Victorian element in the work of Sir Seymour Haden which makes it national and typical and of a special period, (and thus adds to its value for those to whom such qualities are a part, and even a precious part, of an artistic achievement,) separates it absolutely from Whistler's work of any time. Divergent as they are in method, style, and choice of subject there is more of Bracquemond's spirit in Whistler's way of seeing than there is of Haden's. Bracquemond took deeply his lessons from the Japanese, and in all his original work of the early sixties (it was not extensive) we see an effort to spot his surfaces with a decorative arrangement of darks and lights, and to seize the spontaneous impression. He and Whistler at least felt in common the charm and value of spontaneity of effect and a decorative plan. Bracquemond's fine care for the quality of his materials and his indomitable simplicity in the use of his complicated equipment of knowledge were also qualities in line with Whistler's,

but he was at heart a decorator rather than an artist
in the sense that Whistler was an artist, and it is not
possible to go any distance in comparison of the two.

With Legros there was even less chance of the
interplay of intellectual and temperamental points of
view. He and Whistler began to etch at about the
same time, but there is as little likeness between their
methods or their ways of seeing in their etchings as
in their paintings. Legros, despite his classic tend-
encies, was essentially dramatic. M. Alexandre has
cleverly traced to his actual familiarity with the thea-
tre in his youth as a scene-painter, the characteristic
arrangement of his compositions, and many of his
large plates are in truth singularly suggestive of
scenes arranged for the stage. This fact alone would
separate him entirely from Whistler's unobtrusive
and carefully "accidental" quality. But if we examine
the two portraits of Delâtre, the printer, made by
Whistler and Legros respectively, we see how deep
the chasm was between their different ways of repre-
senting a subject, and how adequate Whistler was to
grasp not alone the pictorial but the personal aspect
of the man before him, where Legros conventional-
ized and confused the impression. Whistler's Delâtre
is not only a man but a Frenchman and not only a
Frenchman but a French craftsman. His rather sen-
sitive, observant eyes, his clear-cut features, his air
of capability and training, of being a little finicky of
mind and exigent of manner, are precisely those of
one to whom an artistic craft with its mingling of

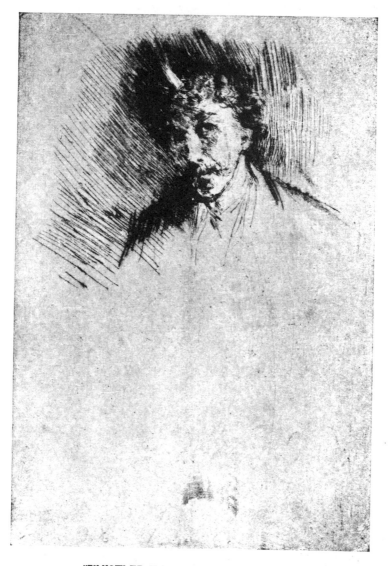

WHISTLER WITH THE WHITE LOCK.

(From the etching in the Avery Collection: Reproduced by courtesy of the Print Department of
the New York Public Library.)

poetry and science would appeal. The Delâtre of
Legros, on the contrary, is earnest and commonplace,
an honest man, but not necessarily a Frenchman or
a craftsman, and with no interest of individuality.

Without multiplying instances of Whistler's un-
likeness to other painter-etchers of his circle, it is safe
to accept him as not even at the beginning a follower.
Much of the charm of his early work lies in this fresh-
ness of outlook upon surroundings more familiar in
literature than in art.

He became known to the public as an etcher chiefly
through his great Thames series, in which the dark
river with its multitudinous burdens, its stately
bridges, its shores swarming with idlers and traffick-
ers, is brought before one in its daily aspect, a part of
the vast town by which it has been enchained and a
part of the familiar life of the people. His biographer
notes that he was the first interpreter of this commer-
cial London, his predecessors having pushed up
toward Richmond and toward Henley in their seeking
for the Morris ideal of a—

—London small and white and clean.

The clear Thames bordered by its gardens green.
He was minutely accurate in his pictures of the
barges and warehouses, the fishing-boats bringing
their fish to the Billingsgate market, the docks and the
taverns, and those who knew these features of the
river life in the sixties report them to be so faithfully
recorded that a true historical value is added to the
artistic value of the etchings in which they appear. It

seems to have been his habit to carry his plates into the actual presence of the scene he was to represent, and to make his quiet, delicately considered compositions in the turmoil of busy places, drawing directly upon the copper without preliminary sketching. M. Duret relates that while he was drawing the beautiful plate called *Rotherhithe* in a repair shop on the bank of the river a brick fell from above just missing his head and causing his hand involuntarily to swerve, making the long perpendicular mark across the plate which may be seen in the print.

In such plates as the *Black Lion Wharf, Eagle Wharf, Adam and Eve Tavern, Thames Warehouses,* and *Limehouse,* he drew with the most minute accuracy each variation in material, colour, or surface of the old buildings. Different widths of board, the lettering of signs, the latticed railings of little balconies, iron brackets, the crooked sashes of the windows, occasional pots of flowers and vines, the ropes and rings and pulleys of complicated machinery, all are noted with scrupulous precision and are held in a true relation and proportion. The little air of conscientiousness that rests upon them and is due not to their multitudinous detail, but to the fact that the line in them is often permitted to define rather than suggest, is so soon absent from Whistler's work that one welcomes it here as the outward and visible sign of his inner labour. That it was not the complete fulfilment of his own ideal we are bound to recognize in recalling his "Propositions"—

"A picture is finished when all trace of the means used to bring about the end has disappeared.

"To say of a picture, as is often said in its praise, that it shows great and earnest labour, is to say that it is uncomplete and unfit for view.

"Industry in Art is a necessity—not a virtue—and any evidence of the same in the production is a blemish, not a quality; a proof, not of achievement, but of absolutely insufficient work, for work alone will efface the footsteps of work."

If we turn from the *Thames Warehouses* or the *Adam and Eve Tavern* to one of the later etchings, such as *The Bridge*, we are in a position to realize the truth of these propositions which hold in a nutshell the statement long sought by critics of the artistic quality *par excellence*. Nothing could wear more completely the light and gracious air of a work of art that has "done itself" than this complicated collocation of irregular buildings, river craft and people—the houses on the bank with their quaint various construction, straggling off into the pleasant distance where glimpses of little trees may be had, the small boats poled ever so lazily up the stream; the delicate arch of the bridge with its odd draperies, the outlines of human forms, standing idly watching, strolling along the water-side, lounging, loafing, forging busily ahead, what does it all seem but the merest accident of a fair day alongshore, when happening upon such a scene, the natural thing was gaily to fix upon the copper the memoranda that shall prevent its dissolving into nothingness in the mind.

Yet if the most facile sketcher among us should pull out his note-book in the presence of a similar throng of incidents and objects and essay to separate from the confusion just those essential elements of it that make for the beauty of the long perspective of the shore, and the perfect curve of the bridge that contrasts with it and yet seems to repeat and flow into it, for the simplicity and suggestiveness of the little figures, for the charming relation between the clear patch of sky and the broad sweep of water, for the completeness in a word of the picture, the task would be found to involve a combination of talent and training such as occurs only once or twice in a generation—or a century, and the facile sketcher doubtless would be greatly at a loss confronting his apparently easy problem.

To make a difficult thing appear easy—that is the final achievement of art on its technical side, yet the artist who succeeds in doing with apparent carelessness what others conspicuously have laboured over naturally arouses suspicion. The average mind is impatient at being put off with less work than is paid for according to the commutation of commerce, and the necessity of presenting a visible result for every fragment of time spent upon a picture has been felt by many an honest artisan. It was this sentiment of false honesty that led to the downfall of the Pre-Raphælites, and under the guise of conscientiousness, it is, of course, of the nature of vanity. Whistler was free from at least this form of the almost universal human blight. It was nothing to him that in his synthetic

arrangements the expressive blank spaces conveyed the impression of slightness. It was everything to him to distinguish the lines holding the utmost possibilities of beauty and significance amid confusing surplusage. Following his line which is flung out rythmically like the gesture of an eloquent hand we become conscious not of what we naturally—without any especial artistic interest in the scene—would see, but of what he wishes us to see. He throws open doors and windows upon nature and lets the mind out upon spacious and beguiling horizons.

His early etchings were promptly appreciated as works of art. Certain prints were exhibited at the Royal Academy in 1859 where that side of his art continued to be represented until 1864. His reputation as an etcher, holding its own for twenty years through the declining popularity of his paintings, led the Fine Art Society of London in 1879 to send him to Venice for the purpose of making a series of twelve etchings. It is interesting to note (on the authority of M. Duret) that he was to receive for these the sum of six hundred pounds sterling and was also to receive ten shillings for each proof that he printed himself. This arrangement is said to have brought about his taking up the printing of his impressions as a regular thing, no one desiring an impression made by a professional printer after seeing the effects obtained by his management of the process. He returned from Venice in November, 1880, after an absence of fourteen months, during which he had etched forty plates, from which the Fine

Art Society made their selection of twelve. A hundred impressions were printed from each and the series sold at fifty guineas. A sufficient number of people cared for the reticent line and beautiful tone of these etchings to make the little enterprise a success from the commercial point of view; but from the critics came a torrent of abuse. Mr. Wedmore ingeniously explains that they, accustomed to representations of Venice embodying suggestions of her past glory and accustomed also to what Mr. Brownell has called Ruskin's "savage and meaningless exuberance" in his *Stones of Venice,* were taken aback and offended by Whistler's quiet little renderings of the wonderful city. Like Sir Bedivere when that knight was sent to throw away Excalibur, he saw "nothing but the waters wap and the waves wan." He saw a low dentellated sky-line of roofs across the lagune, a modern Venice, without Doges, without pomp or splendour, lovely enough in its divested and impoverished state, but lacking its ancient authoritative magnificence. It was this aspect that he represented and it had the merit of complete originality. Nearly all critics have noted the change in Whistler's manner in passing from the Thames etchings to those of Venice. The difference between the two sets is so great, says M. Duret, that one might believe them to be the work of two different men There is, however, an underlying likeness that with little difficulty can be traced, and even the French set contains examples in which the arrangement of the lines and the light and shade is almost identical with

that in certain Venetian plates. If we examine *The Kitchen* and *The Beggars* for their points of resemblance we shall find them neither few nor trivial. In the darker impressions of *The Beggars* they are especially notable. Here, as in *The Kitchen,* a light opening is seen at the end of a dusky passage, the light strikes the wall at the right, then there is a stretch of intense dark and the edges of the plate are in half light. The whole plan of the design is the same in each plate. We find this effect of looking through a window-frame or doorway to a scene beyond in many of the etchings of different periods. In the plate called *Under Old Battersea Bridge* we look between the dark supports of the bridge, in the *Furnace Nocturne* we see a comparatively small square of intense light set in a framework of translucent shadow so vaporous and shifting as hardly to be called shadow, in the *Bead Stringers,* a group of Italian women sit in a doorway, a shuttered window in the distance as in *The Kitchen;* in *The Traghetto* we look through a long tunnel as in *The Beggars* to the lighted opening at the other end. There are countless variations, but the theme is the same. In the same way such plates as *Price's Candle Works, Chelsea Wharf, Cadogan Pier, The Adam and Eve Tavern* are comparable with *The Bridge,* the *Riva, Number Two* and *Upright Venice* in their balance of lines and spaces. In each there is the effect of the long perspective, the amplitude of sky and air, the absence of crowding in the arrangement of the detail. In Mr. Menpes's *Whistler as I Knew*

Him are a trial proof and a later impression of the plate called *Temple Bar,* which together throw no little light on Whistler's method of carrying an etching forward. In the trial proof there are merely some lines indicating the approach of the interest toward the centre of the plate. In this instance the archway is obviously to be the point on which attention is to be concentrated and all the contributory lines lead up to it. In the later impression we see it brilliantly defined with a beautiful play of light and shadow over its surface and some sharp accents of dark on the buildings near it, while the lines that reach to the edge of the plate are left few and faint. Of this pinning down of the attention to the salient elements of the picture Whistler was a consummate master. He never failed to direct your gaze to the exact spot that most interested him, nor did he ever make the guidance too obvious. The virtue of his fluent and restful line is never more gratefully felt than when he leads you with it along vast distances to wide horizons finally to claim your observation for a doorway covered by a vine or some sailing boats asleep between the night and morning.

In going to Venice he had one advantage that could not be gained at home. The scene presented itself as a whole with the details of which he was at first unfamiliar. 'Such a first impression is always synthetic to an extreme degree, and his genius was precisely of the order to hold it and refer to it the later impressions that came with his fuller knowledge of his environ-

ment. The "psychological moment" when he saw
everything perfectly as a part of a co-ordinated ap-
pearance in which nothing loomed larger than its rela-
tive size or took on more importance than belonged to
it in the general plan, was a moment to which he clung,
to which he was able to cling, through all the subse-
quent submerging experiences of his increasing famil-
iarity. He was thus able to write his story of Venice
on the copper with an almost epic largeness in spite of
the smallness of the scale. Such wealth of result with
such economy of means has rarely if ever before been
seen. Occasionally, as in the *Little Venice* and the
Salute: Dawn, we have only atmosphere, a wonderful
sensation of moving air and changing light, held as it
were to the visible scene by a few expressive lines
gaining their expressiveness from the fact that no
other lines challenge or contradict them. It is char-
acteristic of the time in which he worked and its senti-
ment that Burne-Jones might have said of him as
he did of the Impressionists "they don't make anything
else but atmosphere—and I don't think that's enough
—I don't think it's very much." Even Burne-Jones
admitted, however, that Whistler was "another mat-
ter" and in the case of the Venetian etchings the pub-
lic, according to M. Duret's report, for once were on
Whistler's side against the critics.

A second exhibition was held in February, 1883,
in the galleries of the Fine Art Society, and Whistler
prepared for the occasion a catalogue in which were
printed various quotations from the criticisms—the

hostile criticisms—that had appeared in the more influential journals on the subject of his previous exhibition. Visitors to the galleries had the pleasure of reading in their catalogues, over the names of prominent writers, that the etchings of Mr. Whistler had little to recommend them save the eccentricity of their titles, that there was in them a general absence of tone, that Mr. Whistler was eminently vulgar, that he had produced too much for his reputation, etcetera. Thus amused and already somewhat initiated by the praise of eagerly appreciative collectors, they showed a more positive liking for the second series of etchings than for the first.

The latest Venetian series was issued in 1886 by Messrs. Dowdeswell. This was the famous "Twenty-Six" of which twenty-one were views of Venice and the others English subjects. Only thirty-five sets were published and the printing was done by Whistler.

He added to his catalogue on this occasion his eleven *Propositions* in which are announced his opinions on the production of very large plates and on the habit, then common with etchers, of leaving a broad margin of paper around their work which usually was adorned with the miniature sketch known as the *remarque*. An extreme instance of this use of the border is found in the work of Félix Buhot, the French etcher who died in 1898, and who surrounded his main etching with innumerable sketches more or less closely connected with it as if he were following out with his etching needle the

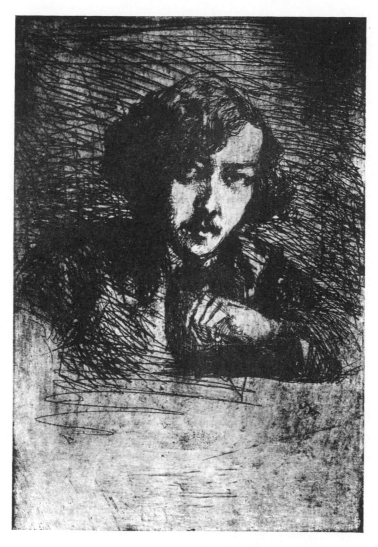

EARLY PORTRAIT OF WHISTLER BY HIMSELF.

(From the etching in the Avery Collection : Reproduced by courtesy of the Print Department of
the New York Public Library.)

dreams or reflections to which it gave rise in his mind. Nothing could be farther from Whistler's concise temper. His *Propositions* state:

I. That in Art it is criminal to go beyond the means used in its exercise.

II. That the space to be covered should always be in proper relation to the means used for covering it.

III. That in etching the means used, or instrument employed, being the smallest possible point, the space to be covered should be small in proportion.

IV. That all attempts to overstep the limits insisted upon by such proportion are inartistic thoroughly, and tend to reveal the paucity of means used instead of concealing the same, as required by Art in its refinement.

V. That the huge plate, therefore, is an offence— its undertaking an unbecoming display of determination and ignorance—its accomplishment a triumph of unthinking earnestness and uncontrolled energy— both endowments of the "duffer."

VI. That the custom of "remarque" emanates from the amateur, and reflects his foolish facility beyond the border of his picture, thus testifying to his unscientific sense of its dignity.

VII. That it is odious.

VIII. That, indeed, there should be no margin on the proof to receive such "remarque."

IX. That the habit of margin, again, dates from the outsider and continues with the collector in his unreasoning connoisseurship—taking curious pleasure in the quantity of paper.

X. That the picture ending where the frame begins, and in the case of the etching, the white mount, being inevitably because of its colour the frame, the picture thus extends itself irrelevantly through the margin to the mount.

XI. That wit of this kind would leave six inches of raw canvas between the painting and its gold frame to delight the purchaser with the quality of the cloth.

In accordance with these views Whistler trimmed all his later etchings close, leaving only a little bar for the butterfly signature and the printer's mark.

Following the *Twenty-Six* came French and English, Belgian and Dutch plates, little shops and scenes on the boulevards and in the public gardens, notes of streets and models and little children, with an occasional single plate given to some subject rarely found in his work, as the magnificent *Sunflowers, Rue des Beaux-Arts* in which it is impossible not to regret the absence of colour, and the little plate called *An Eagle* in which the national bird of the artist's country wears a very mild aspect, but is delightfully drawn. In 1887, the year of Queen Victoria's first Jubilee, he made a little series of plates, called the *Naval Review* set, during the day of the Review at Spithead. This set was presented to the Queen by Whistler in a portfolio of his own design, a fact that emphasized the disagreeable impression caused among his admirers by the sale of the Windsor collection of his etchings in which this presentation set was included.

Like their predecessors, the later etchings embody a

purely personal vision recorded in a purely personal
manner. To their technical qualities practical etchers
have brought their warm support, and even the ama-
teur with a very little study and comparison can dis-
tinguish the special distinction of the flexible line and
the evanescent gradations of tone by which mystery
and romantic charm are brought into the prints as into
the subtlest of the paintings. It is a matter of concern
to the collector that much of the effect depends upon
the printing, the line becoming less and less insistent.
An experienced critic has said with reason that "no
printer can print a good proof from a bad plate, but
per contra, a maladroit printer would surely spoil the
effect of the finest plate in the world." Whistler man-
aged to give a luminous quality to the darkest of his
prints, and his subject invariably lies bathed in am-
bient air. Plates from which impressions have been
made, both by professional printers and by him, reveal
the artistic value of his touch upon the copper as upon
any other material. With his light films of ink he
made his impressions enchantingly poetic where in
the hands of even accomplished craftsmen the same
plate became comparatively prosaic. Each proof, as
Mr. Wedmore has said, is practically a painting by his
hand and the fastidious care of a collector bent upon
securing a characteristic and representative example
is abundantly justified. Even where the choice lies
among impressions each of which Whistler himself has
printed a range is possible. There is the difference in
paper and the difference in the inks used, an impres-

sion in brown ink having an absolutely other pictorial effect from one printed in black ink. Each proof of the Venice *Nocturne* is different from the rest; in one instance, as in the proof owned by Mr. Babbott, it is a pure night effect with the gentlest possible gradation of tones; in another it is evening or early morning with a band of light in the water and sky. In certain impressions a granular effect has been given to the darkest shadow and the wiping has been done with a downward stroke. These variations are of importance only as they meet the taste of the collector. Each copy is beautiful and has an individuality, and each represents the same skill that produced the nocturnes in colour, dealing in this case with printer's ink instead of pigment.

Many of the subjects of the etchings are portraits and these have frequently the extraneous interest of representing members of the talented group in which Whistler moved during his early years. There is *Astruc—A Literary Man* from the poet and sculptor who posed for the music master in Manet's *Leçon de Musique,* and who appears in the etching with bushy dishevelled hair, thick beard and reflective, slightly absent eyes. There was Becquet, also a sculptor but represented as "a fiddler"; a third sculptor, Drouet, furnished the model for a magnificent head that was etched, M. Duret says, in two sittings with five hours of pose. There was Axenfeld and later the Leyland family and there was Swinburne. There were also portraits of Whistler himself, the earliest, made before

1858, showing a mobile face with alert eyes and an expression interrogative and keen, and already dealing with comparisons and measurements.

Numerically, Whistler's etchings are not yet fixed within definite limits. The subjects have considerably exceeded four hundred and of each subject there are usually several known states—and still they come. The prices of the rarer and finer impressions have mounted to so great a height within the past few years as to be in themselves picturesque. In Mr. Wedmore's book on *Fine Prints,* published in 1897, he says:

"As to the prices of Whistlers in the open market? Well, they increase, unquestionably. Some of the very greatest rarities, it may be remembered, have never appeared in the auction-room. There are half-a-dozen, I suppose, for any one of which, did it appear, forty or fifty guineas would cheerfully be paid. . . . The time when Mr. Heywood sold his Whistlers was the fortunate time to buy. A First State of the *Rag Gatherers* was sold then for less than two pounds; a First of the *Westminster Bridge* (then called "The Houses of Parliament") for about five pounds, and many quite desirable things went for a pound apiece— or a few shillings."

At the sale of Mr. Hutchinson's collection in 1892 an impression of *The Palaces* brought less than fifty dollars (£8 15s.); at the Carter sale of 1905 an early impression brought three hundred and ninety dollars, or more than eight times as much, and the winter of 1906 saw this later price doubled. At the Hutchinson

sale an impression of the exquisite plate called *The Garden* sold for less than a tenth of what an impression brought at the Carter sale. At the sale of Dr. Edward Riggle's collection at Sotheby's in 1901 the rare Second State of *The Kitchen* sold for seventeen pounds and five shillings; at the Carter sale less than four years later a Second State brought three hundred and sixty dollars, or more than four times as much.

At the Carter sale a fine impression of the *Nocturne* with the early morning effect brought seven hundred and twenty-five dollars, a price that was noted as record-breaking. In the winter of 1906 at a dealer's sale a fine impression of the *Nocturne* brought fifteen hundred dollars. These comparisons are of little value as indicating the future prices of the etchings, but they show the spirit in which Whistler's work is now received. The less important plates—and this perhaps is more significant—have risen in price proportionately. A good impression of the charming little *Fulham* was sold last winter by one dealer for twenty-four dollars, but at a special exhibition during the same winter it brought nearly twice as much.

It would be quite impossible at the present time to form a complete collection of Whistler's etchings and there are as yet no signs that it ever will be easier for collectors of modest means to gather a number of the more beautiful examples of his work into their Solander boxes.

LITHOGRAPHS

CHAPTER SEVENTH.

Lithographs.

WHISTLER'S attention was turned to lithography in 1878 when Mr. Thomas Way described to him the process that had then been in use about eighty years and was just emerging from the discredit into which it had been cast by the purely commercial and detestable chromos produced by its means. He was not the first to use the lovely and responsive medium with the respect it deserves. The very year that he began to work on the stone a large collection of Daumier's lithographs were on exhibition at the Durand-Ruel galleries in Paris, attesting that artist's noble command of his pliable instrument, Gavarni's work was ended and had included a wide range of technical felicities, the German Menzel had produced his series with brush and scraper. Delacroix, Decamps, Corot and Raffet all had made artistic use of the medium. Fantin-Latour already had adopted it as a means of expression for the emotions inspired in him by music. Whistler, therefore, would have had no excuse for doubting its possibilities. That he did not doubt them is shown by his adventurous plunge into the most difficult subjects with perfect confidence in the power of the stone to yield ultimately successful results.

He at first proposed to issue privately a limited number of impressions to subscribers under the title *Art*

Notes, but the response was so small that the idea was abandoned. Mr. Theodore Watts, editor of Piccadilly, promptly asked for illustrations to that periodical and four drawings were made: *The Toilet, Early Morning.* the *Tall Bridge* and *Broad Bridge.* Only two, *The Toilet* and *Broad Bridge,* were issued, as the magazine then failed. After 1878 lithography lapsed in his interest until 1887, when he again took it up and produced the larger number of his subjects. He worked very carefully as in everything that he attempted, sometimes on the stone and again on transfer paper, in which case he usually worked on the stone after the drawing had been transferred, enriching and completing it.

His lithographs, innocent as the rest of his work of symbolic or historic intention, commemorate delightful aspects of life in Brittany, Devonshire, Paris, Rouen, London and other places explored by the artist for their intimate and finer sides. It is curious to look at such a drawing as the *Little London* with its embankment and bridges, its public buildings and the St. Paul's dome, or such a drawing as the *Savoy Pigeons* with Lambeth Palace and the Houses of Parliament, with barges passing under Charing Cross Bridge, and the endless stream of vehicles and passers-by associated with the great city, and reflect from what an enormous heap of material Whistler deduced his delicate designs. He dealt with the vast cumbrous excessive mass of the town in its most gregarious form. He depicted its movement, its industry, its immensity, its

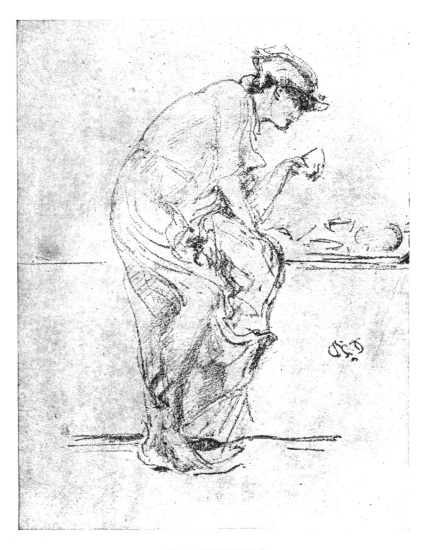

THE HOROSCOPE.
(From Lithograph.)

richness, without once losing his head and making his scheme too big for his means.

He is equally happy in a *genre* which he enters more frequently in his lithographs than in any other of his mediums, in the little pictures, that is, of personal incidents—*The Old Smith's Story; La Blanchisseuse de la Place Dauphine; Tête-à-tête in the Garden; The Clock-Makers, Paimpol;* etc. These are quiet little stories of the day, like those of Daudet, in which, apparently, the artist dropped something of his exigent aversion to descriptive titles; many of the names being in themselves pictures of very definite suggestion. *La Belle Dame Endormie, La Belle Jardinière, Confidences in the Garden, The Horoscope, Afternoon Tea,* all these give access to the little scene depicted. And the scene itself wears in the lithographs a softer charm than in the etchings, owing chiefly, no doubt, to the softer character of the chalk line, but also a little to the fact that here Whistler was frankly experimenting and consequently not quite so sharp and sure in his treatment, and yet was sufficiently learned in his art to know precisely what he was trying for and that he could get it. How far he was a master of lithographic technique none but the initiated may say. So high an authority as Mr. Way recently has declared that it is "likely to be many years before there comes another master to add to the many sides of lithography, others than those in each of which Whistler has left a masterpiece," but Whistler himself called forth this eulogy by referring to himself as "a beginner" in the art as

late as 1896, when he had been familiar with it for nearly twenty years and had worked in it consecutively for about half as long. In a certain sense, perhaps, he was a beginner and always would have remained one. It is hardly probable that he would ever have produced much with the idea of illustrating merely technical problems, or of seeking for that reason the qualities that would bring out the fullest resources of the medium. He was first and foremost an artist, not an expert practitioner, and nothing in the world, we may imagine, interested him so much as the artistic expression of his subject. It was a now historic mistake to call him an *"amateur prodigue"* and he had his own bitter word or two for amateurs. Nevertheless, it would take something from his extraordinary perfection if the trace of the amateur were subtracted from his accomplishment. An artist not less exacting than he in other materials has noted that unless there is a little of the amateur in a man's work it hardly can be ranked as art and it is precisely the unprofessional note in the lithographs that gives them their enchanting grace. Nowhere else except in his pencil and pen and ink drawings does he so gaily reveal his knowledge that "art and joy go hand in hand." The difficulty of the medium is just enough to add zest to the conquering, and its beauty is rewarding to an extreme degree. The black or grey line or wash, showing, as it does, against the white ground has peculiar charms for an artist in love with the thing seen rather than with the method of reproduction, and

the method is free from that rebellion of the material which makes etching a species of battle between the artist and his instrument.

Precisely because he did not regard any method as of more importance on its technical than on its artistic side Whistler demanded extraordinary results, and was not satisfied with anything short of supreme success in producing the final artistic effect. Consequently many of his lithographs, like the finer of his etchings, are of course marvellous from the point of view of the technician who keeps within the known bounds of the process. With the result in mind from the beginning as the important matter Whistler extended its capacity to the furthest limits of his requirements.

In the wonderful lithotint *Early Morning*, for example, the stone was called upon to reproduce that mystery of air and water which he had won with oils, with etching and with pastel. With repeated revision and labour the effect was gained and a comparison of two of the states shows the pains spent upon it. The scene is the river at Battersea, with a group of buildings stretched along the horizon, a bridge in the distance, and in the foreground some barges and two men leaning on a bar. In the first state the clouds in the sky are heavy with sharp edges, and both the sky and river are murky in tone. By scraping and re-etching the cloud edges and heavy darks were removed until an exquisite suggestion of light stealing into the air was gained, and in the second state the soft mists of

dawn hang over the horizon. The note of highest
light was also transferred from the sky at the left to
the shirt or blouse of a longshoreman at the right of
the foreground where it completes with entire felicity
the delicately suggested pattern of light playing
through the composition. In the same way other sub-
jects were transformed. *The Priest's House-Rouen*
is so changed that what was a light house in the first
state is a dark one in the second. *The Blacksmith* in
the first state is gray and dim and in the finished state
brilliant and rich in colour. It is suggestive of the
unremitting attention to reality which survived in
Whistler's art all his distaste for realism that when he
made a rather dark drawing of his life-long intimate,
the Thames, he had the stone taken back to his room
in the Savoy Hotel that he might have nature to refer
to while correcting the defects of the first impression.

A comparison between Whistler's lithographs and
those of Fantin-Latour is interesting as showing how
Whistler's art diverged in this medium from that of
his early companion. Fantin as we know was a mu-
sician by instinct and training and, true to his wor-
shipping disposition, in his lithographs he erected
monuments to different composers, striving to illus-
trate with the chalk the music of Berlioz, Rossini,
Wagner, Schumann and Brahms. If we look at one
of his later prints of a scene in a garden, we see at
once how he meant to convey not merely the impres-
sion but all the possible data of dense foliage, marble
fountains, moonlit sky, and, in the action of the

MOTHER AND CHILD, No. 2.
(From Lithograph.)

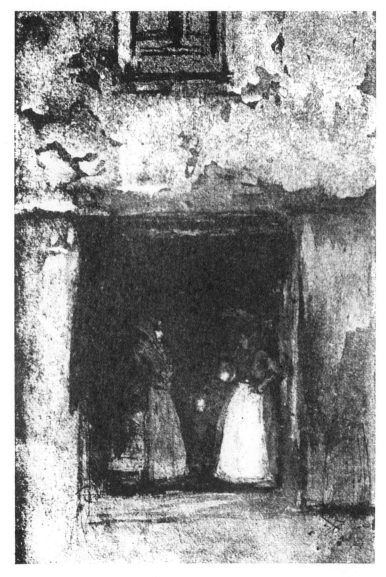

"THE GOSSIPS"—AJACCIO.

figures, a drama of incident and emotion worthy of a large canvas. All the surface is covered, aerial perspective is rendered by marked gradations of tone, objects are modelled in detail and the forms have the roundness of high relief. He managed to do all this without loss of delicacy in the result, but nothing could be more different from the synthesis employed by Whistler, whose lithographs and chalk drawings have just the look of having been made in a temporary undurable medium which from the nature of the materials it is appropriate they should have.

In his coloured lithographs, of which there are half a dozen subjects, Whistler has justified all that he has ever claimed for the charm of unpremeditated effects and apparently unlabourious notes of passing tones and tints. His *Yellow House-Lannion* is perhaps the most engaging of the number. Its brown roof patched with yellow lichen, the green woodwork of its windows, its faint purplish shadows, plunge the mind into contemplation of remembered loveliness in colour and atmosphere, of unforgotten old white buildings bathed in light and touched with the tone of time. Coloured inks and the process are not to be thought of in connection with the mellow sentiment of the perfect little print. All the coloured prints, however, illustrate the possibility of combining a number of colours in a modern lithograph without missing the sense of their resting like fragments of tinted light on a surface suffused with a harmonising tone, the sense that we gain from the best of the old Japanese wood-

blocks. But the peculiar richness and softness of the old Japanese print is not there, and it is tempting to believe that the reason such an artist as Whistler could not in his coloured prints produce an effect of harmony and tone equal to that obtained by the Eastern colour-print artists is simply this—that the pure and costly colours used by the Japanese artists of the eighteenth century were not at his disposal. In the *Draped Figure, reclining,* we have another illustration of the theory of colour repetition analysed by Whistler in his letter to Fantin and shown in so many of his paintings. The principle again is perfectly carried out without the sense of disintegrated colour given by the Impressionists, and in this instance the white ground affords no aid in achieving a general harmony. In the Lenox Library copy the cap is reddish purple with a pale green band and the green appears again in the folds of the thin drapery, hardly tinging it. The yellow of the hair is repeated in the fan. The red of the flushed cheeks is suggested throughout the flesh-tones and the drapery of the couch is touched with red. The outlines are grey and a faint greyish tone shimmers on the surface of the couch. The blue that is quite distinct in the spots on the porcelain jar flutters across the background merely staining it, and a hint of it is in the figure of the fan and in the edge of the drapery that lies upon the floor. The purple of the cap is seen again in the butterfly signature. The paper of this copy is Japan, "extra thin" and of pearly whiteness. It is difficult to convey in words any idea of the ethe-

real lightness of the whole effect in which, notwithstanding its diaphaneity a crisp succinctness of touch is maintained.

In the new catalogue of the lithographs brought out by Mr. Way, a second and revised edition of the one published in 1896, thirty subjects have been added to the one hundred and thirty originally catalogued and described, but only a few of these were drawn, he says, later than 1896. In many cases only a half-dozen proofs were pulled, and in very few cases as many as thirty. This will add, no doubt, to the zest of collectors and to the final market value of the rarer subjects, and an unfortunate circumstance noted by Mr. Way will increase the difficulty already experienced of procuring fine proofs of the greater number of the lithographs. It seems that shortly after the first edition of the catalogue was issued all the stones with Whistler's drawings upon them were withdrawn from the keeping of his printers and placed in the cellars of his solicitors, where they remained until about a year after his death, when an edition of twenty-five proofs was reprinted from certain of them by Mr. Goulding and the drawings erased from the stones. "Now lithographic stones with drawings upon them require attention from time to time," Mr. Way explains, "especially if they are grained stones, as the greater part of Whistler's were, else the ink dries too hard, so that when they are next taken in hand after a long interval, they are liable to suffer serious deterioration in the effort made to recover the printing qualities. The

delicate work weakens by neglect, and the stronger parts are apt to become overstrong in the printer's effort to recover the weaker. The result is a muddy, heavy-looking print when compared with an early proof." As only fifty-five out of almost one hundred subjects handed over to Whistler's solicitors were exhibited at the time of the exhibition of the reprints made after Whistler's death, Mr. Way fears that many of the stones thus suffered irreparable harm.

It is only recently that Whistler's lithographs have been regarded with the respect accorded to his etchings, and even now the best and rarest of them, if it is in the market at all, may be purchased for less than half the price brought by a Whistler etching of equal beauty and rarity. But the time undoubtedly will come when a fine proof of the *Yellow House-Lannion* or the ineffably beautiful figure called *The Horoscope* or the exquisitely tender and pathetic drawings of the artist's wife that express so movingly his inner feeling will be immoderately desired. In the meantime lovers of art of but moderate means may well rejoice that they have within their reach a number of examples of Whistler's art absolutely autographic in character; and, thanks to his scrupulous conscience as an artist, as beautiful in their way as the paintings.

NOTE: Since the above was written a beautiful proof of *The Yellow House* at Lannion has brought three hundred and seventy-five dollars, nearly four times the price it was offered to the same collector less than ten years ago.

ON WHISTLER'S THEORY OF ART

CHAPTER NINTH.

On Whistler's Theory of Art.

WHEN we think of the art of the Nineteenth Century in its richer manifestations, how does Whistler come into the mind? As expressing a tendency of modern times or as correcting modern tendency by the permanent classic ideal? Did he move in a round so narrow that the great people of the past would be justified in asking him the question framed for them by one of his critics: "Was, then, our time so impoverished that this seemed wealth to it?" or did he touch his time on many sides and respond freely to its various solicitations? In attempting to see him justly at this so short range, it is necessary to recall something of what has been accomplished by his contemporaries. We may doubt if ultimately this will be considered an age of poor endeavour or meagre performance. It has given birth to two important landscape schools in France, the so-called "Barbizon School" and that of the "Impressionists," and each school has marked in its own way a point of view completely original and almost new—one, the expression in landscape art of intensely personal sentiment; the other, the expression of science consciously applied in the representation of natural phenomena. In England appeared one painter of landscape who neither developed a school nor belonged to one,—Turner, who died in 1851, at-

tacked and championed for much that he was not and little known or loved for what he was. Constable's influence, on the other hand, extended over more than one country and made the early years of the Nineteenth Century years of departure on the road to ideals in art previously only foreshadowed by isolated examples.

In figure-painting there were many evidences of strong individuality among men of diverse temperaments. Manet was but one year older than Whistler; Watts fourteen years and Rossetti six years older. If he was unlike all these, they were equally unlike each other, so that he neither was an isolated example of originality in the sense that he belonged to no school nor in the sense that he only in his day was original. There surely never was a time when it could be said more truly than in the latter half of the Nineteenth Century that a school of isolated original painters existed. Nevertheless, as we look back over the period covered by his life of sixty-nine years, we seem to be able to grasp a few general tendencies and to observe in what direction the current of the age carried these individual argosies. Nothing is more certain than that they were not borne toward dilletantism. If we compare them with the art of France during the reign of Louis XV. or the art of England in the Eighteenth Century, we perceive at once how little patience the artists of the Nineteenth Century, in these two countries at least, had with artificiality in the ordinary acceptation of the word. Even where

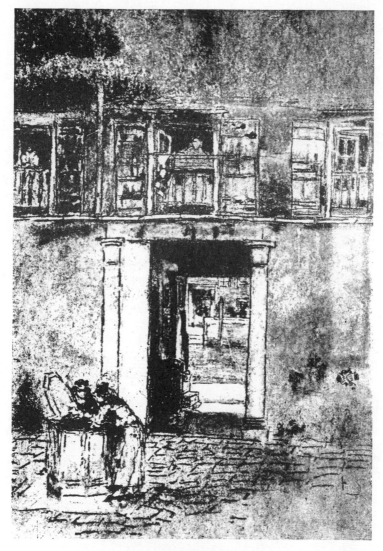

THE DOORWAY—VENICE.
(Pastel.)

they went back, as did Burne-Jones, to a form of expression that might be classed as spiritually baroque and ænemic, they did not so much assume a virtue which they had not as clothe a virtue which they distinctly had with a form unfitted to it. The "sincerity" of Burne-Jones was indubitable, but it had not force enough to guide his workmanship. We can imagine a fastidious craftsman applying to his art the words of Gautier:

"*Fi, du rhythme commode,*
Comme un soulier trop grand."

The Pre-Raphaelite Brotherhood was moved by the same impulse toward reality as the Impressionists. The difference between the two schools was one of mental and imaginative grasp. In France, almost invariably so far as the masters were concerned, together with the impulse toward reality went the desire to realize the unseen. It was not enough for Monet to paint the surface of the natural world, he was impelled to search the sources of movement and vibration in air and light and to know why appearances were as they were, in order intellectually to create instead of imitatively to reproduce them. Nor was it enough for Monet to paint a portrait of Faure as Hamlet in which the identity of the Shakespearean character was superficially indicated; he added his analysis of Faure's point of view and depicted such a Hamlet as was framed in the opera-singer's mind. Material detail as these men used it is surcharged with significance and Whistler pushed significance to its

extreme limit, but with them the significance takes a positive and with him a relative position. Mr. Brownell has indicated the nature of Monet's achievement in getting as near as possible to the individual values of objects as they are seen in nature: "Things now drop into their true place," he says, "look as they really do, and count as they count in nature, because the painter is no longer content with giving us nature itself. Perspective acquires its actual significance, solids have substance and bulk as well as surfaces, distance is perceived as it is in nature, by the actual interposition of atmosphere, chiaro-oscuro is abolished; the ways in which reality is secured being in fact legion the moment real instead of relative values are studied." So far as this Whistler, as we have seen, went with the most distinguished of his contemporaries; like them, he was completely serious, and in representing reality he looked beyond the external, but he went farther than any of them in his discrimination of the relations between what he painted and what he did not paint, which constitutes, I think, his chief claim to originality. Nearly all painters appear in their work to be confining themselves to the subject immediately in hand. They appear to be seeing it not merely as an organic whole, in the case of the capable ones, but as an isolated whole without connections with cognate subjects. For this reason their pictures, however various and differentiated, are apt to have in common the note of emphasis suggesting a certain provincialism in the artist

or at least an absence of that peculiar cosmopolitan quality that brings continually into evidence the presence of a back-ground, invisible as well as visible, and composed of constantly changing, flowing relations between all noted phenomena.

This quality Whistler possessed to such a degree that it dominates his complete accomplishment. Wherever we see one of his pictures we recognize it and feel that it is the true stamp of his individuality. In his portraits he not only refrains from flattering his sitters,—that is the crudest possible statement of it,—he refrains from giving them an undue relative importance. His exacting research into the separate individualities leaves him curiously free to obey the intuition by which he knows how much to insist upon the value of those individualities. Apparently the *Comédie Humaine* was continually in his mind as a woven tapestry might hang in a studio against which to try the tone and colour of the figure to be reproduced. His Carlyle, under this appraising observation, as we already have noted, is not the great man of the world, but one of the world's great men and not the greatest of them. In his *Master Smith of Lyme Regis,* to take another conspicuous example of his typical treatment of a subject, he has introduced the elements of ruggedness and physical force and plain thinking in sufficient proportion to indicate the man's class and type, but he has made no outcry over his possession of these qualities. "There are others," he seems to reflect as he develops the simple physiogomy

and the result is that the blacksmith is not heroically and exclusively a blacksmith, but one of the many endowed with emotions and ideas including those appropriate to his trade, but not limited to them. In literature we all know the tendency toward embodying a single characteristic in a given personage and suppressing everything else to give relief to this; but in art the tendency has not so often been analysed and the eye, moreover, is cheated into ignoring it by æsthetic appeals of colour and form; it nevertheless exists to a wide extent. It is necessary to see Whistler's pictures in a gallery with the work of other painters to understand his extraordinary ability, not merely to make his subjects complex, but to make them a part of a still more complex world. This is the imaginative rationale upon which he constructs his presentations of people.

In his portraits of external nature there is the same imaginative feeling for the vast back-ground and the small part played by any single scene in the continuous and overwhelming panorama. His streets belong to the town, his waves to the ocean, his rivers and their banks to the wide horizons on which they vanish, his doming skies to the envelope of air and mists that wraps about the whirling earth. The universe rolls away on every side from the fragment of his choice, and those for whom the universal has a supreme importance are conscious that under no pressure of momentary interest is he guilty of shutting out the view. The immediate view is never the main purpose

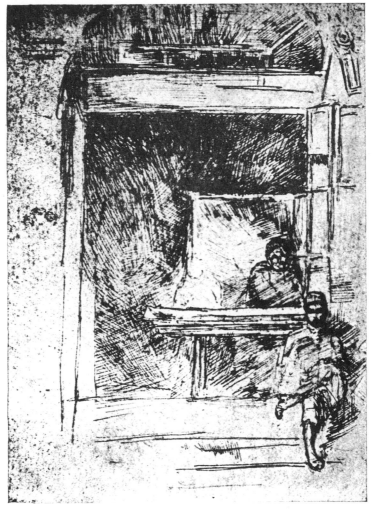

"SHOP"—ALGIERS.

(Pen and Ink.)

of his picture. However he may concentrate atten-
tion upon a single point of interest, there is always
the gradual recession of an infinitely extended en-
vironment. And his unobtrusiveness seems to be less
that of modesty than of wisdom. It is the quality of
civilisation; the lesson of cities, of wide experience, of
the travelled mind. He is uncompanioned in the way
he suggests through his single figures or tiny can-
vases the "remplissage" of life. It is, of course, the
perfection of the initiated temper to treat the simplest
theme with rich reserve; to make it so natural as to be
a tissue of complication precisely as in real life it
would be, and there is nothing so simple that Whistler
does not find in it cross-references and inter-relations,
yet there is nothing, not even the carnival of London,
so complex that he does not simplify it by the exacting
eliminations of his art. What is this but the mood of
modern civilization? It is a mood that in Whistler's
painting does not appeal to the many, the austere
method of its expression being against a popular ap-
peal, yet it is the mood that most reveals the attitude
of the modern mind toward the populous scene. It is
far removed from the old, simple awe in the presence
of natural forces; it is not of the nature even of rever-
ence, but it marks intense appreciation of the scale on
which the universe is constructed, and it testifies to
the sense of proportion at the root of all greatness.
We cannot then think of its possessor as moving in a
narrow round, nor could we if his work contained but
one of the numerous fields of observation in which

Whistler was at home. Had he been only the painter
of night, as most commonly he is called, his revelation
of its dim secrets would have entitled him to our ac-
knowledgment of his penetrating and soaring imag-
ination. Had he been only a portrait painter his
descriptions of human characters would have made it
impossible to speak of him as restricted. Had he
traversed his career with no other tool of trade than
his etching needle, we should have been obliged to
recognize the amplitude of his mental equipment. In
reviewing the fruitful outcome of all his labours, we
must decide that more than any other modern painter
he is the classic exponent of the modern spirit. He
has left innumerable sides of our energies and activi-
ties to be noted by others. He has not attempted to
exhaust the sources of our multitudinous variety. He
has taken what pleased him and left the rest, immense
in bulk and importance. He cannot, therefore, be
said to represent us in all our phases and combinations,
or even in many of them, yet precisely as one of his
portraits expresses the concentrated inner character
of his subject; his work as a whole portrays the inmost
tendency of modern civilisation, the tendency toward
relative judgments.

This not only is the theory of his art to be deduced
from his work, but the sane deduction to be made
from his own words. His exaltation of the casual
note is altogether in the line of his initiated vision; his
imperturbable defence of the painter's limitation to
the technical aspect of his problems is so much evi-

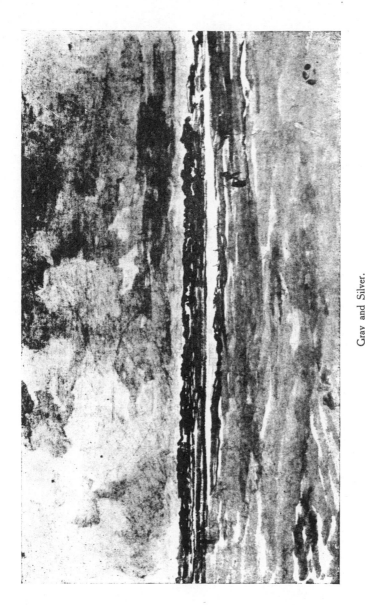

Gray and Silver.
"THE GOLF LINKS"—DUBLIN.
(Water-Colour.)

Reproduced by kind permission of R. A. Canfield, Esq.

dence of his knowledge of the supreme importance of form as the vehicle of spirit, an importance that we remember and forget as often as great art passes into and out of the range of vision; his recognition of art as only one language of those that make thought knowable is most of all the stamp of his discriminating faculty. Let us recall his sturdiest affirmation: "So art," he says, "has become foolishly confounded with education, that all should be equally qualified.

"Whereas, while polish, refinement, culture and breeding are no way arguments for artistic result, it is also no reproach to the most finished scholar or greatest gentleman in the land that he be absolutely without eye for painting or ear for music—that in his heart he prefer the popular print to the scratch of Rembrandt's needle, or the songs of the hall to Beethoven's 'C minor symphony.' Let him but have the wit to say so, and not feel the admission a proof of inferiority." Only an artist with the highest regard for relative values could thus see his art, and thus define it as unnecessary to the life of the mind.

One more impression of his quality may be added to this incomplete notation, not for its special but for its general importance. He has been described truthfully as the apostle of good taste, with a minifying inflection suggested in the phrase. But good taste no longer is a negligible quantity in any practice of life. It involves an incorruptible sense of refined beauty which in itself is a kind of art. It involves particularly a sense of the appropriate which is not the gram-

mar but the style of poetry. It implies sacrifices and restraints worthy of a passionate dedication, and so far as passion is felt in Whistler's art, it is felt as the passion of decorum known to the modern as to the ancient in its highest function. "Dulci et decorum est" not only to die for one's country, but to live for one's ideal. This with singleness of mind he did.

INTRODUCTION TO LIST OF
WHISTLER'S PICTURES

INTRODUCTION

TO LIST OF

WHISTLER'S PICTURES

In the subjoined list no claim is made either to comprehensiveness or to complete accuracy. In spite of the kindness of many owners of Whistler's pictures in furnishing data concerning them, the reluctance or unresponsiveness of others has made it impossible to carry the list beyond what may be considered merely the nucleus for a better one. In its present condition, however, it serves two purposes. It acquaints the general public with a very large number and variety of Whistler's works which not only exist but have been seen by a considerable proportion of the art-lovers of America, France and England; showing more convincingly than could any bald statement of the fact how extended was his range. It also indicates to students the sources to which to go for descriptions of individual pictures in which their interest may be aroused, and gathers together in convenient form for reference the titles contained in the three memorial catalogues already out of easy reach, many of even the larger libraries and museums not possessing the set. In the majority of instances the titles taken from these catalogues have been transferred without change, but any important difference in titles given in two or more of the catalogues has been noted, as where the "Nocturne, Southampton Water" of the Boston catalogue becomes the "Nocturne Black and Gold, Entrance to Southampton Water" of the London catalogue. In a few cases a wrongly named picture has been given its correct title as where the "Nocturne, Blue and Gold," belonging to the Hon. Percy

Wyndham was given in the London catalogue as "Nocturne, Blue and Silver," the owner having kindly informed the compiler of the error. Where fragments of information not appearing in the catalogues have been offered by owners, they have been included, and a few descriptions of pictures listed only in the Boston catalogue, and there undescribed, have been added. The names of the present owners are not given. The names of those who lent the pictures to the various exhibitions are taken directly from the catalogues; but in many cases the pictures have since changed hands. Where the dimensions of the pictures are given only in the French catalogue, the French system of numbering has been retained, and for the sake of simplification in reference the French abbreviations H. and L. have been used in quoting from the Paris catalogue and the English abbreviations H. and B. in quoting from the London and American catalogues. A brief list of titles gathered from recent books on Whistler and not included in the Memorial Exhibitions, has also been added, with a number of items from catalogues of exhibitions held before the artist's death. These catalogues ought still to furnish a rich field for investigation as many of them have not been at the disposal of the present compiler. There are a few titles of pictures, not in the catalogues, which have been furnished by the owners. The total presents an appearance which could not be satisfactory to the professional cataloguer. Its excuse lies in the fact that it makes a beginning from which a creditable ending may be brought about. It is to be expected that a full list of Whistler's works will one day appear from authoritative sources. Until that time it is hoped that the present imperfect list will be found of convenience, and any owners who will be good enough to supply corrections, or information concerning pictures not included, will confer a favour upon the compiler and the publishers. The difficulty of distinguishing between works of the same or nearly the

same title and executed in the same medium, is great, and nothing is more to be desired than exact measurements taken of the canvas or paper without the frame. "Sight measurements" or measurements taken inside of the frame are very misleading. The contribution of exact measurements where they are lacking will be of especial value. There is reason to believe that the measurements given in the catalogues are not always exact. In the case of *The Little Blue Bonnet,* for example, the measurements given in the *édition de luxe* of the London catalogue are 23x18, and it is not stated whether this is a sight measurement or a measurement without the frame. When Mr. Macbeth bought the picture he measured it both inside and without the frame, finding it in the former case 22½x17, and the latter 25½x18¼,

AN INCOMPLETE LIST OF

WHISTLER'S PAINTINGS

IN OIL AND IN WATER COLOUR, PASTELS, AND DRAWINGS

AN INCOMPLETE LIST

OF

WHISTLER'S PAINTINGS

IN OIL AND IN WATER COLOUR, PASTELS, AND DRAWINGS

Compiled from the Catalogue of the Memorial Exhibition at Copley Hall, Boston (February, 1904), the Catalogue of the Memorial Exhibition at the New Gallery, London (from February 22, to April 15, 1905) and the Catalogue of the Memorial Exhibition at Paris (May, 1905). (It is stated in the Paris Catalogue that where no names are given the pictures were lent by Whistler's heirs.)

(1). **"Gold and Brown**
Portrait of Mr. James McNeill Whistler" (Oil).
Boston Catalogue: Page 3, No. 1.
Paris Catalogue: Page 30, No. 29.

(H. 0,470—L. 0,650)

Lent by George W. Vanderbilt, Esq.

(2). **The Fête on the Sands—Ostend**
Boston Catalogue: Page 3, No. 2.
Lent by Miss Ellen S. Hooper.

(3.) **"Chelsea Shops"**
Boston Catalogue: Page 3, No. 3.
Lent by Charles L. Freer, Esq.

(4). **The Grey House**
Boston Catalogue: Page 3, No. 4.
Lent by Charles L. Freer, Esq.

(5). "Green and Gold—
The Great Sea."
Boston Catalogue: Page 3, No. 5.
Paris Catalogue: Page 59, No. 103.
(H. 0,130—L. 0,223, inside the frame)
Lent by Charles L. Freer, Esq.

(6). "The Butcher Shop"
Boston Catalogue: Page 3, No. 6.
Lent by Charles L. Freer, Esq.

(7). On the Normandy Coast
Boston Catalogue: Page 3, No. 7.
Lent by Henry Harper Benedict, Esq.

(8). Sketch of a Girl*
Boston Catalogue: Page 3, No. 8.
Lent by E. B. Haskell, Esq.

(9). Grey and Silver
Trouville.†
Boston Catalogue: Page 3, No. 9.
Lent by W. K. Bixby, Esq.

(10). Chelsea Houses
Boston Catalogue: Page 4, No. 10.
Lent by J. M. Sears, Esq.

(11). "A Note in Red"
Boston Catalogue: Page 4, No. 11.
Lent by Charles L. Freer, Esq.

(* Mr. E. B. Haskell, the owner of this picture, writes that it was painted in Venice in 1882, and given by the artist to his friend William Graham, a landscape-painter of merit, living in Venice at the time.)

(† Mr. W. K. Bixby, the owner of this picture, writes that it was painted in 1901.)

(12). Marine—Grey and Green
 Boston Catalogue: Page 4, No. 12.
 Paris Catalogue: Page 44, No. 63.
 (H. 0,510—L. 0,750)
Lent by Mrs. Potter Palmer.

(13). Study of the Sea from a Boat
 Boston Catalogue: Page 4, No. 13.
Lent by Mrs. Martin Brimmer.

(14). "Petite Mephiste"
 Boston Catalogue: Page 4, No. 14.
 Paris Catalogue: Page 37, No. 52. (Title in French

 Catalogue: "Petite Méphisto.")
 (H. 0,240—L. 0,197, inside the frame)
Lent by Charles L. Freer, Esq.

(15). "Harmony in Green and Rose:
 The Music Room" (Oil).
 Boston Catalogue: Page 4, No. 15.
 Paris Catalogue: Page 20, No. 7.
 (H. 0,940—L. 0,710, inside the frame)
Lent by Col. Frank J. Hecker.

(16). Seascape
 Boston Catalogue: Page 4, No. 16.
Lent by J. M. Sears, Esq.

(17). Girl in Black (Oil)
 Boston Catalogue: Page 4, No. 17.
Lent by Mrs. John C. Bancroft.

(18.) "An Arrangement in Flesh Color and Brown"
 Boston Catalogue: Page 4, No. 18.
(Name not given.)

(19). "The White Symphony"
> *Boston Catalogue:* Page 4, No. 19.
> *Paris Catalogue:* Page 22, No. 11.
> > (H. 0,450—L. 0,600, inside the frame)

Lent by Charles L. Freer, Esq.

> The title in the French Catalogue is under the division with the general title: Les Six Projects—"The Six Schemes," and reads as follows:

> "No 1. Symphonie en blanc. Les trois jeune filles —(*The White Symphony, Three Girls.*)" The following five titles are also under the same general title, and in the French Catalogue are numbered, as indicated by the figures in brackets preceding the titles.

(20). [No. 4]. "Symphony in White and Red"
> *Boston Catalogue:* Page 5, No. 20.
> *Paris Catalogue:* Page 23, No. 14.
> > (H. 0,450—L. 0,600, inside the frame)

Lent by Charles L. Freer, Esq.

(21). [No. 2]. "Venus"
> *Boston Catalogue:* Page 5, No. 21.
> *Paris Catalogue:* Page 23, No. 12.
> > (H. 0,600—L. 0,450, inside the frame)

Lent by Charles L. Freer, Esq.

(22). [No. 3]. "Symphony in Green and Violet"
> *Boston Catalogue:* Page 5, No. 22.
> *Paris Catalogue:* Page 23, No. 13.
> > (H. 0,610—L. 0,450, inside the frame)

Lent by Charles L. Freer, Esq.

(23). [No. 6]. **"Symphony in Blue and Pink"**
Boston Catalogue: Page 5, No. 23.
Paris Catalogue: Page 24, No. 16.
(H. 0,450—L. 0,600, inside the frame)

Lent by Charles L. Freer, Esq.

(24). [No. 5]. **"Variations in Blue and Green"**
Boston Catalogue: Page 5, No. 24.
Paris Catalogue: Page 24, No. 15.
(H. 0,450—L. 0,600, inside the frame)

Lent by Charles L. Freer, Esq.

(25). **Arrangement in Black and Brown**
"Miss Rosa Corder" (Oil).
Boston Catalogue: Page 5, No. 25.
Paris Catalogue: Page 27, No. 21.
(H. 1 m. 93—L. o. m. 93)

Lent by R. A. Canfield, Esq.

(26). **"The Little Blue and Gold Girl"** (Oil)
Boston Catalogue: Page 5, No. 26.
Paris Catalogue: Page 36, No. 48.
(H. 0,720—L. 0,485)

Lent by Charles L. Freer, Esq.

(27). **"Grey and Silver**
La Petite Souris." The Little Mouse.
Boston Catalogue: Page 5, No. 27.
Paris Catalogue: Page 34, No. 41.
(H. 0,510—L. 0,310)

Lent by Miss R. Birnie-Philip.

(28). **Symphony in White** [In the French Catalogue it is
"Symphony in White, No. 2"]
"The Little White Girl."
Boston Catalogue: Page 5, No. 28.
Paris Catalogue: Page 19, No. 5.
(H. 0,760—L. 0,490)

Lent by Arthur Studd, Esq.

(29). Une Jeune Fille des Rues
 Boston Catalogue: Page 5, No. 29.

Lent by Mrs. Frank Gair Macomber.

(30). "Symphony in Violet and Blue" (Oil.)
 Boston Catalogue: Page 6, No. 30.

Lent by Alfred Attmore Pope, Esq.

(31). "The Thames in Ice"
 Boston Catalogue: Page 6, No. 31.
 Paris Catalogue: Page 41, No. 57.
 (H. 0,750—L. 0,540, inside the frame)

Lent by Charles L. Freer, Esq.

(32). "Rose and Silver
 La Princesse du Pays de La Porcelaine." (Oil.)
 Signed "Whistler, 1864."
 Boston Catalogue: Page 6, No. 32.
 Paris Catalogue: Page 21, No. 9.

Lent by Charles L. Freer, Esq. (H. 1,98—L. 1,15)

(33). Violet and Silver
 "Deep Sea"* (Oil).
 Boston Catalogue: Page 6, No. 33.

Lent by John A. Lynch, Esq.

(34). "Westminster Bridge" (Oil). Signed "Whistler,
 1862," in the left lower corner. In the London
 Catalogue the title is "The Last of Old West-
 minster," in the Paris Catalogue, "Old West-
 minster."
 Boston Catalogue: Page 6, No. 34.
 Paris Catalogue: Page 41, No. 56.
 London Catalogue: Page 88, No. 35.

Lent by Alfred Attmore Pope, Esq. (H. 22½—B. 30)

*Exhibited in the Salon of the Champs de Mars, 1894. Bought from the painter
in October of that year by John A. Lynch, of Chicago.

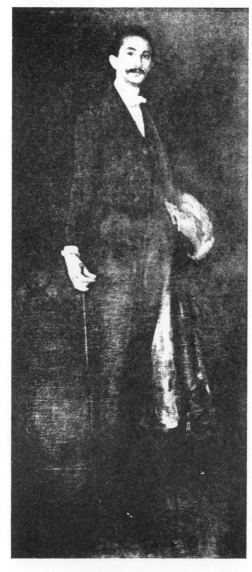

Arrangement in Black and Gold.
"LE COMTE ROBERT DE MONTESQUIOU-
FEZENSAC."

(35). "Portrait de Madame S——
 Vert et Violet."
 Boston Catalogue: Page 6, No. 35.
 Paris Catalogue: Page 29, No. 26.

Lent by Mrs. Cobden Sickert. (H. 0,860—L. 0,610)

(36). **The Master Smith of Lyme-Regis** (Oil)
 Boston Catalogue: Page 6, No. 36.
 Paris Catalogue: Page 30, No. 27.
 London Catalogue: Page 84, No. 24.

(H. 19¾—B. 11½)

Lent by the Museum of Fine Arts, Boston.

(37). **"Variations in Flesh Color and Green**
 The Balcony" (Oil).
 Boston Catalogue: Page 6, No. 37.
 Paris Catalogue: Page 22, No. 10.

(H. 0,590—L, 0,470, inside the frame)

Lent by Charles L. Freer, Esq.

(38). **"Carmen"** (Oil)
 Bold, masculine type of head against a wine-col-
 oured background, red shawl over the head, very thinly
 painted on coarse canvas.
 Boston Catalogue: Page 6, No. 38.

Lent by Alfred Atmore Pope, Esq.

(39). **Arrangement in Black and Gold**
 "Le Comte Robert de Montesquiou-Fezensac" (Oil).
 Full length figure dressed in black against dark
 background. The floor is yellowish-brown, the Count
 holds a slender, yellowish-brown cane in his right hand
 and carries a cloak lined with silvery grey over his left
 arm; he wears a grey glove on his right hand.
 Boston Catalogue: Page 7, No. 39.

Lent by R. A. Canfield, Esq.

(40). **"Grenat et Or**
Le Petit Cardinal."
Boston Catalogue: Page 7, No. 40.

Lent by Miss R. Birnie-Philip.

(41). **"The Little Red Glove"** (Oil)
Boston Catalogue: Page 7, No. 41.
Paris Catalogue: Page 33, No. 39.
(H. 0,500—L. 0,305, inside the frame)

Lent by Charles L. Freer, Esq.

(42). **Coast of Brittany** (Oil)
Boston Catalogue: Page 7, No. 42.
London Catalogue: Page 79, No. 11.
(H. 36—B. 46)

Lent by Ross Winans, Esq.

(43). **The Little Rose of Lyme-Regis** (Oil)
Boston Catalogue: Page 7, No. 43.
Paris Catalogue: Page 34, No. 42.
London Catalogue: Page 85, No. 26.
(H. 19¾—B. 12)

Lent by the Boston Museum of Fine Arts.

(44). **Rose and Gold: "Pretty Nellie Brown"** * (Oil)
A half-length portrait of a young girl. She wears
a deep rose-coloured jacket over a pale pink blouse.
Hair blonde-brown, wine coloured background.
Boston Catalogue: Page 7, No. 44.
(H. 19¾—B. 12)

Lent by Frank Lusk Babbott, Esq.

(* Mr. Frank L. Babbott says that this picture was painted on up to 1900, the year
in which he bought it.)

(45). Portrait of a Lady (Oil)
>Full-length figure of lady in black riding habit against black background.
>*Boston Catalogue:* Page 7, No. 45.

Lent by Alexander J. Cassatt, Esq.

(46) L'Andalusienne (Oil)
>*Boston Catalogue:* Page 7, No. 46.
>*Paris Catalogue:* Page 29, No. 25.
>
>(H. 1 m. 87—L. o. m. 88)

Lent by John H. Whittemore, Esq.

(47). "Harmony in Red
>Lamplight." In Paris Catalogue is added: Portrait of Mrs. J. McNeill Whistler.
>*Boston Catalogue:* Page 7, No. 47.
>*Paris Catalogue:* Page 28, No. 23.
>
>(H. 1 m. 88—L. o. m. 89)

Lent by Miss R. Birnie-Philip.

(48). A Chelsea Girl (Oil)
>Full length figure of young girl in short skirts. She wears a black dress, a white apron (very low in tone) and a yellow scarf at the neck. Stands with arms akimbo.
>*Boston Catalogue:* Page 7, No. 48.

Lent by Alexander J. Cassatt, Esq.

(49). Interior
>*Boston Catalogue:* Page 8, No. 49.

Lent by Miss Fanny Hooper.

(50). Unfinished Portrait
>*Boston Catalogue:* Page 8, No. 50.

Lent by Miss Ellen S. Hooper.

(51). "Blue and Silver—
Trouville."
Boston Catalogue: Page 8, No. 51.
Paris Catalogue: Page 43, No. 60.
(H. 0,590—L. 0,720, inside the frame)

Lent by Charles L. Freer, Esq.

(52). Study of a Head
Boston Catalogue: Page 8, No. 52.

Lent by Francis Bartlett, Esq.

(53). Portrait of Pablo Sarasate
Arrangement in Black (Oil).
Boston Catalogue: Page 8, No. 53.
Paris Catalogue: Page 27, No. 20.
London Catalogue: Page 82, No. 19.
(H. 84—B. 40)

Lent by the Carnegie Institute of Pittsburgh.

(54). Blue and Silver, The Blue Wave, Biarritz (Oil)
Signed "Whistler, 1862," in the lower left corner.
Boston Catalogue: Page 8, No. 54.
Paris Catalogue: Page 41, No. 55.
London Catalogue: Page 86, No. 29.
(H. 24½—B. 34)

Lent by Alfred Attmore Pope, Esq.

(55). Whistler With a Hat (Oil). Signed "Whistler" in the
lower left corner.
Boston Catalogue: Page 8, No. 55.
Paris Catalogue: Page 17, No. 1.
(H. 0,490—L. 0,390)

Lent by Samuel P. Avery, Esq.

(56). Nocturne in Blue and Silver: "Cremorne Lights" (Oil)
 Boston Catalogue: Page 8, No. 56.
 Paris Catalogue: Page 46, No. 69.

 (H. 0,500—L. 0,740)

Lent by Arthur Studd, Esq.

(57). "Variations in Pink and Grey
 Chelsea."
 Boston Catalogue: Page 8, No. 57.

Lent by Charles L. Freer, Esq.

(58). Nocturne, Southampton Water ' (Oil)
 Boston Catalogue: Page 9, No. 58.
 Paris Catalogue: Page 45, No. 67.
 London Catalogue: Page 78, No. 9. (Title in London Catalogue, "Nocturne, Black and Gold, Entrance to Southampton Water.")

 (H. 19—B. 29)

Lent by the Art Institute of Chicago.

(59). Nocturne—"Westminster" (Oil)
 The sky and water are pale turquoise blue. A grey shadow covers the land and the buildings. Two squares of pale yellow light are seen in the tower, and a light reflection is in the water at the right.
 Boston Catalogue: Page 9, No. 59.

Lent by John G. Johnson, Esq.

(60.) Nocturne
 Battersea.
 Boston Catalogue: Page 9, No. 60.
 Paris Catalogue: Page 47, No. 71.

 (H. O. m. 495—L. 1 m. 065)

Lent by George W. Vanderbilt, Esq.

(61). "Nocturne—Grey and Silver—
 Chelsea Embankment."
 Boston Catalogue: Page 9, No. 61.
 Paris Catalogue: Page 48, No. 73.

 (H. 0,610—L. 0,450)
Lent by Charles L. Freer, Esq.

(62). **Arrangement in Black and Brown**
 The Fur Jacket (Oil).
 Boston Catalogue: Page 9, No. 62.
 London Catalogue: Page 80, No. 14.

 (H. 73—B. $34\frac{1}{4}$)
Lent by William Burrell, Esq.

(63). "Nocturne—Blue and Silver—
 Battersea Reach."
 Boston Catalogue: Page 9, No. 63.
 Paris Catalogue: Page 47, No. 70.

 (H. 0,490—L. 0,755, inside the frame)
Lent by Charles L. Freer, Esq.

(64). **Nocturne in Black and Gold**
 "The Falling Rocket."
 Boston Catalogue: Page 9, No. 64.
 Paris Catalogue: Page 45, No. 66.
Lent by Mrs. Samuel Untermyer.

(65). "Nocturne—Blue and Silver—
 Bognor."
 Boston Catalogue: Page 9, No. 65.
 Paris Catalogue: Page 46, No. 68.

 (H. 0,500—L. 0,840, inside the frame)
Lent by Charles L. Freer, Esq.

(66). **Nocturne in Black and Gold**
"The Fire Wheel."
Boston Catalogue: Page 9, No. 66.
Paris Catalogue: Page 45, No. 65.

(H. 0,530—L. 0,750)

Lent by Arthur Studd, Esq.

(67). **Nocturne in Blue and Silver**
"The Lagoon"—Venice.
Boston Catalogue: Page 10, No. 67.

Lent by R. A. Canfield, Esq.

(68). **"Nocturne—Opal and Silver"**
Boston Catalogue: Page 10, No. 68.
Paris Catalogue: Page 49, No. 75.

(H. 0,190—L. 0,250, inside the frame)

Lent by Charles L. Freer, Esq.

(69). **"The Sea"**
Boston Catalogue: Page 10, No. 69.
Paris Catalogue: Page 43, No. 61.

(H. 0,520—L. 0,950)

Lent by John H. Whittemore, Esq.

(70). **The Thames** (In Paris Catalogue "On the Thames")
Boston Catalogue: Page 10, No. 70.
Paris Catalogue: Page 42, No. 58.

(H. 0,500—L. 0,800)

Signed "Whistler, '63," in the lower left corner.

Lent by Mrs. Potter **Palmer.**

(71). **Symphony in White, No. 1**
"White Girl" (Oil).
Signed "Whistler, 1862," in the upper right corner.
Boston Catalogue: Page 10, No. 71.
Paris Catalogue: Page 18, No. 4.
London Catalogue: Page 89, No. 37.

(H. 84—B. 42)

(Title in London Catalogue is **"The Woman in White**, Symphony in White, No. 1.")
Lent by John H. Whittemore, Esq.

(72). **A Street in Old Chelsea**
Boston Catalogue: Page 10, No. 72.
Lent by Denman W. Ross. Esq.

(73). **Symphony in Grey and Green**
"The Ocean."
Boston Catalogue: Page 10, No. 74.
Paris Catalogue: Page 43, No. 62.

(H. 0,800—L. 0,910)

Lent by R. A. Canfield, Esq.

(74). **The Schooner**
Boston Catalogue: Page 11, No. 77.
Lent by Miss A. B. Jennings.

(75). **Grey and Gold**
"The Golden Bay," Ireland (Water-Colour).
Boston Catalogue: Page 11, No. 78.
Butterfly to the left near the lower edge of the frame.
Lent by R. A. Canfield, Esq.

(76). **"Rose and Brown—**
La Cigale."
Boston Catalogue: Page 11, No. 79.
Lent by Charles L. Freer, Esq.

(77). Portrait of Man (Oil)
> *Boston Catalogue:* Page 11, No. 80.
> *London Catalogue:* Page 107, No. 83.
> (H. 11½—B. 6)
> (In the London Catalogue it is "Portrait of E. G.
> Kennedy, Esq.")

Lent by E. G. Kennedy, Esq.

(78). "Wortley—
> Note in Green."
> *Boston Catalogue:* Page 11, No. 81.

Lent by Charles L. Freer, Esq.

(79). "The Sea and Sand"
> *Boston Catalogue:* Page 11, No. 82.

Lent by Charles L. Freer, Esq.

(80). "Rose and Gold —
> The Little Lady Sophie of Soho" (Oil).
> *Boston Catalogue:* Page 11, No. 83.
> *Paris Catalogue:* Page 32, No. 37.
> (H. 0,630—L. 0,520, inside the frame)

Lent by Charles L. Freer, Esq.

(81). "La Note Rouge"
> *Boston Catalogue:* Page 11, No. 84.

Lent by Hon. G. A. Drummond.

(82). Blue and Silver
> Dieppe.
> *Boston Catalogue:* Page 12, No. 85.

Lent by Miss Amy Lowell.

(83). "The Thames near Erith"
 Boston Catalogue: Page 12, No. 86.
Lent by Charles L. Freer, Esq.

(84). **Green and Silver** (Water-Colour)
 The Photographer.
 A stretch of sea and sky with waves breaking on
 a beach where several figures are standing, one of
 them, the photographer, busy with his instrument.
 Boston Catalogue: Page 12, No. 87.
Lent by Howard Mansfield, Esq.

(85). **Marine**
 Boston Catalogue: Page 12, No. 88.
Lent by Miss Mary Hooper.

(86). **Blue and Silver** (Water-Colour)
 Forget Me Not.
 A nude figure with a purple cap; at the left, a slen-
 der plant.
 Boston Catalogue: Page 12, No. 89.
Lent by Howard Mansfield, Esq.

(87). **"Green and Silver**
 Beaulieu."
 Boston Catalogue: Page 12, No. 90.
Lent by Charles L. Freer, Esq.

(88). **Opal and Gold** (Water-Colour)
 "Evening—Pourville."
 Sea and sky with small boat at the left—purplish
 horizon. Butterfly at right of centre near lower margin.
 Boston Catalogue: Page 12, No. 91.
Lent by R. A. Canfield, Esq.

(89). Green and Blue

The Fields—Loches (Water-Colour—body-colour on linen).

Green fields separated from the background of low hills by a little fence. Slim trees to the left. A group of animals near the fence. A greenish blue sky fading almost to white at the horizon line. Butterfly in reddish-brown.

Boston Catalogue: Page 12, No. 92.

Lent by Howard Mansfield, Esq.

(90). "Venetian Courtyard" (Pastel)

Boston Catalogue: Page 12, No. 93.

Paris Catalogue: Page 78, No. 163.

(H. 0,270—L. 0,190, inside the frame)

Lent by Charles L. Freer, Esq.

(91). Blue and Silver

Boston Catalogue: Page 13, No. 94.

Lent by Mrs. John C. Bancroft.

(92). Near Calais

Boston Catalogue: Page 13, No. 95.

Lent by Miss A. B. Jennings.

(93). Green and Blue (Water-Colour)

"The Dancer."

A slender female figure in green gauzy robes. Gold coloured ribbons cross her chest and form a girdle. She wears a red cap with a blue border.

Boston Catalogue: Page 13, No. 96.

Lent by R. A. Canfield, Esq.

(94). **"Zuyder Zee"**
 Boston Catalogue: Page 13, No. 97.

Lent by Col. Frank J. Hecker.

(95). **Violet and Silver** (Water-Colour)
 "The Afternoon Dream."
 Woman in thin robes lying on a couch; a child is also on the couch. The woman faces the spectator; only the back of the child is seen. Blue butterfly to the left of the centre near the top.
 Boston Catalogue: Page 13, No. 98.

Lent by R. A. Canfield, Esq.

(96). **"Blue and Silver**
 The Chopping Channel."
 Boston Catalogue: Page 13, No. 99.

Lent by Charles L. Freer, Esq.

(97). **"A Note in Green"**
 Boston Catalogue: Page 13, No. 100.
 Paris Catalogue: Page 56, No. 89.
 (H. 0,240—L. 0,160)
Lent by Charles L. Freer, Esq.

(98). **"Nocturne—Black and Red**
 Back Canal, Holland"
 Boston Catalogue: Page 13, No. 101.
 Paris Catalogue: Page 63, No. 121.
 (H. 0,210—L. 0,270, inside the frame)
Lent by Charles L. Freer, Esq.

(99). "Nocturne—Grey and Gold
 Canal, Holland"
 Boston Catalogue: Page 13, No. 102.
 Paris Catalogue: Page 62, No. 119.
 (H. 0,283—L. 0,225, inside the frame)

Lent by Charles L. Freer, Esq.

(100). Portrait of Mrs. Whibley
 Boston Catalogue: Page 14, No. 103.
 Paris Catalogue: Page 55, No. 86.
 (H. 0,265—L. 0,185)
 (In the Paris Catalogue the title is "Rose and Silver: Portrait of Mrs. Whibley.")

Lent by Charles L. Freer, Esq.

(101). Young Girl, Standing
 Boston Catalogue: Page 14, No. 104.

Lent by Albert Rouillier, Esq.

(102). "Petit Déjeuner
 Note in Opal."
 Boston Catalogue: Page 14, No. 105.

Lent by Charles L. Freer, Esq.

(103). "Nocturne—
 Grand Canal, Amsterdam"
 Boston Catalogue: Page 14, No. 106.
 Paris Catalogue: Page 63, No. 122.
 (H. 0,245—L. 0,270, inside the frame)

Lent by Charles L. Freer, Esq.

(104). **"Grey and Silver—**
The Mersey"
Boston Catalogue: Page 14, No. 107.
Paris Catalogue: Page 61, No. 113.
(H, 0,145—L. 0,255, inside the frame)
Lent by Charles L. Freer, Esq.

(105). **The Thames**
Blue and Silver.
Boston Catalogue: Page 14, No. 108.
Lent by Mrs. Frank Gair Macomber.

(106). **Off the Brittany Coast**
Boston Catalogue: Page 14, No. 109.
Lent by Henry Harper Benedict, Esq.

(107). **"The Gossips"—Ajaccio** (Water-Colour, partly out-
lined with Pen and Ink)
Boston Catalogue: Page 14, No. 110.
Paris Catalogue: Page 57, No. 95.
(H. 0,270—L. 0,180)
Lent by R. A. Canfield, Esq.

(108). **"Blue and Gold**
The Rose Azalea."
Boston Catalogue: Page 14, No. 111.
Paris Catalogue: Page 71, No. 138.
(H. 0,255—L. 0,165)
Lent by Charles L. Freer, Esq.

(109). **"A Venetian Doorway"** (Pastel)
Boston Catalogue: Page 15, No. 112.
Paris Catalogue: Page 78, No. 165.
(H. 0,273—L. 0,185, inside the frame)
Lent by Charles L. Freer, Esq.

(110). Blue and Silver
"Afternoon—The Channel."
Dark, chopping sea and cloudy sky. Dark blue butterfly to the lower right.
Boston Catalogue: Page 15, No. 113.

Lent by R. A. Canfield, Esq.

(111). "Morning Glories" (Pastel)
Boston Catalogue: Page 15, No. 114.
Paris Catalogue: Page 71, No. 136.
(H. 0,235—L. 0,135)

Lent by Charles L. Freer, Esq.

(112). Mother and Child (Pastel)
Boston Catalogue: Page 15, No. 115.

Lent by John H. Wrenn, Esq.

(113). The Japanese Dress (Pastel, with black crayon outline on brown paper)
Woman standing, holding Japanese umbrella in right hand. Colours of umbrella, deep yellow, pale blue, and white. The robe is decorated with a pattern of peacock blue, flesh colour and light blue. The underrobe is grey-blue with touches of light blue and of bright rose. The sash is vermilion. Cap flesh colour, with band of blue. Butterfly is peacock-blue. The hair is yellow.
Boston Catalogue: Page 15, No. 116.

Lent by Howard Mansfield, Esq.

(114). "Blue and Violet" (Pastel)
Boston Catalogue: Page 15, No. 117.
Paris Catalogue: Page 71, No. 140.
(H. 0,255—L. 0,150)

Lent by Miss R. Birnie-Philip.

(115). **"May"** (Early Pastel)
 Boston Catalogue: Page 15, No. 118.
 Paris Catalogue: Page 68, No. 127.

 (H. 0,90—L. 0,157)

Lent by Miss R. Birnie-Philip.

(116). **The Captive** (Pastel)
 A woman is seated on a sofa and is restraining a child who tries to climb over the arm of the sofa. The outline is in black on brown paper, with touches of yellow and of white. Butterfly on the back of the sofa.
 Boston Catalogue: Page 15, No. 119.

Lent by R. A. Canfield, Esq.

(117). **"Sleeping"** (Pastel)
 Boston Catalogue: Page 15, No. 120.

Lent by Charles L. Freer, Esq.

(118). **"The Purple Cap"** (Pastel)
 Boston Catalogue: Page 15, No. 121.
 Paris Catalogue: Page 73, No. 146.

 (H. 0,260—L. 0,165)

Lent by Charles L. Freer, Esq.

(119). **Two Standing Figures** (Pastel)
 Boston Catalogue: Page 16, No. 122.

Lent by Mrs. Frank Gair Macomber.

(120). **The Palace**
 Pink and White (Pastel).
 Boston Catalogue: Page 16, No. 123.

Lent by H. O. Havemeyer, Esq.

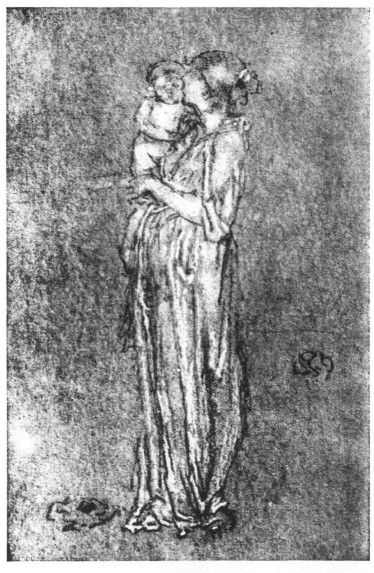

Blue and Violet.
"IRIS."
(Pastel.)

(121). Greek Girl (Pastel)
Boston Catalogue: Page 16, No. 124.
Lent by H. O. Havemeyer, Esq.

(122). Blue and Violet
"Iris" (Pastel)
Boston Catalogue: Page 16, No. 125.
Paris Catalogue: Page 73, No. 145.
(H. 0,272—L. 0,180)
Lent by R. A. Canfield, Esq.

(123). "Mother and Child—
The Pearl" (Pastel)
Boston Catalogue: Page 16, No. 126.
Lent by Charles L. Freer, Esq.

(124). Archway, Venice (Pastel)
A child is leaning against the left wall; standing figure in the middle; woman's figure within archway. Colours: red, light green and dark green. Woman wears an orange shawl and there is a little blue in the ɪpper part of an arched doorway seen through the larger arch. In this doorway are also light pink and yellow. A green shutter is above the woman's left shoulder. Rose colour in the wall above deepening to crimson in the window above the doorway seen at the right.
Boston Catalogue: Page 16, No. 127.
Lent by Howard Mansfield, Esq.

(125). "Writing on the Wall" (Pastel)
Boston Catalogue: Page 16, No. 128.
Paris Catalogue: Page 69, No. 131.
(H. 0,260—L. 0,160, inside the frame)
Lent by Charles L. Freer, Esq.

(126). **The Dancing Girl** (Pastel)
> The figure is drawn with much movement, yellow drapery.
> *Boston Catalogue:* Page 16, No. 129.

Lent by Howard Mansfield, Esq.

(127). **"Rose and Red**
> The Little Pink Cap" (Pastel).
> *Boston Catalogue:* Page 16, No. 130.
> *Paris Catalogue:* Page 73, No. 144.
> > (H. 0,255—L. 0,180, inside the frame)

Lent by Charles L. Freer, Esq.

(128). **"The Green Cap"** (Pastel)
> *Boston Catalogue:* Page 17, No. 131.

Lent by Charles L. Freer, Esq.

(129). **A Japanese Woman** (Pastel)
> *Boston Catalogue:* Page 17, No. 132.

Lent by Hon. John P. Elton.

(130). **"A Violet Note"** (Pastel)
> *Boston Catalogue:* Page 17, No. 133.

Lent by Charles L. Freer, Esq.

(131). **"Spring"** (Pastel)
> *Boston Catalogue:* Page 17, No. 134.

Lent by Col. Frank J. Hecker.

(132). **"Grey and Silver—**
> Pier, Southend."
> *Boston Catalogue:* Page 17, No. 135.
> *Paris Catalogue:* Page 60, No. 109.
> > (H. 0,145—L. 0,232, inside the frame)

Lent by Charles L. Freer, Esq.

(133). **The Queen's Naval Jubilee, 1897**
 Boston Catalogue: Page 17, No. 136.

Lent by Miss Tuckerman.

(134). **"The Studio**
 Note in Pink and Purple."
 Boston Catalogue: Page 17, No. 137.

Lent by Charles L. Freer, Esq.

(135). **Grey and Silver**
 "The Golf Links"—Dublin (Water-Colour).
 Green fields, wild, cloudy sky. Butterfly in grey
 near lower right-hand corner.
 Boston Catalogue: Page 17, No. 138.

Lent by R. A. Canfield, Esq.

(136). **"The Shop"**
 An Exterior.
 Boston Catalogue: Page 17, No. 139.

Lent by Mrs. Frances M. French.

(137). **Grey Note**
 Mouth of the Thames.
 Boston Catalogue: Page 18, No. 140.

Lent by Walter Gay, Esq.

(138). **Grey and Gold**
 "Belle-Isle" (Water-Colour).
 Boston Catalogue: Page 18, No. 141.
 Paris Catalogue: Page 59, No. 106.
 (H. 0,205—L. 0,130)

Lent by R. A. Canfield, Esq.

(139). Marine
 Boston Catalogue: Page 18, No. 142.
Lent by Miss Louisa C. Hooper.

(140). Marine
 Boston Catalogue: Page 18, No. 143.
Lent by Mrs. Bancel Lafarge.

(141). "The Pink Cap" (Water-Colour)
 Figure standing with back toward spectator. He
turned in profile. Transparent drapery. Butterfly
grey outline a third of the way up at the left.
 Boston Catalogue: Page 18, No. 144.
Lent by R. A. Canfield, Esq.

(142). Schevingen (Water-Colour)
 Boston Catalogue: Page 18, No. 145.
 London Catalogue: Page 94, No. 42.
 (H. 4½—B.
 (In London Catalogue the title reads, "Lit
Scheveningen: a grey note.")
Lent by Walter Gay, Esq.

(143). Blue and Silver (Water-Colour)
 "Morning"—Ajàccio.
 Pier with crowd of figures, crisp clouds in sky.
 Boston Catalogue: Page 18, No. 146.
Lent by R. A. Canfield, Esq.

(144). "The Sea Shore"
 Boston Catalogue: Page 18, No. 147.
 Paris Catalogue: Page 59, No. 104.
 (H. 0,205—L. 0,120, inside the fram
Lent by Charles L. Freer, Esq.

(145). "Market, Ajaccio" (Pencil)
Boston Catalogue: Page 19, No. 148.
Paris Catalogue: Page 83, No. 186.

(H. 0,120—L. 0,080)

Lent by Miss R. Birnie-Philip.

(146). "Ajaccio" (Pencil)
Boston Catalogue: Page 19, No. 149.
Lent by Miss R. Birnie-Philip.

(147). "Ajaccio" (Sepia Wash)
Boston Catalogue: Page 19, No. 150.
Lent by Miss R. Birnie-Philip.

(148). "Ajaccio" (Pencil)
Boston Catalogue: Page 19, No. 151.
Lent by Miss R. Birnie-Philip.

(149). "Algiers" (Pencil)
Boston Catalogue: Page 19, No. 152.
Lent by Miss R. Birnie-Philip.

(150). "Ajaccio" (Sepia)
Boston Catalogue: Page 19, No. 153.
Lent by Miss R. Birnie-Philip.

(151). "Green and Brown—Ajaccio" (Wash)
Boston Catalogue: Page 19, No. 154.
Lent by Miss R. Birnie-Philip.

(152). "Ajaccio" (Pencil)
Boston Catalogue: Page 19, No. 155.
Lent by Miss R. Birnie-Philip.

(153). **"Old House, Canterbury, England"** (Pen and Ink)
Boston Catalogue: Page 19, No. 156.

Lent by Miss R. Birnie-Philip.

(154). **Street Scene in London**
Fog (Pastel).
Boston Catalogue: Page 20, No. 157.

Lent by Mrs. D. B. Flint.

(155). **"At Sea"** (Pen and Ink)
Figures leaning over the railing of a ship. Brown ink. Butterfly above the centre at the right.
Boston Catalogue: Page 20, No. 158.

Lent by R. A. Canfield, Esq.

(156). **"Street," Corsica** (Pen and Ink)
Boston Catalogue: Page 20, No. 159.

Lent by R. A. Canfield, Esq.

(157). **"The Dancer"** (No. 1) (Pen and Ink)
The dancer has right foot raised and holds a closed fan. Butterfly to the left, below the centre. Drapery of figure transparent.
Boston Catalogue: Page 20, No. 160.

Lent by R. A. Canfield, Esq.

(158). **"The Forge"** (Pencil)
Very silvery in tone. Butterfly to the left of the centre.
Boston Catalogue: Page 20, No. 161.

Lent by R. A. Canfield, Esq.

(159). **"The Café"—Algiers** (Pen and Ink)
Two arched doorways, the larger at the left with a bench in front at one side, and an awning above. A tree cuts across the larger doorway. Butterfly to the left of the centre.
Boston Catalogue: Page 20, No. 162.
Lent by R. A. Canfield, Esq.

(160). **"Shop"—Algiers** (Pen and Ink)
Butterfly left centre. Little boy at right in front. Woman back of him inside of shop.
Boston Catalogue: Page 20, No. 163.
Lent by R. A. Canfield, Esq.

(161). **Algiers—"A Street"** (Pen and Ink)
Butterfly to the left of the centre.
Boston Catalogue: Page 20, No. 164.
Lent by R. A. Canfield, Esq.

(162). **"The Dancer"** (No. 2) (Pen and Ink)
The dancer has left foot raised, and holds open fan in right hand. Transparent drapery. Butterfly is at left under fan.
Boston Catalogue: Page 20, No. 165.
Lent by R. A. Canfield, Esq.

(163). **"Street"—Ajaccio** (Pencil)
Boston Catalogue: Page 20, No. 166.
Lent by R. A. Canfield, Esq.

(164). **Fanny Leyland**
Boston Catalogue: Page 21, No. 167.
Lent by John H. Wrenn, Esq.

(165). **The Evolution of the Butterfly** (Pen and Ink)
 Boston Catalogue: Page 21, No. 168.
Lent by Mrs. John C. Bancroft.

(166). **Sketch** (Sepia Wash)
 Boston Catalogue: Page 21, No. 169.
Lent by Mrs. Louise Chandler Moulton.

(167). **Twenty-two drawings and sketches done by Mr. Whistler while at school at Pomfret, Conn., about 1850.**
 Boston Catalogue: Page 21, No. 170.
Lent by Samuel Hammond, Esq.

(168). **Cadet Drawings Under Instruction**
 1. (Pen and Ink.) 2. (Wash.)
 Boston Catalogue: Page 21, No. 171.
Lent by Dept. of Drawing, U. S. Military Academy, West Point, N. Y.

(169). **Chalk Drawing**
 Boston Catalogue: Page 21, No. 172.
Lent by Albert Eugene Gallatin, Esq.

(170). **Girl with a Fan** (Pastel)
 Boston Catalogue: Page 21, No. 173.
Lent by Howard Mansfield, Esq.

(171). **Woman with a Fan** (Pastel)
 Boston Catalogue: Page 21, No. 174.
Lent by Howard Mansfield, Esq.

(172). **Sunset Note** (Pastel)
 Boston Catalogue: Page 21, No. 175.
Lent by Howard Mansfield, Esq.

(173). Model Resting (Pastel)
Boston Catalogue: Page 22, No. 176.

Lent by Howard Mansfield, Esq.

(174). Model in Armchair (Pastel)
Boston Catalogue: Page 22, No. 177.

Lent by Howard Mansfield, Esq.

(175). Model with a Fan (Pastel)
Standing figure facing right, white gown. Fan with red figures held up to mouth; red sash. Bright white touch back of fan.
Boston Catalogue: Page 22, No. 178.

Lent by Howard Mansfield, Esq.

(176). Portrait Study (Pastel)
Very crisp black crayon outline of man with head resting on his hand, facing right. White shirt.
Boston Catalogue: Page 22, No. 179.

Lent by Howard Mansfield, Esq.

(177). Portrait Sketch (Pastel)
Black crayon outline of man. Full face.
Boston Catalogue: Page 22, No. 180.

Lent by Howard Mansfield, Esq.

(178). Study for a Picture (Pastel)
Three figures of women, bending figure at left, kneeling figure with flowers, standing figure with jug in right hand and Japanese parasol in left hand.
Boston Catalogue: Page 22, No. 181.

Lent by Howard Mansfield, Esq.

(179). Nude Figure, Standing (Pastel)

Figure faces to the right. Hair brown. Touches of white pastel back of figure. Touches of flesh colour on body.

Boston Catalogue: Page 22, No. 182.

Lent by Howard Mansfield, Esq.

(180). Draped Figure, Standing (Pastel)

Woman in long classic transparent draperies, blue cap. Stands with one arm resting on a shelf, the other hanging at her side.

Boston Catalogue: Page 22, No. 183.

Lent by Howard Mansfield, Esq.

(181). Sketch of a Girl (Pastel)

The girl is Florence Leyland. Yellow hair falls over her shoulders. She wears a flounced dress with touches of blue and rose in the flounces. The sash has rose-coloured lines in it and the cuff is white.

Boston Catalogue: Page 22, No. 184.

Lent by Howard Mansfield, Esq.

(182). La Mère Gérard (Oil)

Signed "Whistler" at the right.

Paris Catalogue: Page 17, No. 2.

London Catalogue: Page 102, No. 68.

(H. 11—B. 8)

Lent by Algernon Charles Swinburne, Esq.

(183). Head of An Old Man Smoking

Signed "Whistler" at the right.

Paris Catalogue: Page 18, No. 3.

(H. 0,400—L. 0,350)

Lent by M. Drouet.

(184). Tête de Paysanne (Oil)
 Paris Catalogue: Page 18, No. 3 bis.
 London Catalogue: Page 106, No. 80.
 (H. 9⅞—B. 6¾)
 (Title in London Catalogue, "Tête de Femme.")

Lent by Madame la Comtesse de Béarn.

(185). A White Note
 Paris Catalogue: Page 19, No. 6.
 (H. 0,380—L. 0,320)

Lent by Mrs. Cobden-Sickert.

(186). "Endormie"
 Page 68, No. 126.
 (H. 0,183—L. 0,273)

(187). Caprice in Purple and Gold: The Golden Screen
 Signed "Whistler, 1864."
 Paris Catalogue: Page 20, No. 8.
 (H. 0,460—L. 0,490, inside the frame)

Lent by Charles L. Freer, Esq.

(188). Arrangement in Black and Grey
 Portrait of "My Mother" (Oil).
 Paris Catalogue: Page 25, No. 17.
 London Catalogue: Page 83, No. 23.
 (H. 56—B. 64)

Lent by the Musée National du Luxembourg.

(189). Portrait of Miss Cicely Henrietta Alexander
 (Now Mrs. Bernard Spring Rice) (Oil)
 Paris Catalogue: Page 26, No. 18.
 London Catalogue: Page 87, No. 32.
 (H. 74—B. 39)

Lent by W. C. Alexander, Esq.

[Mr. Alexander writes that this portrait was painted at Chelsea in 1874, and was begun just before that of Carlyle. The commission was given after Mr. Alexander had seen the portrait of the artist's mother.]

(190). **Portrait of Miss Alexander** (Oil)
Paris Catalogue: Page 26, No. 19.
London Catalogue: Page 116, No. 109.

(H. 74—B. 37)

(In the London Catalogue the title is "Portrait of Agnes Mary, Miss Alexander.")

Lent by W. C. Alexander, Esq.

[Mr. Alexander writes that this picture was painted in the drawing-room of the Aubrey House, Kensington, W., which previously had been decorated by Whistler. The picture was left unfinished on account of the illness of Miss Alexander.]

(191). **Portrait of Mr. George W. Vanderbilt**
Paris Catalogue: Page 28, No. 22.

(H. 2 m. 06—L. o. m. 94)

Lent by George W. Vanderbilt, Esq.

(192). **Rose and Gold: The Tulip**
Paris Catalogue: Page 29, No. 24.

(H. 1 m. 90—L. o. m. 89)

Lent by Miss R. Birnie-Philip.

(193). **Portrait of Doctor Davenport**
Paris Catalogue: Page 30, No. 28.

(H. 0,580—L. 0,380)

Lent by Dr. Isaac Davenport.

(194). Le Philosophe (Oil)
Paris Catalogue: Page 31, No. 30.
London Catalogue: Page 111, No. 96.
(H. 8½—B. 4¾)
Lent by Madame la Comtesse de Béarn.

(195). Portrait of Miss Annie Haden
Signed "To Annie—Whistler" in lower right corner.
Paris Catalogue: Page 31, No. 31.
(H. 0,410—L. 0,270)
Lent by M. Jérôme Doucet.

(196). The Rose Scarf
Paris Catalogue: Page 31, No. 32.
(H. 0,275—L. 0,200)

(197). Ivoire et or. Portrait de Madame V.
Paris Catalogue: Page 31, No. 33.
(H. 0,650—L. 0,549)
Lent by George W. Vanderbilt, Esq.

(198). The Jade Necklace
Paris Catalogue: Page 32, No. 34.
(H. 0,500—L. 0,310)

(199). The Boy in a Cloak
Paris Catalogue: Page 32, No. 35.
(H. 0,960—L. 0,690)

(200). Brown and Gold: De Race
Paris Catalogue: Page 33, No. 36.
H. 0,500—L. 0,300)

(201). Lily
Paris Catalogue: Page 33, No. 38.
(H. 0,610—L. 0,500)

(202). **Dorothy Seton. A Daughter of Eve**
Paris Catalogue: Page 33, No. 40.
(H. 0,510—L. 0,310)

(203). **The Little London Sparrow**
Paris Catalogue: Page 34, No. 41 bis.
(H. 0,500—L. 0,350)
Lent by George W. Vanderbilt, Esq.

(204). **The Little Faustina**
Paris Catalogue: Page 35, No. 43.
(H. 0,510—L. 0,300)

(205). **"La Toison rouge"**
Paris Catalogue: Page 35, No. 44.
(H. 0,520—L. 0,320)

(206). **Portrait d'enfant**
Paris Catalogue: Page 35, No. 45.
(H. 0,630—L. 0,490)
Lent by George W. Vanderbilt, Esq.

(207). **Portrait of a Baby**
Paris Catalogue: Page 36, No. 46.
London Catalogue: Page 105, No. 76.
(H. 19½—B. 11¾)
Lent by Brandon Thomas, Esq.

(208). **"Le bébé francais"**
Paris Catalogue: Page 36, No. 47.
(Circular—0,350)

(209). **Rose and Green. A Study**
Paris Catalogue: Page 36, No. 49.
(H. 0,800—L. 0,510)

(210). **Ariel**
>> *Paris Catalogue:* Page 37, No. 50.
>>
>> (H. 0,225—L. 0,134)

(211). **Flesh Colour and Silver. The Card Players**
>> *Paris Catalogue:* Page 37, No. 51.
>>
>> (H. 0,134—L. 0,238)

(212). **The Little White Sofa** (Oil)
>> *Paris Catalogue:* Page 37, No. 53.
>> *London Catalogue:* Page 112, No. 98.
>>
>> (H. 4—B. 6½)

Lent by A. Arnold Hannay, Esq.

(213). **The Little Red Note**
>> *Paris Catalogue:* Page 38, No. 54.
>>
>> (H. 0,098—L. 0,155)

Lent by H. Cust, Esq., M. P.

(214). **Crepuscule. Flesh Colour and Green. Valparaiso**
>> Signed "Whistler, Valparaiso, '65," in lower left corner.
>> *Paris Catalogue:* Page 42, No. 59.
>> *London Catalogue:* Page 110, No. 93. (Valparaiso Nocturne.)
>>
>> (H. 22—B. 29)

Lent by W. Graham Robertson, Esq.

(215). **Grey and Silver. The Thames**
>> *Paris Catalogue:* Page 44, No. 64.
>>
>> (H. 0,610—L. 0,460)

(216). **Nocturne in Blue and Green**
>> *Paris Catalogue:* Page 48, No. 72.
>>
>> (H. 0,500—L. 0,500)

Lent by W. C. Alexander, Esq.

(217). **Nocturne, Westminster, Grey and Gold**
 Paris Catalogue: Page 48, No. 74.

 (H. 0,470—L. 0,300)
Lent by A. A. Hannay, Esq.

(218). **The Sea. Britanny**
 Paris Catalogue: Page 49, No. 76.

 (H. 0,095—L. 0,155)

(219). **Violet and Blue. The Little Bathers**
 Pérosquérié.
 Paris Catalogue: Page 49, No. 77.

 (H. 0,130—L. 0,215)
Lent by A. A. Hannay, Esq.

(220). **St. Ives. The Beach**
 Paris Catalogue: Page 49, No. 78.
 London Catalogue: Page 109, No. 88.

 (H. 8⅞—B. 11½)
Lent by Monsieur J. E. Blanche.

(221). **Note in Blue and Opal, the Sun Cloud**
 Paris Catalogue: Page 50, No. 79.

 (H. 0,130—L. 0,225)
Lent by Charles L. Freer, Esq.

(222). **The Little Red House**
 Paris Catalogue: Page 50, No. 80.

 (H. 0,230—L. 0,145)

(223). **"Le blanchisseuse; Dieppe"**
 Paris Catalogue: Page 50, No. 81.

 (H. 0,255—L. 0,150)

(224). **The Little Forge; Lyme Regis**
 Paris Catalogue: Page 50, No. 82.

 (H. 0,145—L. 0,245)

(225). **A Grey Note; Village Street**
　　Paris Catalogue: Page 50, No. 83.
　　　　　　　　　　(H. 0,138—L. 0,227)

(226). **An Orange Note. The Sweet Shop**
　　Paris Catalogue: Page 51, No. 84.
　　　　　　　　　　(H. 0,130—L. 0,222)
Lent by Charles L. Freer, Esq.

(227). **The Canal. Amsterdam**
　　Paris Catalogue: Page 51, No. 85.
　　　　　　　　　　(H. 0,150—L. 0,145)

(228). **Noir et Or. Madge O'Donoghue** (Water-Colour)
　　Paris Catalogue: Page 55, No. 87.
　　　　　　　　　　(H. 0,240—L. 0,170)
Lent by A. A. Hannay, Esq.

(229). **Harmony in Violet and Amber**
　　Paris Catalogue: Page 55, No. 88.
　　　　　　　　　　(H. 0,245—L. 0,150)
Lent by Charles L. Freer, Esq.

(230). **Gold and Brown. The Guitar Player**
　　Paris Catalogue: Page 56, No. 90.
　　　　　　　　　　(H. 0,235—L. 0,148)

(231). **Bravura in Brown**
　　Paris Catalogue: Page 56, No. 91.
　　　　　　　　　　(H. 0,270—L. 0,170)
Lent by Charles L. Freer, Esq.

(232). **Draped Figure and Cupid**
　　Paris Catalogue: Page 56, No. 92.
　　　　　　　　　　(H. 0,250—L. 0,175)
Lent by Madame la Comtesse de Béarn.

(233). **The Little Blue Cap**
　　Paris Catalogue: Page 57, No. 93.
　　　　　　　　　　(H. 0,285—L. 0,190)

(234). **"Rose et argent. Fleurs de printemps"**
Paris Catalogue: Page 57, No. 94.

(H. 284—L. 0,184)

(235). **Grey and Green. A Shop in Brittany** (Water-Colour
on Canvas)
Paris Catalogue: Page 57, No. 96.

(H. 0,155—L. 0,250)

(236). **Chelsea Children**
Paris Catalogue: Page 57, No. 97.

(H. 0,110—L. 0,210)
Lent by Charles L. Freer, Esq.

(237) **Chelsea Shops**
Paris Catalogue: Page 58, No. 98.

(H. 0,140—L. 0,225)

(238). **Terry's Fruit-Shop; Chelsea**
Paris Catalogue: Page 58, No. 99.

(H. 0,150—L. 0,210)

(239). **Moreby Hall**
Paris Catalogue: Page 58, No. 100.

(H. 0,180—L. 0,270, inside the frame)
Lent by Charles L. Freer, Esq.

(240). **Westminster from the Savoy**
Paris Catalogue: Page 58, No. 101.

(H. 0,230—L. 0,145)

(241). **Note in Blue and Opal. Jersey**
Paris Catalogue: Page 58, No. 102.

(H. 0,120—L. 0,240, inside the frame)
Lent by Charles L. Freer, Esq.

(242). **The Opal Beach**
Paris Catalogue: Page 59, No. 105.

(H. 0,156—L. 0,246, inside the frame)
Lent by Charles L. Freer, Esq.

(243). **Violet and Silver. Low Tide. Belle Isle**
Paris Catalogue: Page 60, No. 107.

(H. 0,140—L. 0,220)

(244). **Blue and Silver. Belle Isle**

(H. 0,220—L. 0,138)
Paris Catalogue: Page 60, No. 108.

(245). **Southend Pier**
Paris Catalogue: Page 60, No. 110.

(H. 0,168—L. 0,225, inside the frame)
Lent by Charles L. Freer, Esq.

(246). **The Opal Sea**
Paris Catalogue: Page 61, No. 111.

(H. 0,140—L. 0,220)

Lent by Mrs. Cobden Sickert.

(247). **In the Channel**
Paris Catalogue: Page 61, No. 112.

(H. 0,170—L. 0,270)

Lent by Mrs. Charles Knowles.

(248). **Silver and Grey. The Fishing Fleet**
Paris Catalogue: Page 61, No. 114.

(H. 0,130—L. 0,210)

(249). **A Note in Grey and Green. Holland**
Paris Catalogue: Page 62, No. 115.

(H. 0,140—L. 0,230)

(250). **Sea and Sand; Domberg** (Water-Colour)
Paris Catalogue: Page 62, No. 116.

(H. 0,220—L. 0,135)

(251). **Dordrecht** (Water-Colour)
Paris Catalogue: Page 62, No. 117.

(H. 0,140—L. 0,220)

(252). **On the Sea Shore** (Water-Colour)
Paris Catalogue: Page 62, No. 118.

(H. 0,138—L. 0,226)

(253). **Nocturne.** Amsterdam in Winter (Water-Colour)
 Paris Catalogue: Page 63, No. 120.

(H. 0,195—L. 0,265, inside the frame)
Lent by Charles L. Freer, Esq.

———

THE FOLLOWING NUMBERS, FROM 254 TO 306, ARE GROUPED IN THE FRENCH CATALOGUE UNDER THE DESCRIPTIVE HEADING "PASTELS AND DRAWINGS."

(254). **Croquis de la Série des Voyages du Rhin** (Pencil drawing) **1858**
 Paris Catalogue: Page 67, No. 122A.

(H. 0,210—L. 0,155)
Lent by Charles L. Freer, Esq.

(255). **Portrait of Fantin-Latour** (Crayon Drawing) 1859
 Paris Catalogue: Page 67, No. 122B.
Lent by Madame Fantin-Latour.

(256). **Portrait of Whistler** (Black Crayon on Brown Paper)
 Paris Catalogue: Page 67, No. 123.

(H. 0,170—L. 0,135)
Lent by J. P. Heseltine, Esq.

(257). **Mrs. Leyland**
 Paris Catalogue: Page 67, No. 123 bis.
 London Catalogue: Page 108, No. 84.

(H. 10¾—B. 6¾)
Lent by Monsieur J. E. Blanche.

(258). **Figure Reading** (Drawing with Two Crayons on Brown Paper)
 Paris Catalogue: Page 68, No. 124.

(H. 0,230—L. 0,170)
Lent by Mrs. Charles Knowles.

(259). **Study of Nude** (Drawing with Two **Crayons**)
Paris Catalogue: Page 68, No. 125.

(H. 0,230—**L. 0,173**)

Lent by Mrs. Charles Knowles.

(260). **Draped Model** (Black Crayon and Pastel on **Brown** Paper)
Paris Catalogue: Page 68, No. 128.

(H. 0,250—**L. 0,170**)

Lent by J. P. Heseltine, Esq.

(261). **Black and Red. The Egyptian**
Paris Catalogue: Page 69, No. 129.

(H. 0,287—**L. 0,190**)

(262). **Study of Nude** (Black Crayon and Pastel)
Paris Catalogue: Page 69, No. 130.

(H. 0,250—**L. 0,170**)

Lent by Mrs. Charles Knowles.

(263). **Vénus Astarté**
Paris Catalogue: Page 70, No. 132.

(H. 0,268—L. 0,168, inside **the frame**)

Lent by Charles L. Freer, Esq.

(264). **Venus**
Paris Catalogue: Page 70, No. 133.

(H. 0,283—**L. 0,182**)

(265). **Youth**
Paris Catalogue: Page 70, No. 134.

(266). **Draped Model**
Paris Catalogue: Page 70, No. 135.

(H. 0,230—**L. 0,150**)

Lent by J. P. Heseltine, Esq.

(267). **The Purple Iris**
Paris Catalogue: Page 71, No. 137.

(H. 0,275—L. 0,120, inside **the frame**)

Lent by Charles L. Freer, Esq.

(268.) **"Le Ruban"**
> *Paris Catalogue:* Page 71, No. 139.
> > (H. 0,280—L. 0,185)

(269). **Bleu et Violet. La Jacinthe**
> *Paris Catalogue:* Page 72, No. 141.
> > (H. 0,267—L. 0,191)

(270). **The Tambourine**
> *Paris Catalogue:* Page 72, No. 142.
> > (H. 0,283—L. 0,200)

(271). **The Baby's Promenade**
> *Paris Catalogue:* Page 72, No. 143.
> > (H. 0,285—L. 0,190)

(272). **Mother and Child**
> *Paris Catalogue:* Page 74, No. 147.
> > (H. 0,280—L. 0,190)

Lent by Madame Potter-Palmer.

(273). **The Shell**
> *Paris Catalogue:* Page 74, No. 148.
> > (H. 0,192—L. 0,287)

Lent by Charles L. Freer, Esq.

(274). **Bead Stringing**
> *Paris Catalogue:* Page 74, No. 149.
> > (H. 0,284—L. 0,190)

(275). **The Conversation**
> *Paris Catalogue:* Page 75, No. 150.
> > (H. 0,192—L. 0,280)

(276). **Violet and Gold**
> *Paris Catalogue:* Page 75, No. 151.
> > (H. 0,190—L. 0,182)

(277). **Long Venice**
> *Paris Catalogue:* Page 75, No. 152.
> > (H. 0,108—L. 0,270, inside the frame)

Lent by R. A. Canfield, Esq.

"THE CEMETERY."—VENICE.

(Pastel.)

Reproduced for the first time by kind permission of R. A. Canfield, Esq.

(278). **The Grand Canal. Venise**
> *Paris Catalogue:* Page 75, No. 153.
>> (H. 0,258—L. 0,158, inside the frame)

Lent by Charles L. Freer, Esq.

(279). **Nocturne. Venise**
> *Paris Catalogue:* Page 76, No. 154.
>> (H. 0,190—L. 0,270, inside the frame)

Lent by R. A. Canfield, Esq.

(280). **The Cemetery. Venice**
> *Paris Catalogue:* Page 76, No. 155.
>> (H. 0,155—L. 0,270)

Lent by R. A. Canfield, Esq.

(281). **Un Canal. Venise**
> *Paris Catalogue:* Page 76, No. 156.
>> (H. 0,290—L. 0,132)

Lent by R. A. Canfield, Esq.

(282). **The Ferry. Venice**
> *Paris Catalogue:* Page 76, No. 157.
>> (H. 0,277—L. 0,128, inside the frame)

Lent by R. A. Canfield, Esq.

(283). **Venise**
> *Paris Catalogue:* Page 77, No. 158.

Lent by A. A. Hannay, Esq. (H. 0,300—L. 0,155)

(284). **Calle. Venise** (Pastel)
> *Paris Catalogue:* Page 77, No. 159.
> *London Catalogue:* Page 100, No. 60.

Lent by J. P. Heseltine, Esq. (H. 10½—B. 7)

(285). **A Street in Venice**
> *Paris Catalogue:* Page 77, No. 160.
>> (H. 0,285—L. 0,110, inside the frame)

Lent by Charles L. Freer, Esq.

(286). **A Street. Venice**
> *Paris Catalogue:* Page 77, No. 161.
>> (H. 0,255—L. 0,090, inside the frame)

Lent by R. A. Canfield, Esq.

(287). **La Barca. Venise**
> *Paris Catalogue:* Page 78, No. 162.
>> (H. 0,200—L. 0,265)

(288). **Base of a Tower. Venice**
> *Paris Catalogue:* Page 78, No. 164.
>> (H. 0,290—L. 0,160)

Lent by J. P. Heseltine, Esq.

(289). **The Doorway. Venice**
> *Paris Catalogue:* Page 79, No. 166.
>> (H. 0,275—L. 0,190, inside the frame)

Lent by R. A. Canfield, Esq.

(290). **Doorway**
> *Paris Catalogue:* Page 79, No. 167.
>> (H. 0,273—L. 0,170, inside the frame)

Lent by Charles L. Freer, Esq.

(291). **Modèle Nu, debout, passant une robe**
> *Paris Catalogue:* Page 79, No. 168.
>> (H. 0,270—L. 0,198)

(292). **Modèle drapé, couché, tenant un enfant dans ses bras**
> *Paris Catalogue:* Page 80, No. 169.
>> (H. 0,200—L. 0,170)

(293). **Figure drapée, couchée. Un enfant nu est couché devant elle**
> *Paris Catalogue:* Page 80, No. 170.
>> (H. 0,200—L. 0,270)

(294). **Modèle drapé, debout devant une balustrade**
> *Paris Catalogue:* Page 80, No. 171.
>> (H. 0,270—L. 0,700)

(295.) **Tête d'homme barbu** (Pencil Sketch)
Paris Catalogue: Page 80, No. 172.
(H. 0,070—L. 0,065)

(296). **Tête d'homme barbu** (Pencil Sketch)
Paris Catalogue: Page 80, No. 173.
(H. 0,105—L. 0,075)

(297). **Croquis**
Paris Catalogue: Page 80, No. 174.
(H. 0,800—L. 0,075)

(298). **Croquis** (Pencil)
Paris Catalogue: Page 81, No. 175.
(H. 0,140—L. 0,090)

(299). **Tête de petite fille** (Pencil)
Paris Catalogue: Page 81, No. 176.
(H. 0,098—L. 0,058)

(300). **Tête d'enfant** (Pencil)
Paris Catalogue: Page 81, No. 177.
(H. 0,060—L. 0,050)

(301). **Une rue le soir** (Pen and Wash)
Paris Catalogue: Page 81, No. 178.
(H. 0,080—L. 0,090)

(302). **Old Houses, Canterbury**
Paris Catalogue: Page 81, No. 179.
(H. 0,130—L. 0,090)

(303). **Doorway: Ajaccio** (Sepia)
Paris Catalogue: Page 82, No. 181.
(H. 0,140—L. 0, 080)

(304). **Interior: Ajaccio** (Water-Colour and Sepia)
Paris Catalogue: Page 82, No. 182.
(H. 0,140—L. 0,080)

(305). **La Mule** (Sepia)
Paris Catalogue: Page 82, No. 183.
(H. 0,137—L. 0,080)

(306). **Children: Ajaccio** (Pencil Sketch)
Paris Catalogue: Page 83, No. 185.

(H. 0,140—L. 0,080)

(306*a*). **Street: Ajaccio** (Pencil)
Paris Catalogue: Page 83, No. 187.

(H. 0,137—L. 0,078)

(307). **Japanese Figure: Seated** (Black and White Chalk
on Brown Paper)
London Catalogue: Page 42, No. 389.

(H. 10½—B. 6⅞)
Lent by the Executors of the late J. Staats Forbes, Esq.

(308). **Female Figure with Fan** (Black and White Chalk
on Brown Paper)
London Catalogue: Page 43, No. 390.

(H. 7¾—B. 4¾)
Lent by the Executors of the late J. Staats Forbes, Esq.

(309). **Female Figure, Back** (Black and White Chalk on
Brown Paper)
London Catalogue: Page 43, No. 391.

(H. 11—B. 6¾)
Lent by the Executors of the late J. Staats Forbes, Esq.

(310). **Female Figure with Fan** (Black and White Chalk
on Brown Paper)
London Catalogue: Page 43, No. 392.

(H. 8—B. 5)
Lent by the Executors of the late J. Staats Forbes, Esq.

(311). **Female Figure, Front** (Black and White Chalk on
Brown Paper)
London Catalogue: Page 44, No. 393.

(H. 10½—B. 6¾)
Lent by the Executors of the late J. Staats Forbes, Esq.

(312). **A Nude** (Black and White Chalk on Brown Paper)
London Catalogue: Page 44, No. 394.

(H. 10½—B. 7½)

Lent by the Executors of the late J. Staats Forbes, Esq.

(313). **Female Figure, Hand on Rail** (Black and White Chalk on Brown Paper)
London Catalogue: Page 44, No. 395.

(H. 14½—B. 6¾)

Lent by the Executors of the late J. Staats Forbes, Esq.

(314). **Female Figure, Looking Over Her Shoulder** (Black and White Chalk on Brown Paper)
London Catalogue: Page 44, No. 396.

(H. 8—B. 5)

Lent by the Executors of the late J. Staats Forbes, Esq.

(315). **Female Figure in Flounced Dress** (Black and White Chalk on Brown Paper)
London Catalogue: Page 45, No. 397.

(H. 12½—B. 6¾)

Lent by the Executors of the late J. Staats Forbes, Esq.

(316). **Lady with Fan** (Black and White Chalk on Brown Paper)
London Catalogue: Page 45, No. 398.

(H. 7¾—B. 5)

Lent by the Executors of the late J. Staats Forbes, Esq.

(317). **Three Figures, Pink and Grey** (Oil)
London Catalogue: Page 45, No. 399.

(H. 55½—B. 72)

Lent by Alfred Chapman, Esq.

(318). **School House on Fire** (Water-Colour)
London Catalogue: Page 61, No. 154.

(H. 5—B. 7¾)

Lent by Mrs. W. McNeill Whistler.

(319). **Sam Weller's Lodging in the Fleet Prison** (Water-
 Colour)
 London Catalogue: Page 61, No. 155.

 (H. 4¼—B. 5⅞)

Lent by Mrs. W. McNeill Whistler.

(320). **Illustrations to Sir Henry Thompson's Catalogue of
 His Collection of Blue and White Nankin Porce-
 lain, 1878** (Indian Ink)
 London Catalogue: Page 61, Nos. 156, 157, 158, 159,
 160, 161.

Lent by Pickford R. Waller, Esq.

(321). **Design for Matting** (Black and Coloured Chalk on
 Brown Paper)
 London Catalogue: Page 62, No. 162.

 (H. 10⅝—B. 6⅞)

Lent by Mrs. Knowles.

(322). **Studies of Nudes** (Black and White Chalk)
 Three complete figures and notes of heads, torso,
 etc.
 London Catalogue: Page 62, No. 163.

 (H. 11¾—B. 7¾)

Lent by Laurence W. Hodson, Esq.

(323). **A Study** (Black and White Chalk on Brown Paper)
 London Catalogue: Page 62, No. 164.

 (H. 9—B. 6⅝)

Lent by Mrs. Knowles.

(324). **A Female Figure** (Black and White Chalk on
 Brown Paper)
 London Catalogue: Page 63, No. 165.

 (H. 8¾—B. 6¼)

Lent by Sir James Knowles.

(325). **Full-Length Nude** (Pastel and Black Chalk on Brown Paper)
 London Catalogue: Page 63, No. 166.
 (H. 13—B. 7)

Lent by Sir James Knowles.

(326). **Mother and Child** (Black and White Chalk on Brown Paper)
 London Catalogue: Page 63, No. 167.
 (H. 7—B. 8½)

Lent by Sir James Knowles.

(327). **Study of a Nude** (Black and White Chalk on Brown Paper)
 London Catalogue: Page 64, No. 168.
 (H. 10—B. 5½)

Lent by Sir James Knowles.

(328). **Water Colour on Tinted Paper**
 London Catalogue: Page 64, No. 169.
 (H. 7¼—B. 6)

Lent by Sir James Knowles.

(329). **A Nude Figure** (Pastel and Black and White Chalk on Brown Paper)
 London Catalogue: Page 64, No. 170.
 (H. 10½—B. 7½)

Lent by Sir James Knowles.

(330). **Study for Dress** (Pastel)
 London Catalogue: Page 64, No. 171.
 (H. 9¾—B. 3¾)

Lent by W. C. Alexander, Esq.

(331). **Maude Standing** (Black Chalk on Brown Paper)
 London Catalogue: Page 65, No. 172.
 (H. 10¼—B. 6¾)

Lent by Thomas Way, Esq.

(332). **Drawing from the Nude, No. 1** (Chalk and Pastel on Brown Paper)
London Catalogue: Page 65, No. 173.

(H. 9¼—B. 6)

Lent by Edmund Davis, Esq.

(333). **Figure** (Pastel on Brown Paper)
London Catalogue: Page 65, No. 174.

(H. 10—B. 6)

Lent by Madame Blanche Marchesi.

(334). **Harmony in Gold and Brown** (Pastel on Brown Paper)
London Catalogue: Page 65, No. 175.

(H. 5¾—B. 10)

Lent by Pickford R. Waller, Esq.

(335). **Souvenir of Velasquez** (Black and White Chalk on Brown Paper)
London Catalogue: Page 66, No. 176.

(H. 6½—B. 5¼)

Lent by H. Graves, Esq.

(336). **Girl with Parasol** (Pen and Ink)
London Catalogue: Page 66, No. 177.

(H. 6¼—B. 3¾)

Lent by G. R. Halkett, Esq.

(337). **Lady with a Fan** (Pencil Drawing, touched with White)
London Catalogue: Page 66, No. 178.

(H. 7¾—B. 4¼)

Lent by C. L. Rothenstein, Esq.

(338). **Studies in Lead Pencil for Butterflies Used in the Artist's Publications**
London Catalogue: Page 66, No, 179 and No. 180.
Lent by H. J. Pollitt, Esq.

(339). Portrait of Whistler (Pen and Ink Drawing)
Study for the full length portrait, exhibited in the International Exhibition in Paris in 1900.
London Catalogue: Page 66, No. 181.

(H. 4—B. 3¼)

Lent by Joseph Pennell, Esq.

(340). Pen Sketch for the Portrait of Sarasate
London Catalogue: Page 67, No. 182.

(H. 5¼—B. 2¾)

Lent by Charles Morley, Esq.

(341). A Sleeping Figure (Black Chalk)
1860 Costume.
Signed "Whistler."
London Catalogue: Page 67, No. 183.

(H. 9—B. 6½)

Lent by B. B. MacGeorge, Esq.

(342). A Sleeping Figure (Black Chalk)
1860 Costume.
Signed "Whistler."
London Catalogue: Page 67, No. 184.

(9¼—7¾)

(343). Study for the Portrait of Carlyle (Pen, Ink and Wash)
London Catalogue: Page 67, No. 185.

(H. 4—B. 3¾)

Lent by T. Way, Esq.

(344). Figure Reading (Black and White Chalk on Brown Paper)
London Catalogue: Page 67, No. 186.

(H. 8⅛—B. 6⅝)

Lent by Mrs. Knowles.

(345). **Figure of a Child** (Black and White Chalk on Brown
 Paper)
 London Catalogue: Page 68, No. 187.

(H. 9—B. 7)

Lent by Mrs. Knowles.

(346). **Draped Figure** (Black and White Chalk on Brown
 Paper)
 London Catalogue: Page 68, No. 188.

(H. 10⅜—B. 6⅞)

Lent by Mrs. Knowles.

(347). **Study of a Nude** (Black and White Chalk on Brown
 Paper)
 London Catalogue: Page 68, No. 189.

(H. 9⅞—B. 6⅝)

Lent by Mrs. Knowles.

(348). **Nelly** (Pencil Drawing on Blue Paper)
 1860 Dress.
 London Catalogue: Page 68, No. 191.

(H. 8—B. 6¼)

Lent by Laurence W. Hodson, Esq.

(349). **Illustration to "The First Sermon"** (Proof of Wood
 Engraving)
 "Good Words," 1862, engraved by Dalziel Bros.
 London Catalogue: Page 69, No. 192.

(H. 6—B. 4½)

Lent by Harold Hartley, Esq.

(350). **Illustration to "The First Sermon"** (Proof of Wood
 Engraving)
 "Good Words," 1862, engraved by Dalziel Bros.
 London Catalogue: Page 69, No. 193.

(H. 6—B. 4½)

Lent by Harold Hartley, Esq.

(351). **The Morning Before the Massacre of St. Bartholo-**
 mew (Proof of Wood Engraving)
 "Once a Week," Vol. VII, p. 210. Engraved by
 Dalziel.
 London Catalogue: Page 69, No. 194.

 (H. 6—B. 4)
 Lent by Messrs. Chatto and Windus.

(352). **Count Burkhardt** (Proof of Wood Engraving)
 "Once a Week," Vol. VII, p. 378. Engraved by
 Swain.
 London Catalogue: Page 69, No. 195.

 (H. 6¼—B. 4)
 Lent by Messrs. Chatto and Windus.

(353). **The Major's Daughter.** (Proof of Wood Engraving)
 Signed "Whistler."
 "Once a Week," Vol. VI, p. 712.
 London Catalogue: Page 70, No. 196.

 (H. 5—B. 4¼)
 Lent by Messrs. Chatto and Windus.

(354). **The Relief Fund in Lancashire.** (Proof of Wood
 Engraving)
 "Once a Week," Vol. VI, p. 712.
 London Catalogue: Page 70, No. 197.

 (H. 5½—B. 4)
 Lent by Messrs. Chatto and Windus.

(355). **A Portrait** (Pencil Drawing on Wood Block, Un-
 engraved)
 London Catalogue: Page 70, No. 198.

 (H. 2½—B. 2½)
 Lent by Joseph Pennell, Esq.

(356). **Study of a Head**, Slight (Pencil Drawing on Wood, Unengraved)
 London Catalogue: Page 70, No. 199.

(H. 2¼—B. 1¾)

Lent by Joseph Pennell, Esq.

(357). **Study of a Head**, No. 2, Slight (Pencil Drawing on Wood Unengraved)
 London Catalogue: Page 70, No. 200.

(H. 4¼—B. 2¾)

Lent by Joseph Pennell, Esq.

(358). **An Illustration on Wood; a Little Figure Under the Sea Gazing at a Fish**
 London Catalogue: Page 70, No. 201.

(H. 2⅛—B. 1¾)

Lent by Joseph Pennell, Esq.

(359). **Study of a Girl in Bed, Covered by an Elaborate Quilt on Which Sits a Monkey**
 London Catalogue: Page 71, No. 202.

(H. 2½—B. 4¼)

Lent by Joseph Pennell, Esq.

(360). **Portrait of the Artist** (Black and White Chalk Drawing)
 London Catalogue: Page 71, No. 203.

(H. 10—B. 6¾)

Lent by Thomas Way, Esq.

(361). **A Study** (Black and White Chalk on Brown Paper)
 London Catalogue: Page 71, No. 204.

Lent by Mrs. Knowles. (H. 7⅛—B. 4⅞)

(363). **Study of Nude Figure** (Pen Drawing)
 London Catalogue: Page 71, No. 205.

(H. 4½—B. 2)

Lent by William Heinemann, Esq.

(363). **Old Battersea Bridge** (Black and White Chalk Drawing on Brown Paper)
London Catalogue: Page 71, No. 206.
Lent by H. J. Pollitt, Esq. (H. 6¾—B. 10½)

(364). **A Frame of Ten Early Pencil Sketches Which Were Given to His Niece, Mrs. Thynne, by Whistler, After She Had Posed for Him as a Child**
London Catalogue: Page 72, No. 207.

Lent by Mrs. Charles Thynne.

(365). **The Widow** (Oil)
London Catalogue: Page 75, No. 1.

(H. 22—B. 17)
Lent by the Executors of the late J. Staats Forbes, Esq.

(366). **Nocturne, Blue and Gold, St. Mark's** (Oil)
London Catalogue: Page 75, No. 2.

(H. 17½—B. 23½)

Lent by John J. Cowan, Esq.

(367). **Sea and Rain** (Oil)
Signed "Whistler, '65."
London Catalogue: Page 75, No. 3.

(H. 19⅝—B. 28½)

Lent by Alexander Young, Esq.

(368). **Girl with a Red Feather** (Oil)
London Catalogue: Page 75, No. 4.

(H. 19—B. 11)
Lent by the Executors of the late J. Staats Forbes, Esq.

(369). **Arrangement in Grey and Black, Thomas Carlyle** (Oil)
London Catalogue: Page 76, No. 5.

(H. 67—B. 56)

Lent by the Glasgow Corporation.

(370). **Girl in Black** (Oil)
 London Catalogue: Page 76, No. 6.
Lent by Monsieur X. (H. 19—B. 11)

(371). **Symphony in White, No. 3** (Oil)
 Signed: "Symphony in White, No. 3, Whistler, 1867."
 London Catalogue: Page 77, No. 7.
Lent by Edmund Davis, Esq. (H. 19¼—B. 29)

(372). **The Little Blue Bonnet, Blue and Coral** (Oil)
 London Catalogue: Page 77, No. 8.
 (Oval, H. 22½—B. 17—sight measurement)
 (H. 23½—B. 18¼, without the frame)
Lent by William Heinemann, Esq.
 (Sold to Mr. William Macbeth, August 31, 1906.)

(373). **Portrait of Monsieur Theodore Duret, Writer on Art** (Oil)
 London Catalogue: Page 78, No. 10.
Lent by Monsieur Théodore Duret. (H. 72—B. 32½)

(374). **Nocturne, Blue and Gold, Old Battersea Bridge** (Oil)
 London Catalogue: Page 79, No. 12.
Lent by Robert H. C. Harrison, Esq. (H. 26—B. 19¾)

(375.) **Whistler in His Studio** (Oil)
 London Catalogue: Page 79, No. 13.
Lent by Douglas Freshfield, Esq. (H. 23—B. 17¼)

(376). **The Artist's Studio** (Oil)
 Another version of No. 375.
 London Catalogue: Page 80, No. 15.
Lent by the City of Dublin Gallery. (H. 23½—B. 18)

(377). **Blue and Gold, Valparaiso, Nocturne** (Oil)
London Catalogue: Page 80, No. 16.

(H. 29½—B. 19½)

Lent by George McCulloch, Esq.

Mr. McCulloch writes, July, 1906, that he still owns this picture.

(378). **Brown and Silver, Old Battersea Bridge** (Oil)
London Catalogue: Page 81, No. 17.

(H. 24½—B. 29½)

Lent by Edmund Davis, Esq.

(379). **Brown and Gold, Lillie in Our Alley** (Oil)
London Catalogue: Page 81, No. 18.

(H. 20—B. 11½)

Lent by John J. Cowan, Esq.

(380). **Lilian, Daughter of E. G. Woakes, Esq., M.D.** (Oil)
London Catalogue: Page 82, No. 20.

(H. 20—13½)

Lent by E. G. Woakes, Esq., M.D.

(381). **Cremorne, No. 1** (Oil)
London Catalogue: Page 82, No. 21.

(H. 19½—B. 30)

Lent by Mrs. Alexander Argenti.

(382). **Study in Brown** (Oil)
London Catalogue: Page 83, No. 22.

(H. 20—B. 12)

Lent by Baroness de Meyer.

(383). **Cremorne Gardens, No. 2** (Oil)
London Catalogue: Page 84, No. 25.

(H. 25—B. 51)

Lent by T. R. Way, Esq.

(384). **Arrangement in Black, No. 3, Portrait of Sir Henry Irving as Philip II. of Spain** (Oil)
 Owned by Mr. Thomas, of Philadelphia, Pa.
 London Catalogue: Page 85, No. 27.

 (H. 81—B. 41)

Lent by Sir Henry Irving.

(385). **The Girl in Red** (Oil) ·
 London Catalogue: Page 85, No. 28.

 (H. 19¾—B. 12)

Lent by the Executors of the late J. Staats Forbes, Esq.

(386). **Portrait of the Artist** (Oil)
 London Catalogue: Page 86, No. 30.

 (H. 29½—B. 21)

Lent by George McCulloch, Esq.

 Mr. McCulloch writes, July, 1906, that he still owns the picture.

(387). **Nocturne, Blue and Green** (Oil)
 London Catalogue: Page 86, No. 31.

 (H. 18½—B. 23¼)

Lent by W. C. Alexander, Esq.

 Mr. Alexander writes that the date of this Nocturne is 1874 or 1875.

(388). **Trafalgar Square, Chelsea** (Oil)
 London Catalogue: Page 88, No. 33.
Lent by J. W. Martin White, Esq. (H. 18—B. 2!)

 Mr. White writes that this picture was bought by him "three or four years ago" from Agnews, and formerly belonged to Albert Moore.

(389). **The Violinist**
 London Catalogue: Page 88, No. 34.

 (H. 30—B. 19½)

Lent by Monsieur Z.

(390). **Nocturne, Blue and Gold** (Oil)
London Catalogue: Page 89, No. 36.
Lent by the Hon. Percy Wyndham. (H. 18—B. 24)

The Honorable Percy Wyndham writes concerning this picture that it was painted in 1871 or 1872, that it was bought in 1872 or 1874, and that it was wrongly listed in the London Catalogue as "Nocturne, Blue and Silver."

(391). **Arrangement in Grey and Gold, Nocturne, Battersea Bridge** (Oil)
London Catalogue: Page 90, No. 38.
Lent by Mrs. Flower. (H. 18—B. 23¼)

(392). **Pink and Rose: The Mother's Sleep** (Water-Colour)
London Catalogue: Page 93, No. 39.
Lent by John J. Cowan, Esq. (H. 7—B. 10½)

(393). **Design for a Mosaic** (Pastel)
London Catalogue: Page 93, No. 40.
Lent by W. Graham Robertson, Esq. (H. 10¼—B. 6½)

(394). **Nude Figure and Cupid** (Water-Colour)
London Catalogue: Page 93, No. 41.
Lent by Madame la Comtesse de Béarn. (H. 10—B. 7)

(395). **Sea** (Water-Colour)
London Catalogue: Page 94, No. 43.
Lent by Mrs. A. M. Jarvis. (H. 4¾—B. 8¼)

(396). **Rose et Vert; L'Iris: Portrait of Miss Kinsella** (Oil)
London Catalogue: Page 94, No. 44.
Lent by Miss Kinsella. (H. 74—B. 34)

(397). **The Salute, Venice, from the Riva Schiavoni**
(Water-Colour)
London Catalogue: Page 95, No. 45.

(H. 5¼—B. 8¾)

Lent by B. B. MacGeorge, Esq.

(398). **Venice** (Pastel)
London Catalogue: Page 95, No. 46.

(H. 6¾—B. 11)

Lent by Madame Blanche Marchesi.

(399). **Study of Mrs. Leyland** (Pastel on Brown Paper)
London Catalogue: Page 95, No. 47.

(H. 10—B. 6½)

Lent by Thomas Way, Esq.

(400). **The Convalescent** (Water-Colour)
London Catalogue: Page 96, No. 48.

(H. 9½—B. 6¼)

Lent by Dr. John W. MacIntyre.

(401). **Sea Beach and Figures** (Pastel)
London Catalogue: Page 96, No. 49.

(H. 5½—B. 10½)

Lent by Sir William Eden, Bart.

(402). **Nocturne, Cremorne Gardens, No. 3** (Oil)
London Catalogue: Page 96, No. 50.

(H. 17—B. 24)

Lent by C. Conder, Esq.

(403). **Arrangement in Grey, Portrait of Master Stephen Manuel** (Oil)
London Catalogue: Page 97, No. 51.

(H. 19¼—B. 14½)

Lent by Mrs. Manuel.

(404). **Bead Stringers, Venice** (Pastel)
London Catalogue: Page 97, No. 52.

(H. 10¼—B. 4)

Lent by Thomas Way, Esq.

(405). **Arrangement in Black, No. 2, Portrait of Mrs. Louis Huth** (Oil)
London Catalogue: Page 97, No. 53.

(H. 75—B. 39)

Lent by Louis Huth, Esq.

(406). **Marble Palace, Venice** (Pastel)
London Catalogue: Page 98, No. 54.

(H. 11—B. 5¼)

Lent by Thomas Way, Esq.

(407). **A Harmony in Blue and Silver** (Oil)
London Catalogue: Page 98, No. 55.

(H. 5—B. 8½)

Lent by His Honour Judge Evans.

(408). **A Venetian Water Gate** (Pastel on Brown Paper)
London Catalogue: Page 98, No. 56.

(H. 11—B. 7¼)

Lent by Lord Battersea.

(409). **Belle à jour, Blue and Violet** (Oil)
London Catalogue: Page 99, No. 57.

(H. 6½—B. 4)

Lent by Madame Blanche Marchesi.

(410). **Study of a Girl's Head and Shoulders** (Oil)
London Catalogue: Page 99, No. 58.

Lent by Baroness de Meyer. (H. 6—B. 3)

(411). **The Shop Window** (Oil)
London Catalogue: Page 99, No. 59.

Lent by A. Arnold Hannay, Esq. (H. 4¾—B. 8½)

(412). **A Venetian Courtyard** (Pastel)
 London Catalogue: Page 100, No. 61.
Lent by Lord Battersea. (H. 11½—B. 5½)

(413). **Nocturne in Green and Gold, The Falling Rocket** (Oil)
 London Catalogue: Page 100, No. 62.
 (H. 25—B. 30, outside the frame)
Lent by William Heinemann, Esq.
 Now owned by the Metropolitan Museum of Art.
 The only title on the back of the canvas is "Nocturne in Green and Gold" with the butterfly monogram below it at the right. The added title, "The Falling Rocket," which is given in the London Catalogue, is probably wrong as no rocket appears in the picture.

(414). **Annabel Lee** (Pastel)
 London Catalogue: Page 101, No. 63.
 (H. 12½—B. 6½)
Lent by Thomas Way, Esq.

(415). **The Sea, Pourville** (Oil)
 London Catalogue: Page 101, No. 64.
 (H. 4—B. 6½)
Lent by A. Arnold Hannay, Esq.

(416). **Portrait of Mrs. Louis Jarvis** (Oil)
 London Catalogue: Page 101, No. 65.
Lent by Mrs. A. M. Jarvis. (H. 23½—B. 16)

(417). **In the Channel** (Water-Colour)
 London Catalogue: Page 101, No. 66.
Lent by Mrs. Knowles.

(418). **Battersea** (Water-Colour)
 London Catalogue: Page 102, No. 67.
 (H. 3⅜—B. 4¾)
Lent by Sir William Eden, Bart.

(419). **Grey and Silver, Chelsea Wharf** (Oil)
London Catalogue: Page 102, No. 69.

(H. 23½—B. 17¾)

Lent by P. A. B. Widener, Esq.

(420). **Little Nude** (Pastel)
London Catalogue: Page 103, No. 70.

(H. 10—B. 5)

Lent by Thomas Way, Esq.

(421). **An Arrangement** in Black (Oil)
London Catalogue: Page 103, No. 71.

(H. 9¼—B. 7)

Lent by Alexander Henderson, Esq.

(422). **Dieppe** (Oil)
London Catalogue: Page 104, No. 72.

(H. 4½—B. 8)

Lent by Douglas Freshfield, Esq.

(423). **The Purple Cap** (Pastel)
London Catalogue: Page 104, No. 73.

(H. 10½—B. 6¼)

Lent by Thomas Way, Esq.

(424). **Study for the Head of Miss Cicely H. Alexander** (Oil)
London Catalogue: Page 104, No. 74.

Lent by Alexander Reid, Esq. (H. 10—B. 14½)

(425). **At the Piano** (Oil)
London Catalogue: Page 105, No. 75.

Lent by Edmund Davis, Esq. (H. 26—B. 35½)

(426). **Portrait of a Baby** (Oil)
London Catalogue: Page 105, No. 76.

Lent by Brandon Thomas, Esq. (H. 19½—B. 11¾)

(427). **Note in Red and Violet** (Oil)
 London Catalogue: Page 105, No. 77.

 (H. 4½—B. 8)
Lent by Miss Constance Halford.

Miss Constance Halford writes that she thinks this picture was painted at St. Ives, in Cornwall.

(428). **The Base of the Tower, Venice** (Pastel)
 London Catalogue: Page 106, No. 78.
 French Catalogue: Page 78, No. 164 (?).

 (H. 11½—B. 6¾)
Lent by J. P. Heseltine.

 No doubt the same picture, although the measurements in the two catalogues differ slightly.

(429). **The Blue Girl** (Pastel on Brown Paper)
 London Catalogue: Page 106, No. 79.

 (H. 10½—B. 6¾)
Lent by Madame Blanche Marchesi.

(430). **Variations in Violet and Green** (Oil)
 London Catalogue: Page 107, No. 81.

 (H. 23½—B. 12½)
Lent by Sir Charles McLaren, Bart.

(431). **Draped Model** (Black and White Chalk on Brown
 Paper)
 London Catalogue: Page 107, No. 82.
Lent by Mrs. Knowles. (H. 10⅜—B. 6⅞)

(432). **The Beach** (Water-Colour)
 London Catalogue: Page 108, No. 85.
Lent by Mrs. Knowles. (H. 8⅛—B. 4⅝)

(433). **Landscape** (Oil)
 London Catalogue: Page 108, No. 86.
Lent by Alexander Young, Esq. (H. 11¾—B. 24)

(434). **Study of Rosettes** (Black and Coloured Chalk on Brown Paper)
London Catalogue: Page 108, No. 87.

H. 11—B. 7)

Lent by Mrs. Knowles.

(435). **Portrait of L. A. Ionides, Esq.** (Oil)
London Catalogue: Page 109, No. 89.

(H. 15½—B. 11¾)

Lent by L. A. Ionides, Esq.

(436). **Nocturne, Chelsea Rags** (Oil)
London Catalogue: Page 109, No. 90.

(H. 14—B. 20)

Lent by John J. Cowan, Esq.

(437). **On the Thames at Chelsea** (Pastel)
London Catalogue: Page 109, No. 91.

(H. 10½—B. 6¼)

Lent by W. C. Alexander, Esq.
Mr. Alexander writes that the date of this picture is 1874 or 1875.

(438). **The Isles of Venice** (Pastel)
London Catalogue: Page 110, No. 92.

(H. 2—B. 10½)

Lent by W. Baptiste Scoones, Esq.

(439). **The General Dealer** (Oil)
London Catalogue: Page 110, No. 94.

(H. 4½—B. 8¼)

Lent by John J. Cowan, Esq.

(440). **The Lily** (Pastel)
London Catalogue: Page 111, No. 95.

(H. 13½—B. 9)

Lent by W. Bernard Knobel, Esq.

(441). **Portrait Sketch of F. R. Leyland** (Oil)
 London Catalogue: Page 111, No. 97.

(H. 14—B. 8¾)

Lent by Charles Conder, Esq.

(442). **Seated Figure** (Pastel)
 London Catalogue: Page 112, No. 99.

(H. 7½—B. 5)

Lent by Thomas Way, Esq.

(443). **Portrait of F. R. Leyland, Esq.** (Oil)
 London Catalogue: Page 113, No. 100.

(H. 72—B. 34)

Lent by Mrs. Val Prinsep.

(444). **A Freshening Breeze** (Oil)
 London Catalogue: Page 113, No. 101.

(H. 8½—B. 5)

Lent by John G. Ure, Esq.

(445). **Rose and Red: The Barber's Shop at Lyme-Regis**
 (Oil)
 London Catalogue: Page 113, No. 102.

(H. 4½—B. 8)

Lent by Humphrey Roberts, Esq.

Mr. Roberts writes, July, 1906: "I have parted with the picture to Messrs. Wm. Marchant & Co., 5 Regent Street, London.

(446). **Portrait of Dr. William McNeill Whistler** (Oil)
 London Catalogue: Page 114, No. 103.

(H. 17—B. 14)

Lent by Mrs. W. McNeill Whistler.

(447). **The Seashore** (Oil)
 London Catalogue: Page 114, No. 104.

(H. 3⅜—B. 5½)

Lent by Sir William Eden, Bart.

(448). **A Canal, Venice** (Water-Colour)
London Catalogue: Page 114, No. 105.
Lent by B. B. MacGeorge, Esq. (H. 8¾—B. 5¼)

(449). **Brown and Gold, The Cure's Little Class** (Oil)
London Catalogue: Page 115, No. 106.
Lent by John J. Cowan, Esq. (H. 4½—B. 8¼)

(450). **Petite bonne à la porte d'une Auberge** (Oil)
London Catalogue: Page 115, No. 107.
Lent by Mrs. H. S. Schwann. (H. 8⅜—B. 4¾)

(451). **Portrait of Miss Yvonne Forster** (Black and White
Chalk on Brown Paper)
London Catalogue: Page 115, No. 108.
Lent by Miss A. E. Forster. (H. 8⅛—B. 5¼)

(452). **Souvenir of the Gaiety** (Pastel)
London Catalogue: Page 116, No. 110.
Lent by Sir William Eden, Bart. (H. 4⅜—B. 6½)

(453). **Baby Leyland** (Pastel on Brown Paper)
London Catalogue: Page 116, No. 111.
Lent by Thomas Way, Esq. (H. 10—B. 6½)

(454). **A Little Red Note, Dordrecht** (Water-Colour)
London Catalogue: Page 119, No. 112.
Lent by W. Bryant, Esq. (H. 4¾—B. 8½)

(455). **Three Drawings in One Frame** (Pastel on Grey
Paper)
a. Model leaning forward, full length, lightly
draped, looking to right. (H. 9—B. 6)
b. Portrait of the Artist (Black Chalk on Brown
Paper). (H. 6—B. 5½)
c. Model with Flowers (Pastel and Chalk).
(H. 9¾—B. 6¾)
London Catalogue: Page 119, No. 113.
Lent by J. P. Heseltine, Esq.

(456). **A Grey Note** (Body Colour)
London Catalogue: Page 120, No. 114.

(H. 6—B. 10⅝)

Lent by Mrs. Knowles.

(457). **Study for Dress** (Pastel)
London Catalogue: Page 120, No. 115.

(H. 9¾—B. 5¾)

Lent by W. C. Alexander, Esq.
Mr. Alexander writes that this was drawn in 1875.

(458). **Design for a Fan** (Water-Colour)
London Catalogue: Page 120, No. 116.

(H. 6½—extreme B. 19¼)

Lent by C. H. Shannon, Esq.

(459). **Diana at the Pool** (Oil)
Copy of a picture in the Louvre by Boucher.
London Catalogue: Page 120, No. 117.

(H. 23—B. 27)

Lent by Louis W. Winans, Esq.

(460). **Blue and Gold** (Pastel)
London Catalogue: Page 121, No. 118.

(H. 11—B. 4¾)

Lent by Mrs. Knowles.

(461). **Venice** (Pastel)
London Catalogue: Page 121, No. 119.

(H. 9¾—B. 7)

Lent by Laurence W. Hodson, Esq.

(462). **Maude Reading, in a Hammock** (Water-Colour)
London Catalogue: Page 121, No. 120.

(H. 5¼—B. 8¾)

Lent by G. H. Buek, Esq.

(463). **St. Ives, Cornwall** (Water-Colour)
 London Catalogue: Page 122, No. 121.
Lent by Thomas Way, Esq. (H. 6¾—B. 4⅞)

(464). **Nocturne, Valparaiso, Silver and Gold** (Water-Colour)
 London Catalogue: Page 122, No. 122.
Lent by G. N. Stevens, Esq. (H. 8¾—B. 6½)

(465). **Study for the Peacock Room** (Pencil Drawing)
 London Catalogue: Page 122, No. 123.
Lent by A. Ludovici, Esq. (H. 6⅜—B. 6½)

(466). **Benedictine Monks, a Very Early Sketch** (Pen and Pencil)
 London Catalogue: Page 122, No. 124.
Lent by Mrs. W. McNeill Whistler.

(467). **Girl Reading** (Pen Sketch)
 London Catalogue: Page 123, No. 126.
Lent by William Heinemann, Esq. (H. 6—B. 4¾)

(468). **Two Sketches in One Frame** (Pen Drawing)
 Illustrations for "Thoughts at Sunrise," a song by Mrs. Moncrieff.
 (*a*). The sun is rising over a great lake, sprays of blossom and waving grass to right.
 (H. 6¾—B. 4¼)
 (*b*). The sun is rising over a great plain, a flight of birds from it toward the zenith. Blossoming boughs and waving grass to right.
 London Catalogue: Page 123, No. 127.
Lent by Mrs. Moncrieff. (H. 6¾—B. 4⅝)

(469). **La Toilette** (Pen Drawing on Blue Paper)
 London Catalogue: Page 124, No. 128.
Lent by Madame Blanche Marchesi. (H. 6¾—B. 4½)

(470). **Selsea Bill** (Water-Colour)
 London Catalogue: Page 124, No. 129.
Lent by B. B. MacGeorge, Esq. (H. 8½—B. 12)

(471). **A Marine Sunset** (Water-Colour)
 London Catalogue: Page 124, No. 130.
Lent by Thomas Way, Esq. (H. 5—B. 6½)

(472). **Pencil Drawing of Baby**
 London Catalogue: Page 125, No. 138.
Lent by Ll. J. W. Bebb, Esq.

(473). **Honfleur, Grey and Silver** (Water-Colour)
 London Catalogue: Page 125, No. 139.
Lent by Professor Emil Sauer. (H. 8—B. 4¾)

(474). **Crepuscule in Opal, Trouville** (Oil)
 London Catalogue: Page 125, No. 140.
Lent by Frederick Jameson, Esq. (H. 13—B. 18)

(475). **La Note Rouge** (Oil)
 London Catalogue: Page 126, No. 142.
 (H. 8¾—B. 11¾)
Lent by Sir George A. Drummond, K.C.B.

(476). **Drawing of Elderly Woman, with Inscription
 "James to Aunt Kate, 1844"**
 (*Whistler:* Théodore Duret, page 1, reproduction.)

(477). **Sketch of Miss Grace Alexander**
 (*Whistler:* Théodore Duret, page 34, mention; page
 111, illustration.)

(478). **Sketch for Portrait of Miss Alexander [Agnes
 Mary] Full Length**
 (*Whistler:* Théodore Duret, page 37, reproduction.)

(479). **Sketch for Portrait of Miss Alexander [Agnes
 Mary] Half Length**
 (*Whistler:* Théodore Duret, page 38, reproduction.)

(480). **Copy of the Andromeda by Ingres** (Oil)
> (Exhibited at the Keppel Galleries in New York in 1905.)

(481). **Harmony in Blue and Gold:**
The Peacock Room (Oil)
> (Exhibited at Messrs. Obach's Galleries, London, June, 1904.)

(482). **Portraits of Fanny, Florence and Elinor Leyland** (in Oil, unfinished)
> (*Whistler:* Théodore Duret, page 48, mention.)

(483). **Portrait of Florence Leyland** (Ink)
> (*Whistler:* Théodore Duret, page 53, reproduction.)

(484). **Harmony in Grey and Rose: Portrait of Lady Meux**
> (*Whistler:* Théodore Duret, page 95, mention; page 102, reproduction.)

(485). **Arrangement in Black and White: Portrait of Lady Meux**
> (Exhibited at the Salon of 1882. In the Salon Catalogue it is wrongly listed as *Portrait of M. Harry Men.* Also reproduced in Duret's *Whistler,* facing page 152.)

(486). **Portrait of Lady Archibald Campbell** (now called *The Lady with the Yellow Buskin*)
> (In the W. P. Wilstach Collection, Philadelphia, Pa.)

(487). **Sketch for Unexecuted or Destroyed Picture**
> (*Whistler:* Théodore Duret, page 6, reproduction.)

(488). **Portrait of Lady Colin Campbell, Harmony in Ivory White** (Oil)
> (Exhibited at the Society of British Artists in 1886.)

(489). **Portrait of Mrs. Walter Sickert, Arrangement in Violet and Rose** (Oil)
> (Exhibited at the Society of British Artists in 1887.)

(490). **Miss Connie Gilchrist**
(Listed in *Whistler:* By H. W. Singer, No. 32.)

(491). **Purple and Gold: Phryne the Superb, Builder of Temples**
(Exhibited at the Albright Gallery, Buffalo, 1905.)

(492). **Die Lange Leizen, of the Six Marks**
(Exhibited at the Royal Academy, 1864.)
Now in the John G. Johnson collection.

(493). **Wapping**
(Exhibited at the Royal Academy, 1864.)

(494). **Alone with the Tide** (Oil)
(Exhibited at the Royal Academy, 1862.)

(495). **Harmony in Amber and Black**
(Exhibited at the Grosvenor Gallery, 1877.)

(496). **Arrangement in Black and White, No. 1, L'Americaine**
(Exhibited at the Grosvenor Gallery, 1878, and at the Comparative Exhibition of Native and Foreign Art, New York, 1904.)

(497). **Arrangement in Yellow and Gray**
(Amsterdam Museum.)

(498). **Portrait of Lady E., Brown and Gold**
(Exhibited at the Champs de Mars, 1894.)

(499). **Gold and Orange: The Neighbour**
(Exhibited at the International Society of Sculptors, Painters and Gravers, 1901.)

(500). **Arrangement in Flesh Colour and Red**
(*Whistler:* Théodore Duret, page 157, reproduction.)

(501). **Pen and Ink Sketch. Girl's Head in Profile**
(*Whistler:* Théodore Duret, page 167, reproduction.)

(502). **Study in India Ink, a Head**
(*Whistler:* Théodore Duret, page 198, reproduction.)

(503). **Sketch**
(*Whistler:* Théodore Duret, last page, reproduction.)

(504). **Symphony in Grey—Early Morning, Thames**
(Exhibited at the Comparative Exhibition of Native and Foreign Art, New York, 1904.)

(505). **Southend, The Pleasure Yacht** (Water-Colour)
(*The Art of J. McNeill Whistler:* T. R. Way and G. R. Dennis, page 96.)

(506). **London Bridge** (Water-Colour)
(*The Art of J. McNeill Whistler:* T. R. Way and G. R. Dennis, page 96.)

(507). **The Ermine Coat** (Pastel?)
(Exhibited at the Goupil Gallery, 1904.)

(508). **Mrs. Leyland, Seated, Back** (Pen and Ink)
(*Whistler:* Théodore Duret, page 131, reproduction.)

(509). **Pen and Ink Sketch of Woman Standing**
(*Whistler:* Théodore Duret, page 147, reproduction.)

(510). **St. Paul's:** (Pen and Ink.) "The feather end of the quill pen was used as a brush for the washes."
(*Whistler as I Knew Him:* Mortimer Menpes. Facing page 23.)

(510a). **The Lady in Grey** (Body-Colour)
A standing figure dressed in grey, against a very dark grey background. A large hat in the right hand. Butterfly more than a third of the way up, on the right.
(Owned by the Metropolitan Museum of Art.)
(H. 10¾—B. 4⅞.)

(511) **Lady Meux** (Pen and Ink)
 (*Whistler as I Knew Him:* Mortimer Menpes. Facing page 20.)

(512). **A Bye Canal, Venice** (Pastel)
 (*Whistler as I Knew Him:* Mortimer Menpes. Facing page 26.)

(513). **Dorothy Menpes** (Oil)
 (*Whistler as I Knew Him:* Mortimer Menpes. Facing page 44.)

(514). **Master Menpes** (Oil)
 (*Whistler as I Knew Him:* Mortimer Menpes. Facing page 88.)

(515). **A Study in Rose and Brown** (Oil)
 (*Whistler as I Knew Him:* Mortimer Menpes. Facing page 128.)

(516). **Pen and Ink Sketch for the Portrait of Lady Meux in Grey and Rose:** (Signed Twice with the Butterfly.)
 (In the possession of Howard Mansfield, Esq.)

(517). **Small Drawing of a Woman's Figure** (Nude)
 (In the possession of the Baroness de Meyer.)

(518). **Small Sea-scape of the Dieppe Beach**
 (In the possession of the Baroness de Meyer.)

(519). **Mother and Child: Pastel; Date, 1885**
 (In the possession of William Burrell, Esq.)

(520). **Drawing in Ink or Sepia, 1851 or 1852**
 A fiddler is playing while a number of men are dancing and others look on.
 (In the possession of Miss Mary Park.)

(521). Drawing in Ink or Sepia, 1851 or 1852
A man sitting with legs crossed on a beer keg.
(In the possession of Miss Mary Park.)

(522). Symphony in Blue (Oil)
(In the possession of Mrs. John L. Gardner.)

(523). Trouville (Oil)
(In the possession of Mrs. John L. Gardner.)

(524). Study of a Cat (Sketch)
(In the possession of Howard Mansfield, Esq.)

(525). "Price's Candle Works"—Battersea. Symphony in Blue (Pastel)
A view of the Thames at Battersea. The horizon
line is an intense blue with pale yellow lights and re-
flections in the water. Butterfly monogram in lower
right corner. Some lines of purple at the left of the
butterfly. (H. $4\frac{7}{16}$—B. $13\frac{1}{4}$.)
(In the possession of William Macbeth, Esq.)

(526). Portrait of R. A. Canfield, Esq. (Oil)
(In the possession of R. A. Canfield, Esq.)

(527). Portrait of the Artist International Exhibition 1900

(528.) La Napolitaine—Rose and Or (Oil)
A half length full-face view of dark-haired, dark-
eyed woman in a rose-coloured dress with dark trim-
mings at the neck. The dress is cut away from the
throat in a V shaped opening showing a single row of
coral beads. The eyes are turned a little to the spec-
tator's left. The hands do not show. Dark golden
brown background. Never exhibited.
H. $19\frac{1}{4}$ B. $11\frac{1}{8}$ (inside the frame.)
Owned by R. A. Canfield, Esq.

A LIST OF
WHISTLER'S LITHOGRAPHS

A LIST OF
WHISTLER'S LITHOGRAPHS

Compiled from the Catalogues of the Memorial Exhibitions at Boston,
London and Paris in 1904 and 1905.

The letter W preceding the number at the right refers
to the catalogue by Thomas R. Way, Second Edition, 1905,
George Bell and Sons, London; H. Wunderlich and Com-
pany, New York. In the catalogues of the Memorial Exhi-
bitions the titles of the lithographs are frequently different
from those used by Mr. Way, a fact that makes for more or
less confusion. In the subjoined list an attempt has been
made to identify the subjects of the Memorial Catalogues
with those of Mr. Way's Catalogue and supply the correct
Way number where it does not already appear.

(1). **Study, Figure of a Lady** W 1
 London Catalogue: Page 49, No. 1.

(2). **Study, Female Figure** W 2
 London Catalogue: Page 49, No. 2.

(3). **Study, Female Figure** W 3
 London Catalogue: Page 49, No. 3.

(4). **Limehouse** W 4
 Boston Catalogue: Page 24, No. 1.
 Paris Catalogue: Page 87, No. 188.
 London Catalogue: Page 49, No. 4.

(5). **Nocturne** W 5
 Boston Catalogue: Page 24, No. 2.
 Paris Catalogue: Page 87, No. 189.
 London Catalogue: Page 49, No. 5.

(6). **The Toilet** W 6
 Boston Catalogue: Page 24, No. 3.
 London Catalogue: Page 49, No. 6.

(7). **Early Morning** W 7
 Boston Catalogue: Page 24, No. 4.
 Paris Catalogue: Page 87, No. 190.
 London Catalogue: Page 49, No. 7.

(8). **The Broad Bridge** W 8
 London Catalogue: Page 49, No. 8.

(9). **The Tall Bridge** W 9
 Boston Catalogue: Page 24, No. 6.
 London Catalogue: Page 49, No. 9.

(10). **Gaiety Stage Door** W 10
 Paris Catalogue: Page 87, No. 191.
 London Catalogue: Page 49, No. 10.

(11). **Victoria Club** W 11
 Paris Catalogue: Page 87, No. 192.
 London Catalogue: Page 49, No. 11.

(12). **Old Battersea Bridge** W 12
 Boston Catalogue: Page 24, No. 7.
 Paris Catalogue: Page 87, No. 193.
 London Catalogue: Page 49, No. 12.

(13). **Reading** W 13
 Boston Catalogue: Page 24, No. 8.
 London Catalogue: Page 49, No. 13.

(13a). Sketches (Drawn on Stone Later Cleaned) W 13a
 Boston Catalogue: Page 24, No. 9.
 London Catalogue: Page 49, No. 13a.

(14). The Fan W 14
 London Catalogue: Page 49, No. 14.

(15). Study, Classical Figure, Lightly Draped W 15
 London Catalogue: Page 49, No. 15.

(16). Entrance Gate, St. Bartholomew's W 16
 Paris Catalogue: Page 87, No. 194.
 London Catalogue: Page 49, No. 16.

(17). Churchyard W 17
 Boston Catalogue: Page 24, No. 10.
 Paris Catalogue: Page 87, No. 195.
 London Catalogue: Page 49, No. 17.

(18). Little Court, Cloth Fair W 18
 Paris Catalogue: Page 87, No. 196.
 London Catalogue: Page 50, No. 18.

(19). Lindsay Row, Chelsea W 19
 Paris Catalogue: Page 87, No. 197.
 London Catalogue: Page 50, No. 19.

(20). Chelsea Shops W 20
 Paris Catalogue: Page 87, No. 198.
 London Catalogue· Page 50, No. 20.

(21). Drury Lane Rags W 21
 Paris Catalogue: Page 88, No. 199.
 London Catalogue: Page 50, No. 21.

(22). Chelsea Rags W 22
 Boston Catalogue: Page 25, No. 11.
 Paris Catalogue: Page 88, No. 200.
 London Catalogue: Page 50, No. 22.

(23). **Courtyard, Chelsea Hospital** W 23
 Boston Catalogue: Page 25, No. 12.
 London Catalogue: Page 50, No. 23.

(24). **The Farriers** W 24
 London Catalogue: Page 50, No. 24.

(25). **The Winged Hat** W 25
 Boston Catalogue: Page 25, No. 13.
 Paris Catalogue: Page 88, No. 202.
 London Catalogue: Page 50, No. 25.

(26). **Gants de Suède** W 26
 Boston Catalogue: Page 25, No. 14.
 Paris Catalogue: Page 88, No. 203.
 London Catalogue: Page 50, No. 26.

(27). **The Tyresmith** W 27
 Boston Catalogue: Page 25, No. 15.
 Paris Catalogue: Page 88, No. 204.
 London Catalogue: Page 50, No. 27.

(28). **Maunder's Fish-Shop, Chelsea** W 28
 Boston Catalogue: Page 25, No. 16.
 Paris Catalogue: Page 88, No. 205.
 London Catalogue: Page 50, No. 28.

(29). **The Little Nude Model, Reading** W 29
 Boston Catalogue: Page 25, No. 17.
 Paris Catalogue: Page 88, No. 206.
 London Catalogue: Page 50, No. 29.

(30). **The Dancing Girl** W 30
 Boston Catalogue: Page 25, No. 18.
 Paris Catalogue: Page 88, No. 207.
 London Catalogue: Page 50, No. 30.

(31). **The Model Draping** W 31
 Paris Catalogue: Page 88, No. 208.
 London Catalogue: Page 50, No. 31.

(32). **The Horoscope** W 32
 Boston Catalogue: Page 25, No. 19.
 Paris Catalogue: Page 89, No. 209.
 London Catalogue: Page 50, No. 32.

(33). **The Novel. Girl Reading** W 33
 Boston Catalogue: Page 25, No. 20.
 Paris Catalogue: Page 89, No. 211.
 London Catalogue: Page 50, No. 33.

(34). **Gatti's** W 34
 London Catalogue: Page 50, No. 34.

(35). **Hotel Colbert Windows** W 35
 Paris Catalogue: Page 89, No. 211.
 London Catalogue: Page 50, No. 35.

(36). **Cock and Hens, Hotel Colbert** W 36
 Paris Catalogue: Page 89, No. 212.
 London Catalogue: Page 50, No. 36.

(37). **Staircase** W 37
 London Catalogue: Page 50, No. 37.

(38). **The Garden** W 38
 Boston Catalogue: Page 25, No. 21.
 Paris Catalogue: Page 89, No. 213.
 Called in Paris Catalogue "Le Thé" (The Tea Party.)
 London Catalogue: Page 50, No. 38.

(39). Vitré—The Canal in Brittany W 39
 Boston Catalogue: Page 26, No. 22.
 Paris Catalogue: Page 89, No. 214.
 London Catalogue: Page 50, No. 39.

(40). The Market Place—Vitré W 40
 Boston Catalogue: Page 26, No. 23.
 Paris Catalogue: Page 89, No. 215.
 London Catalogue: Page 50, No. 40.

(41). Gabled Roofs—Vitré W 41
 Paris Catalogue: Page 89, No. 216.
 London Catalogue: Page 50, No. 41.

(42). The Clock-Makers, Paimpol W 42
 Boston Catalogue: Page 26, No. 24.
 Paris Catalogue: Page 89, No. 217.

(43). The Steps. Luxembourg W 43
 Boston Catalogue: Page 26, No. 25.
 Paris Catalogue: Page 89, No. 218.
 London Catalogue: Page 50, No. 43.

(44). Conversation Under the Statue—
 Luxembourg Gardens W 44
 Paris Catalogue: Page 89, No. 219.
 London Catalogue: Page 50, No. 44.

(45). The Pantheon from the Terrace
 of the Luxembourg Gardens W 45
 Paris Catalogue: Page 90, No. 220.
 London Catalogue: Page 51, No. 45.

(46). The Draped Figure—Seated W 46
 Boston Catalogue: Page 26, No. 26.
 Paris Catalogue: Page 90, No. 221.
 London Catalogue: Page 51, No. 46.

(47). **Nude Model Reclining** W 47
 Paris Catalogue: Page 90, No. 222.
 London Catalogue: Page 51, No. 47.

(48). **Nursemaids "Les Bonnes du Luxembourg"** W 48
 Boston Catalogue: Page 26, No. 27.
 Paris Catalogue: Page 90, No. 223.
 London Catalogue: Page 51, No. 48.

(49). **The Long Balcony** W 49
 Paris Catalogue: Page 90, No. 224.
 London Catalogue: Page 51, No. 49.

(50). **The Little Balcony** W 50
 Paris Catalogue: Page 90, No. 225.
 London Catalogue: Page 51, No. 50.

(51). **Little Draped Figure, Leaning** W 51
 Paris Catalogue: Page 90, No. 226.
 London Catalogue: Page 51, No. 51.

(52). **The Long Gallery, Louvre** W 52
 Boston Catalogue: Page 26, No. 28.
 Paris Catalogue: Page 90, No. 227.
 London Catalogue: Page 51, No. 52.

(53). **The Whitesmiths, Impasse des Carmélites** W 53
 Boston Catalogue: Page 26, No. 29.
 Paris Catalogue: Page 90, No. 228.
 London Catalogue: Page 51, No. 53.

(54). **Tête-à-Tête in the Garden** W 54
 Paris Catalogue: Page 91, No. 229.
 London Catalogue: Page 51, No. 54.

(55). **The Terrace, Luxembourg** W 55
 Paris Catalogue: Page 91, No. 230.
 London Catalogue: Page 51, No. 55.

(56). The Little Café au Bois W 56
Paris Catalogue: Page 91, No. 231.
London Catalogue: Page 51, No. 56.

(57). Late Picquet W 57
Paris Catalogue: Page 91, No. 232.
London Catalogue: Page 51, No. 57.

(58). The Laundress. La Blanchisseuse de la Place Dau-
phine W 58
Boston Catalogue: Page 26, No. 30.
Paris Catalogue: Page 91, No. 233.
London Catalogue: Page 51, No. 58.

(59). Rue Furstenburg W 59
Boston Catalogue: Page 26, No. 31.
Paris Catalogue: Page 91, No. 234.
London Catalogue: Page 51, No. 59.

(60). Confidences in the Garden W 60
Paris Catalogue: Page 91, No. 235.
London Catalogue: Page 51, No. 60.

(61). La Jolie New-Yorkaise W 61
Paris Catalogue: Page 91, No. 236.
London Catalogue: Page 51, No. 61.

(62). La Belle Dame Paresseuse W 62
Boston Catalogue: Page 26, No. 32.
Paris Catalogue: Page 91, No. 237.

(63). La Belle Jardinière W 63
Boston Catalogue: Page 27, No. 33.
Paris Catalogue: Page 91, No. 238.
London Catalogue: Page 51, No. 63.

(64). **The Duet** W. 64
 Boston Catalogue: Page 27, No. 34.
 Paris Catalogue: Page 91, No. 239.
 London Catalogue: Page 51, No. 64.

(65). **The Duet, No. 2.** W 65
 Paris Catalogue: Page 91, No. 240.

(66). **Stéphane Mallarmé** W. 66
 Boston Catalogue: Page 27, No. 35.
 Paris Catalogue: Page 91, No. 241.
 London Catalogue: Page 51, No. 66.

(67). **The Draped Figure, Back View** W 67
 Paris Catalogue: Page 92, No. 242.

(68). **La Robe Rouge** W. 68
 Boston Catalogue: Page 27, No. 36.
 Paris Catalogue: Page 92, No. 243.
 London Catalogue: Page 52, No. 68.

(69). **La Belle Dame Endormie** W 69
 Boston Catalogue: Page 27, No. 37.
 Paris Catalogue: Page 92, No. 244.
 London Catalogue: Page 52, No. 69.

(70). **La Fruitière de la Rue de Grenelle** W 70
 Boston Catalogue: Page 27, No. 38.
 Paris Catalogue: Page 92, No. 245.
 London Catalogue: Page 52, No. 70.

(71). **The Sisters** W 71
 Boston Catalogue: Page 27, No. 39.
 London Catalogue: Page 71.

(72). **The Forge. Passage du Dragon** W. 72
 Boston Catalogue: Page 27, No. 40.
 Paris Catalogue: Page 92, No. 246.
 London Catalogue: Page 52, No. 72.

(73). **The Smith, Passage du Dragon** W 73
 Boston Catalogue: Page 27, No. 41.
 Paris Catalogue: Page 92, No. 247.
 London Catalogue: Page 52, No. 73.

(74). **The Priest's House—Rouen** W 74
 Boston Catalogue: Page 27, No. 42.
 Paris Catalogue: Page 92, No. 248.
 London Catalogue: Page 52, No. 74.

(75). **A Portrait** W 75
 Boston Catalogue: Page 27, No. 43.
 London Catalogue: Page 52, No. 75.

(76). **Figure Study** W 76
 Boston Catalogue: Page 28, No. 44.
 London Catalogue: Page 52, No. 76.

(77). **Study** W 77
 London Catalogue: Page 52, No. 77.

(78). **The Doctor** W 78
 Boston Catalogue: Page 28, No. 45.
 Paris Catalogue: Page 92, No. 249.
 London Catalogue: Page 52, No. 78.

(79). **Walter Sickert** W 79
 Boston Catalogue: Page 28, No. 46.
 London Catalogue: Page 52, No. 79.

(80). **Mother and Child—No. 1.** W 80
 Boston Catalogue: Page 28, No. 47.
 Paris Catalogue: Page 92, No. 250.
 London Catalogue: Page 52, No. 80.

(81). **Back of the Gaiety Theatre** W 81
 Paris Catalogue: Page 92, No. 251.
 London Catalogue: Page 52, No. 81.

(82). **Girl with Bowl** W 82
 Paris Catalogue: Page 92, No. 252.
 London Catalogue: Page 52, No. 82.

(83). **The Little Doorway, Lyme-Regis** W 83
 Boston Catalogue: Page 28, No. 48.
 Paris Catalogue: Page 92, No. 253.
 London Catalogue: Page 52, No. 83.

(84). **The Master Smith** W 84
 Paris Catalogue: Page 92, No. 254.
 London Catalogue: Page 52, No. 84.

(85). **The Sunny Smithy** W 85
 Paris Catalogue: Page 93, No. 255.
 London Catalogue: Page 52, No. 85.

(86). **The Good Shoe** W 86
 Paris Catalogue: Page 93, No. 256.
 London Catalogue: Page 52, No. 86.

(87). **Father and Son** W 87
 Paris Catalogue: Page 93, No. 257.
 London Catalogue: Page 52, No. 87.

(88). **The Smith's Yard** W 88
 Boston Catalogue: Page 28, No. 49.
 Paris Catalogue: Page 93, No. 258.
 London Catalogue: Page 52, No. 88.

(89). **The Strong Arm** W 89
 Paris Catalogue: Page 93, No. 259.
 London Catalogue: Page 52, No. 89.

(90). **The Blacksmith** W 90
 Paris Catalogue: Page 93, No. 260.
 London Catalogue: Page 53, No. 90.

(91). **The Brothers** W 91
 Boston Catalogue: Page 28, No. 50.
 Paris Catalogue: Page 93, No. 261.
 London Catalogue: Page 53, No. 91.

(92). **The Fair** W 92
 Boston Catalogue: Page 28, No. 51.
 Paris Catalogue: Page 93, No. 262.
 Called in Paris Catalogue: Lyme-Regis—The
 Fair.
 London Catalogue: Page 53, No. 92.

(93). **John Grove** W 93
 Boston Catalogue: Page 28, No. 52.
 London Catalogue: Page 53, No. 93.

(94). **The Little Steps. Lyme-Regis** W 94
 Boston Catalogue: Page 28, No. 53.
 Paris Catalogue: Page 93, No. 263.
 London Catalogue: Page 53, No. 94.

(95). **Study of a Horse** W 95
 London Catalogue: Page 53, No. 95.

(96). **Sunday—Lyme-Regis** W 96
 Boston Catalogue: Page 28, No. 54.
 Paris Catalogue: Page 93, No. 264.
 London Catalogue: Page 53, No. 96.

(97). **The Fifth of November** W 97
 Paris Catalogue: Page 93, No. 265.
 London Catalogue: Page 53, No. 97.

(98). **The Old Smith's Story** W 98
 Paris Catalogue: Page 93, No. 266.
 London Catalogue: Page 53, No. 98.

(99). **Figure Study in Colors** W 99
 Boston Catalogue: Page 29, No. 55.
 London Catalogue: Page 53, No. 99.

(100). **Red House, Paimpol** W 100
 Boston Catalogue: Page 29, No. 56.
 Paris Catalogue: Page 95, No. 285.
 London Catalogue: Page 53, No. 100.

(101). **Yellow House, Lannion** W 101
 Boston Catalogue: Page 29, No. 57.
 Paris Catalogue: Page 95, No. 286.
 London Catalogue: Page 53, No. 101.

(102). **Mother and Child—No. 2.** W 102
 Boston Catalogue: Page 29, No. 58.
 Paris Catalogue: Page 93, No. 267.
 London Catalogue: Page 53, No. 102.

(103). **Firelight—Mrs. Pennell** W 103
 London Catalogue: Page 53, No. 103.

(104). **Firelight—Joseph Pennell, No. 1.** W 104
 London Catalogue: Page 53, No. 104.

(105). **Firelight—Joseph Pennell, No. 2.** W 105
 London Catalogue: Page 53, No. 105.

(106). **The Barber's Shop in the Mews** W 106
 London Catalogue: Page 53, No. 106.

(107). **Portrait of T. Way, No. 1.** W 107
 London Catalogue: Page 53, No. 107.

(108). **Portrait of T. Way, No. 2.** W 108
 London Catalogue: Page 53, No. 108.

(109). **Kensington Gardens** W 109
 Boston Catalogue: Page 29, No. 59.
 London Catalogue Page 53, No. 109.

(110). **Little Evelyn** W 110
 Boston Catalogue: Page 29, No. 60.
 London Catalogue: Page 53, No. 110.

(111). **Study—Joseph Pennell, No. 3.** W 111
 Boston Catalogue: Page 29, No. 61.
 London Catalogue: Page 54, No. 111.

(112). **The Russian Schube—Portrait of Joseph Pennell,**
 No. 4. W 112
 London Catalogue: Page 53, No. 112.

(113). **Needlework** W 113
 Boston Catalogue: Page 29, No. 62.
 Paris Catalogue: Page 94, No. 268.
 London Catalogue: Page 54, No. 113.

(114). **The Manager's Window—Gaiety Theatre** W 114
 Boston Catalogue: Page 29, No. 63.
 Paris Catalogue: Page 94, No. 269.
 London Catalogue: Page 54, No. 114.

(115). **Little Dorothy** W 115
 London Catalogue: Page 54, No. 115.

(116). **Portrait Study** W 116
 London Catalogue: Page 54, No. 116.

(117). **Portrait Study—A Young Man** W 117
 London Catalogue: Page 54, No. 117.

(118). **Savoy Pigeons** W 118
 Boston Catalogue: Page 29, No. 64.
 Paris Catalogue: Page 94, No. 270.
 London Catalogue: Page 54, No. 118.

(119). **Evening—Little Waterloo Bridge** W 119
 Boston Catalogue: Page 30, No. 65.
 Paris Catalogue: Page 94, No. 271.
 London Catalogue: Page 54, No. 119.

(120). **Charing Cross Railway Bridge** W 120
Boston Catalogue: Page 30, No. 66.
Paris Catalogue: Page 94, No. 272.
London Catalogue: Page 54, No. 120.

(121). **Little London** W 121
Boston Catalogue: Page 30, No. 67.
Paris Catalogue: Page 94, No. 273.
London Catalogue: Page 54, No. 121.

(122). **The Siesta** W 122
London Catalogue: Page 54, No. 122.

(123). **Waterloo Bridge** W 123
Boston Catalogue: Page 30, No. 68.
Paris Catalogue: Page 94, No. 274.
London Catalogue: Page 54, No. 123.

(124). **By the Balcony** W 124
London Catalogue: Page 54, No. 124.

(125). **The Thames** W 125
Boston Catalogue: Page 30, No. 69.
Paris Catalogue: Page 94, No. 275.
London Catalogue: Page 54, No. 125.

(126). **St. Anne's—Soho** W 126
Boston Catalogue: Page 30, No. 70.
Paris Catalogue: Page 94, No. 276.
London Catalogue: Page 54, No. 126.

(127). **Sketch of Mr. Henley** W 127
Boston Catalogue: Page 30, No. 71.
London Catalogue: Page 54, No. 127.

(128). **The Butcher's Dog** W 128
Boston Catalogue: Page 30, No. 72.
Paris Catalogue: Page 94, No. 277.
London Catalogue: Page 54, No. 128.

(129). **St. Giles-in-the-Fields** W 129
Boston Catalogue: Page 30, No. 73.
Paris Catalogue: Page 94, No. 278.
London Catalogue: Page 54, No. 129.

(130). **Little London Model** W 130
London Catalogue: Page 54, No. 130.

(131). **Maude Seated—A Lady in a Big Chair** W 131
London Catalogue: Page 55, No. 133.

(132). **Old Battersea Bridge, No. 2** W 132
London Catalogue: Page 59, No. 145.

(133). **Fireplace—Vitré** W 133
Boston Catalogue: Page 31, No. 80.
London Catalogue: Page 54, No. 131.

(134). **Mother and Child, No. 3** W 134
Paris Catalogue: Page 95, No. 280.
London Catalogue: Page 56, No. 135.

(135). **Mother and Child, No. 4** W 135
London Catalogue: Page 57, No. 139.
(Description differs in London Catalogue.)

(136). **Mother and Child, No. 5** W 136
London Catalogue: Page 57, No. 140.
(Description differs in London Catalogue.)

(137). **Portrait of M. le Comte de Montesquiou, No. 1**

W 137
London Catalogue: Page 58, No. 144.

(138). **Comte de Montesquiou, No. 2** W 138
London Catalogue: Page 60, No. 149.

(139). **Count Robert de Montesquiou, No. 3** W 139
(Not exhibited at the Boston, London or Paris memorials.)

(140). **The Garden Porch—Le Jardin, Rue du Bac, No. 2**
W 140

Paris Catalogue: Page 95, No. 281.
London Catalogue: Page 56, No. 137.

(141). **The Man with a Sickle—Le Jardin, Rue du Bac, No. 1**
W 141
Paris Catalogue: Page 94, No. 279.
London Catalogue: Page 55, No. 134.

(142). **Dr. Whistler, No. 2**
W 142
London Catalogue: Page 58, No. 143.

(143). **The Black Bonnet—Perhaps "Unfinished Sketch of Lady Haden."**
W 143
London Catalogue: Page 58, No. 142.

(144). **Two Sketches**
W 144
London Catalogue: Page 56, No. 136.

(145). **A Smith of Lyme-Regis**
W 145
London Catalogue: Page 57, No. 141.

(146). **Two Slight Sketches**
W 146
London Catalogue: Page 57, No. 138.

(147). **Afternoon Tea**
W 147
Boston Catalogue: Page 30, No. 74.
Paris Catalogue: Page 95, No. 282.
London Catalogue: Page 59, No. 146.

(148). **La Danseuse**
W 148
London Catalogue: Page 55, No. 132.

(149). **Portrait Study: Miss Charlotte R. Williams** W 149
(Not in Boston, London or Paris memorial catalogues.)

(150). **Stéphane Mallarmê, No. 2** W 150
 (Not in Boston, London or Paris memorial cata-
 logues.)

(151). **The Shoe-Maker** ,W 151
 Paris Catalogue: Page 95, No. 283.
 London Catalogue: Page 59, No. 147.

(152). **A Lady Seated** W 152
 Boston Catalogue: Page 30, No. 75.

(153). **The Medici Collar** W 153
 (Not in Boston, London or Paris memorial cata-
 logues.)

(154). **Nude Model, Standing** W 154
 (Not in Boston, London or Paris memorial cata-
 logues.)

(155). **Draped Figure, Standing** W 155
 London Catalogue: Page 60, No. 151.

(156). **Draped Figure, Reclining** W 156
 Boston Catalogue: (Girl on couch) Page 31, No. 76.
 London Catalogue: Page 61, No. 152.

(157). **Lady and Child** W 157
 Paris Catalogue: Page 95, No. 287, or 288?

(158). **The Cap** W 158
 Boston Catalogue: Page 31, No. 77 or 78.

(159). **The Girl** ,W 159
 Boston Catalogue: Page 31, No. 77 or 78.

(160). **Two Sketches** W 160
 London Catalogue: Page 60, No. 148.

(161). The Fur Jacket ,W. 161

 Boston Catalogue: Page 31, No. 79.

 (Not in Way Catalogue, 1905 Edition.)

Numbers 287 and 288 of the Paris Catalogue, Page 95, are given simply as Colour Study No. 1, and Colour Study No. 2, without a Way number. They probably appear in the new edition of the Way Catalogue but are not easy to identify as no description of them is given in the Paris Catalogue.

A LIST OF
WHISTLER'S ETCHINGS

A LIST OF

WHISTLER'S ETCHINGS

SHOWN AT THE MEMORIAL EXHIBITIONS AT BOSTON, LONDON AND PARIS IN 1904 AND 1905, AND BY THE GROLIER CLUB IN 1904.

Compiled from the Catalogues of the Exhibitions, with the few numbers not shown added.*

The letter W before the number on the right refers to the Wedmore catalogue, the letter S to the Supplement by an Amateur and the letter G to the Grolier Club catalogue of 1904.

Only the subjects are given. The two noble monuments to Whistler's fame as an etcher, the catalogue to be published by the Grolier Club and Mr. Howard Mansfield's catalogue for the Caxton Club, will contain the results of indefatigable research and care in the compilation of all obtainable data. As in the case of the lithographs, the names and descriptions of the plates have sometimes differed in the various catalogues. It is hoped that in the present lists a reasonable degree of accuracy has been attained in giving to each title its correct Wedmore, supplement, or Grolier number. So large a proportion of the subjects were in the Grolier Club Exhibition, that when a subject was exhibited at any one of the Memorial Exhibitions and not at the Grolier Club, a note has been made to that effect.

Where Grolier Club follows the title of a subject, it indicates that the subject was exhibited at the Grolier Club only, and not at the Memorial Exhibitions.

(1). **Early Portrait of Whistler** W 1
 Grolier Club. No. 1.
 From the Wedmore Catalogue.

(2). **Annie Haden** W 2
 Grolier Club. No. 2.

(3). **The Dutchman Holding the Glass** W 3
 Grolier Club. No. 3.

(4). **Liverdun** W 4
 Boston Catalogue: Page 3, No. 1.
 London Catalogue: Page 21, No. 4.

(5). **La Rétameuse (The Tinker Woman)** W 5
 Boston Catalogue: Page 3, No. 2.
 Paris Catalogue: Page 101, No. 291.
 London Catalogue: Page 21, No. 5.

(6). **En Plein Soleil** W 6
 London Catalogue: Page 21, No. 6.

(7). **The Unsafe Tenement** W 7
 Boston Catalogue: Page 3, No. 3.
 Paris Catalogue: Page 101, No. 296.
 London Catalogue: Page 21, No. 7.

(8). **The Dog on the Kennel** W 8
 London Catalogue: Page 21, No. 8.

(9). **La Mère Gérard** W 9
 Paris Catalogue: Page 101, No. 292.
 London Catalogue: Page 21, No. 9.

(10). **La Mère Gérard, Stooping** W 10
 Grolier Club. No. 11.

(11). **Street at Saverne** W 11
 Boston Catalogue: Page 3, No. 6.
 Paris Catalogue: Page 101, No. 293.
 London Catalogue: Page 21, No. 11.

(12). **Gretchen at Heidelberg** W 12
Boston Catalogue: Page 3, No. 7.

(13). **Little Arthur** W 13
Paris Catalogue: Page 101, No. 294.
London Catalogue: Page 21, No. 13.

(14). **La Vielle aux Loques** W 14
Boston Catalogue: Page 3, No. 8.
Paris Catalogue: Page 101, No. 295.
London Catalogue: Page 21, No. 14.

(15). **Annie** W 15
Boston Catalogue: Page 4, No. 9.
Paris Catalogue: Page 101, No. 296.
London Catalogue: Page 21, No. 15.

(16). **La Marchande de Moutarde** W 16
Boston Catalogue: Page 4, No. 10.
Paris Catalogue: Page 101, No. 297.
London Catalogue: Page 21, No. 16.

(17). **The Rag Gatherers** W 17
Boston Catalogue: Page 4, No. 11.
Paris Catalogue: Page 101, No. 298.
London Catalogue: Page 21, No. 17.

(18). **Fumette** W 18
Boston Catalogue: Page 4, No. 13.
Paris Catalogue: Page 101, No. 299.
London Catalogue: Page 21, No. 18.

(19). **The Kitchen** W 19
Boston Catalogue: Page 4, No. 14.
Paris Catalogue: Page 101, No. 300.
London Catalogue: Page 21, No. 19.

(20). **The Title to the French Set** ,W 20
1858. *Paris Catalogue:* Page 101, No. 301.
London Catalogue: Page 21, No. 20.

(21). **Auguste Delâtre** ,W. 21
Boston Catalogue: Page 4, No. 16.
London Catalogue: Page 21, No. 21.

(22). **A Little Boy** ,W 22
London Catalogue: Page 22, No. 22.

(23). **Seymour** W 23
London Catalogue: Page 22, No. 23.

(24). **Annie, Seated** W 24
Boston Catalogue: Page 4, No. 17.
London Catalogue: Page 22, No. 24.

(25). **Reading by Lamp-Light** W 25
Boston Catalogue: Page 4, No. 18.
London Catalogue: Page 22, No. 25.

(26). **The Music Room** W 26
Boston Catalogue: Page 4, No. 20.
Paris Catalogue: Page 101, No. 302.
London Catalogue: Page 22, No. 26.

(27). **Soupe à Trois Sous** W 27
Boston Catalogue: Page 5, No. 22.
Paris Catalogue: Page 102, No. 303.
London Catalogue: Page 22, No. 27.

(28). **Bibi Valentin** ,W 28
Boston Catalogue: Page 5, No. 23.
1859. *Paris Catalogue:* Page 102, No. 304.
London Catalogue: Page 22, No. 28.

(29). **Reading in Bed** ,W 29
London Catalogue: Page 22, No. 29.

(30). **Bibi Lalouette** .W. 30
 Boston Catalogue: Page 5, No. 25.

1859. *Paris Catalogue:* Page 102, No. 305.
 London Catalogue: Page 22, No. 30.

(31). **The Wine Glass** .W. 31
 Boston Catalogue: Page 5, No. 26.
 London Catalogue: Page 22, No. 31.

(32). **Greenwich Pensioner** W 32
 Boston Catalogue: Page 5, No. 27.
 London Catalogue: Page 22, No. 32.

(33). **Greenwich Park** .W 33
 Boston Catalogue: Page 5, No. 28.
 London Catalogue: Page 22, No. 33.

(34). **Nursemaid and Child** W 34
 London Catalogue: Page 22, No. 34.

(35). **Thames Warehouses** W 35
 Boston Catalogue: Page 5, No. 30.

1859. *Paris Catalogue:* Page 102, No. 306.
 London Catalogue: Page 22, No. 35.

(36). **Westminster Bridge** W 36
 Boston Catalogue: Page 5, No. 31.

1859. *Paris Catalogue:* Page 102, No. 307.
 London Catalogue: Page 22, No. 36.

(37). **Limehouse** W 37
 Boston Catalogue: Page 5, No. 32.

1859. *Paris Catalogue:* Page 102, No. 308.
 London Catalogue: Page 22, No. 37.

(38). **A Wharf** W 38
 London Catalogue: Page 22, No. 38.

(39). Tyzac, Whiteley & Co W. 39
 Boston Catalogue: Page 5, No. 33.
1859. *Paris Catalogue:* Page 102, No. 309.
 London Catalogue: Page 22, No. 39.

(40). Black Lion Wharf W. 40
 Boston Catalogue: Page 6, No. 34.
1850. *Paris Catalogue:* Page 102, No. 310.
 London Catalogue: Page 22, No. 40.

(41). The Pool W. 41
 Boston Catalogue: Page 6, No. 35.
1850. *Paris Catalogue:* Page 102, No. 311.
 London Catalogue: Page 22, No. 41.

(42). Thames Police W. 42
 Boston Catalogue: Page 6, No. 36.
 London Catalogue: Page 22, No. 42.

(43). 'Long-shore Men W. 43
 Boston Catalogue: Page 6, No. 37.
 London Catalogue: Page 23, No. 43.

(44). The Lime-Burner W. 44
 Boston Catalogue: Page 6, No. 38.
1859. *Paris Catalogue:* Page 102, No. 312.
 London Catalogue: Page 23, No. 44.

(45). Billingsgate W. 45
 Boston Catalogue: Page 6, No. 39.
 London Catalogue: Page 23, No. 45.

(46). Landscape with the Horse W. 46
 London Catalogue: Page 23, No. 46.

(47). Arthur Seymour W. 47
 Boston Catalogue: Page 6, No. 41.
 Paris Catalogue: Page 102, No. 313.

(48). Becquet W 48
Boston Catalogue: Page 6, No. 42.
Paris Catalogue: Page 102, No. 314.
London Catalogue: Page 23, No. 48.

(49). Astruc, A Literary Man W 49
Boston Catalogue: Page 6, No. 43.

(50). Fumette, Standing W 50
Boston Catalogue: Page 6, No. 44.
1850. *Paris Catalogue:* Page 102, No. 315.
London Catalogue: Page 23, No. 50.

(51). Fumette's Bent Head W 51
Boston Catalogue: Page 7, No. 45.
London Catalogue: Page 23, No. 51.

(52). Whistler W 52
Boston Catalogue: Page 7, No. 46.
1850. *Paris Catalogue:* Page 102, No. 316.
London Catalogue: Page 23, No. 52.

(53). Drouet W 53
Boston Catalogue: Page 7, No. 47.
1850. *Paris Catalogue:* Page 102, No. 317.
London Catalogue: Page 23, No. 53.

(54). Finette W 54
Boston Catalogue: Page 7, No. 48.
1850. *Paris Catalogue:* Page 102, No. 318.
London Catalogue: Page 23, No. 54.

(55). Paris: Isle de la Cité W 55
Boston Catalogue: Page 7, No. 49.
London Catalogue: Page 23, No. 55.

(56). **Venus** W 56
 (Not in the Catalogues of the Boston, London or
 Paris Exhibitions or in that of the Grolier Club Exhi-
 bition.)

(57). **Annie Haden** W 57
 Boston Catalogue: Page 7, No. 50.
1860. *Paris Catalogue:* Page 102, No. 319.
 London Catalogue: Page 22, No. 57.

(58). **Mr. Mann** W 58
 Boston Catalogue: Page 7, No. 51.
 London Catalogue: Page 23, No. 58.

(59). **The Penny Boat** W 59
 London Catalogue: Page 23, No. 59.

(60). **Rotherhithe** W 60
 Boston Catalogue: Page 7, No. 52.
1860. *Paris Catalogue:* Page 102, No. 320.
 London Catalogue: Page 23, No. 60.

(61). **Axenfeld** W 61
 Boston Catalogue: Page 7, No. 54.
1860. *Paris Catalogue:* Page 102, No. 321.
 London Catalogue: Page 23, No. 61.

(62). **The Engraver** W 62
 Boston Catalogue: Page 7, No. 55.

(63). **The Forge** W 63
 Boston Catalogue: Page 8, No. 56.

1861. *Paris Catalogue:* Page 103, No. 322.
 London Catalogue: Page 23, No. 63.

(64). **Joe** W 64
 Boston Catalogue: Page 8, No. 57.

(65). **The Miser** W 65
 Boston Catalogue: Page 8, No. 60.
 London Catalogue: Page 24, No. 65.

(66). **Vauxhall Bridge** W 66
 London Catalogue: Page 24, No. 66.

(67). **Millbank** W 67
 London Catalogue: Page 24, No. 67.

(68). **The Punt** W 68
 London Catalogue: Page 24, No. 68.

(69). **Sketching** W 69
 London Catalogue: Page 24, No. 69.

(70). **Westminster Bridge in Progress** W 70
 London Catalogue: Page 24, No. 70.

(71). **The Little Wapping** W 71
 London Catalogue: Page 24, No. 71.

(72). **The Little Pool** W 72
1861. *Paris Catalogue:* Page 103, No. 323.
 London Catalogue: Page 24, No. 72.

(73). **The Tiny Pool** W 73
 Grolier Club: No. 76.

(74). **Ratcliffe Highway** W 74
 Grolier Club: No. 77.

(75). **Encamping** W 75
 London Catalogue: Page 24, No. 75.

(76). **Ross Winans** W 76
 Boston Catalogue: Page 8, No. 61.
 Paris Catalogue: Page 103, No. 324.
 London Catalogue: Page 24, No. 76.

(77). **The Storm**　　　　　　　　　　　　　W 77
 Boston Catalogue: Page 8, No. 62.
1861. *Paris Catalogue:* Page 103, No. 325.
 London Catalogue: Page 24, No. 77.

(78). **Little Smithfield**　　　　　　　　　　W 78
 London Catalogue: Page 24, No. 78.

(79). **Cadogan Pier**　　　　　　　　　　　W 79
 Boston Catalogue: Page 8, No. 63.
 London Catalogue: Page 24, No. 79.

(80). **Old Hungerford Bridge**　　　　　　W 80
 Boston Catalogue: Page 8, No. 64.
 London Catalogue: Page 24, No. 80.

(81). **Chelsea Wharf**　　　　　　　　　　W 81
 London Catalogue: Page 24, No. 81.

(82). **Amsterdam, Etched from the Tolhuis**　W 82
 Boston Catalogue: Page 8, No. 65.
1863. *Paris Catalogue:* Page 103, No. 326.
 London Catalogue: Page 24, No. 82.

(83). **Weary**　　　　　　　　　　　　　　W 83
 Boston Catalogue: Page 9, No. 67.
1863. *Paris Catalogue:* Page 103, No. 327.
 London Catalogue: Page 24, No. 83.

(84). **Shipping at Liverpool**　　　　　　　W 84
 Grolier Club, No. 87.

(85). **Chelsea Bridge and Church**　　　　W 85
 London Catalogue: Page 24, No. 85.

(86). **Speke Hall**　　　　　　　　　　　　W 86
 Boston Catalogue: Page 9, No. 68.
1870. *Paris Catalogue:* Page 103, No. 328.
 London Catalogue: Page 24, No. 86.

(87). **The Model, Resting** W 87
Boston Catalogue: Page 9, No. 70.
London Catalogue: Page 25, No. 87.

(88). **Whistler's Mother** W 88
Boston Catalogue: Page 9, No. 71.
Paris Catalogue: Page 103, No. 329.
London Catalogue: Page 25, No. 88.

(89). **Swan Brewery** W 89
London Catalogue: Page 25, No. 89.

(90). **Fosco** W 90
London Catalogue: Page 25, No. 90.

(91). **The Velvet Dress** W 91
Boston Catalogue: Page 9, No. 72.
1873. *Paris Catalogue:* Page 103, No. 330.

(92). **The Little Velvet Dress** W 92
Boston Catalogue: Page 9, No. 75.
1873. *Paris Catalogue:* Page 103, No. 331.
London Catalogue: Page 25, No. 92.

(93). **F. R. Leyland** W 93
London Catalogue: Page 25, No. 93.

(94). **Fanny Leyland** W 94
Boston Catalogue: Page 9, No. 76.
1873. *Paris Catalogue:* Page 103, No. 332.
London Catalogue: Page 25, No. 94.

(95). **Elinor Leyland** W 95
Boston Catalogue: Page 9, No. 77.
Paris Catalogue: Page 103, No. 333.
London Catalogue: Page 25, No. 95.

(96). **Florence Leyland** W 96
 Boston Catalogue: Page 9, No. 78.
 Paris Catalogue: Page 103, No. 334.
 London Catalogue: Page 25, No. 96.

(97). **Reading a Book** W 97
 London Catalogue: Page 25, No. 97.

(98). **Tatting** W 98
 London Catalogue: Page 25, No. 98.

(99). **Maude, Standing** W 99
 Boston Catalogue: Page 9, No. 79.
 London Catalogue: Page 25, No. 99.

(100). **Maude, Seated** W 100
 London Catalogue: Page 25, No. 100.

(101). **The Beach** W 101
 Grolier Club, No. 107.

(102). **Tillie: A Model** W 102
 Boston Catalogue: Page 10, No. 80.
 London Catalogue: Page 25, No. 102.

(103). **Seated Girl** W 103
 Boston Catalogue: Page 10, No. 81.

(104). **The Desk** W 104
 London Catalogue: Page 25, No. 104.

(105). **Resting** W 105
 London Catalogue: Page 25, No. 105.

(106). **Agnes** W 106
 Boston Catalogue: Page 10, No. 82.
 Paris Catalogue: Page 103, No. 335.
 London Catalogue: Page 25, No. 106.

(107). The Model, Lying Down W 107
 Paris Catalogue: Page 103, No. 336.

(108). Two Sketches W 108
 (Not included in the Boston, London or Paris Memorial Exhibitions or in that of the Grolier Club.)

(109). The Boy W 109
 Boston Catalogue: Page 10, No. 83.
 Paris Catalogue: Page 103, No. 337.
 London Catalogue: Page 26, No. 109.

(110). Swinburne W 110
 (Neither 110 nor 111 was included in the Memorial Exhibitions or in that of the Grolier Club.)

(111). Lady at a Window W 111

(112). A Child on a Couch W 112
 London Catalogue: Page 26, No. 112.

(113). Sketch of a Girl, Nude W 113
 (Not included in the Memorial Exhibitions or in that of the Grolier Club.)

(114). Steamboats off the Tower W 114
 Boston Catalogue: Page 10, No. 85.
 London Catalogue: Page 26, No. 114.

(115). The Little Forge W 115
 Boston Catalogue: Page 10, No. 86.
1875. *Paris Catalogue:* Page 103, No. 338.
 London Catalogue: Page 26, No. 115.

(116). Two Ships W 116
 London Catalogue: Page 26, No. 116.

(117). **The Piano** W 117
 Boston Catalogue: Page 10, No. 88.
1875. *Paris Catalogue:* Page 103, No. 339.
 London Catalogue: Page 26, No. 117.

(118). **The Scotch Widow** W 118
 Boston Catalogue: Page 10, No. 89.

(119). **Speke Shore** W 119
 Boston Catalogue: Page 10, No. 90.
 Paris Catalogue: Page 103, No. 340.
 London Catalogue: Page 26, No. 119.

(120). **The Dam Wood** W 120
 Boston Catalogue: Page 10, No. 91.
1873. *Paris Catalogue:* Page 104, No. 341.
 London Catalogue: Page 26, No. 120.

(121). **Shipbuilder's Yard** W 121
 London Catalogue: Page 26, No. 121.

(122). **The Guitar-Player** W 122
 Boston Catalogue: Page 11, No. 92.
 Paris Catalogue: Page 104, No. 342.
 London Catalogue: Page 26, No. 122.

(123). **London Bridge** W 123
 Boston Catalogue: Page 11, No. 93.
 London Catalogue: Page 26, No. 123.

(124). **Price's Candle Works** W 124
 Boston Catalogue: Page 11, No. 95.
 Paris Catalogue: Page 104, No. 343.
 London Catalogue: Page 26, No. 124.

(125). **Battersea: Dawn** W 125
 Boston Catalogue: Page 11, No. 98.
 Paris Catalogue: Page 104, No. 344.
 London Catalogue: Page 26, No. 125.

(126). **The Muff** W 126
London Catalogue: Page 27, No. 126.

(127). **A Sketch of Ships** W 127
London Catalogue: Page 27, No. 127.

(128). **The White Tower** W 128
London Catalogue: Page 27, No. 128.

(129). **The Troubled Thames** W 129
(Not included in the Memorial Exhibitions or that
of the Grolier Club.)

(130). **A Sketch from Billingsgate** W 130
Boston Catalogue: Page 11, No. 99.
London Catalogue: Page 27, No. 130.

(131). **Fishing Boats, Hastings** W 131
London Catalogue: Page 27, No. 131.

(132). **Wych Street** W 132
Paris Catalogue: Page 104, No. 345.
London Catalogue: Page 27, No. 132.

(133). **Temple Bar** W 133
London Catalogue: Page 27, No. 133.

(134). **Free Trade Wharf** W 134
Boston Catalogue: Page 11, No. 100.
London Catalogue: Page 27, No. 134.

(135). **The Thames, Toward Erith** W 135
Boston Catalogue: Page 11, No. 101.
London Catalogue: Page 27, No. 135.

(136). **Lindsay Houses** W 136
Boston Catalogue: Page 11, No. 103.
1878. *Paris Catalogue:* Page 104, No. 346.
London Catalogue: Page 27, No. 136.

(137). **From Pickled Herring Stairs** W 137
 Boston Catalogue: Page 11, No. 104.
 London Catalogue: Page 27, No. 137.

(138). **Lord Wolseley** W 138
 Boston Catalogue: Page 12, No. 105.
 Paris Catalogue: Page 104, No. 347.
 London Catalogue: Page 27, No. 138.

(139). **Irving as Philip of Spain** W 139
 London Catalogue: Page 27, No. 139.

(140). **St. James's Street** W 140
 Boston Catalogue: Page 12, No. 106.
 London Catalogue: Page 27, No. 140.

(141). **Battersea Bridge** W 141
 Boston Catalogue: Page 12, No. 107.
 Paris Catalogue: Page 104, No. 348.
 London Catalogue: Page 27, No. 141.

(142). **Whistler with the White Lock** W 142
 Grolier Club. No. 143.

(143). **The Large Pool** W 143
 Boston Catalogue: Page 12, No. 108.
1879. *Paris Catalogue:* Page 104, No. 349.
 London Catalogue: Page 27, No. 143.

(144). **The "Adam and Eve," Old Chelsea** W 144
 Boston Catalogue: Page 12, No. 110.
 London Catalogue: Page 27, No. 144.

(145). **Putney Bridge** W 145
 Boston Catalogue: Page 12, No. 111.
 Paris Catalogue: Page 104, No. 350.
 London Catalogue: Page 27, No. 145.

(146). **The Little Putney** W 146
Boston Catalogue: Page 12, No. 112.
London Catalogue: Page 28, No. 146.

(147). **Hurlingham** W 147
Boston Catalogue: Page 12, No. 113.
London Catalogue: Page 28, No. 147.

(148). **Fulham** W 148
Boston Catalogue: Page 12, No. 114.
London Catalogue: Page 28, No. 148.

(149). **The Little Venice** W 149
Boston Catalogue: Page 13, No. 116.
Paris Catalogue: Page 104, No. 351.
London Catalogue: Page 28, No. 149.

(150). **Nocturne** W 150
Boston Catalogue: Page 13, No. 117.
Paris Catalogue: Page 104, No. 352.
London Catalogue: Page 28, No. 150.

(151). **The Little Mast** W 151
Paris Catalogue: Page 104, No. 353.
London Catalogue: Page 28, No. 151.

(152). **The Little Lagoon** W 152
Boston Catalogue: Page 13, No. 119.
Paris Catalogue: Page 104, No. 354.
London Catalogue: Page 28, No. 152.

(153). **The Palaces** W 153
Boston Catalogue: Page 13, No. 120.
Paris Catalogue: Page 104, No. 355.
London Catalogue: Page 28, No. 153.

(154). **The Doorway** W 154
 Boston Catalogue: Page 13, No. 121.
 Paris Catalogue: Page 105, No. 356.
 London Catalogue: Page 28, No. 154.

(155). **The Piazzetta** W 155
 Paris Catalogue: Page 105, No. 357.
 London Catalogue: Page 28, No. 155.

(156). **The Traghetto, Second Plate** W 156
 Boston Catalogue: Page 13, No. 124.
 Paris Catalogue: Page 105, No. 358.
 London Catalogue: Page 28, No. 156.

(157). **The Riva, No. 1** W 157
 Paris Catalogue: Page 105, No. 359.
 London Catalogue: Page 28, No. 157.

(158). **Two Doorways** W 158
 Boston Catalogue: Page 13, No. 125.
 Paris Catalogue: Page 105, No. 360.
 London Catalogue: Page 28, No. 158.

(159). **The Beggars** W 159
 Boston Catalogue: Page 13, No. 127.
 Paris Catalogue: Page 105, No. 361.
 London Catalogue: Page 28, No. 159.

(160). **The Mast** W 160
 Boston Catalogue: Page 13, No. 128.
 Paris Catalogue: Page 105, No. 362.
 London Catalogue: Page 28, No. 160.

(161). **Doorway and Vine** W 161
 London Catalogue: Page 28, No. 161.

(162). **Wheelwright** W 162
 London Catalogue: Page 28, No. 162.

(163). **San Biagio** W 163
Boston Catalogue: Page 14, No. 129.
Paris Catalogue: Page 105, No. 363.
London Catalogue: Page 28, No. 163.

(164). **Bead-Stringers** W 164
Paris Catalogue: Page 105, No. 364.
London Catalogue: Page 28, No. 164.

(165). **Turkeys** W 165
London Catalogue: Page 28, No. 165.

(166). **Fruit-Stall** W 166
Boston Catalogue: Page 14, No. 131.
Paris Catalogue: Page 105, No. 365.
London Catalogue: Page 28, No. 166.

(167). **San Giorgio** W 167
Boston Catalogue Page 14, No. 132.
Paris Catalogue: Page 105, No. 366.
London Catalogue: Page 28, No. 167.

(168). **Nocturne, Palaces** W 168
Boston Catalogue: Page 14, No. 133.
Paris Catalogue: Page 105, No. 367.
London Catalogue: Page 28, No. 168.

(169). **Long Lagoon** W 169
Boston Catalogue: Page 14, No. 135.
Paris Catalogue: Page 105, No. 368.
London Catalogue: Page 28, No. 169.

(170). **The Temple** W 170
London Catalogue: Page 29, No. 170.

(171). **The Bridge** W 171
Boston Catalogue: Page 14, No. 136.
Paris Catalogue: Page 105, No. 369.
London Catalogue: Page 29, No. 171.

(172). **Upright Venice** W 172
 Boston Catalogue: Page 14, No. 137.
 Paris Catalogue: Page 105, No. 370.
 London Catalogue: Page 29, No. 172.

(173). **Little Court, Drury Lane** W 173
 Paris Catalogue: Page 105, No. 371.
 London Catalogue: Page 29, No. 173.

(174). **Lobster Pots** W 174
 London Catalogue: Page 29, No. 174.

(175). **The Riva, No. 2** W 175
 Boston Catalogue: Page 14, No. 138.
 Paris Catalogue: Page 105, No. 372.
 London Catalogue: Page 29, No. 175.

(176). **Drury Lane** W 176
 London Catalogue: Page 29, No. 176.

(177). **The Balcony** W 177
 Boston Catalogue: Page 14, No. 139.
 Paris Catalogue: Page 106, No. 373.
 London Catalogue: Page 29, No. 177.

(178). **Fishing Boat** W 178
 London Catalogue: Page 29, No. 178.

(179). **Ponte Piovan** W 179
 Boston Catalogue: Page 15, No. 140.
 London Catalogue: Page 29, No. 179.

(180). **Garden** W 180
 Boston Catalogue: Page 15, No. 141.
 London Catalogue: Page 29, No. 180.

(181). **The Rialto** W 181
Boston Catalogue: Page 15, No. 142.
Paris Catalogue: Page 106, No. 374.
London Catalogue: Page 29, No. 181.

(182). **Long Venice** W 182
Boston Catalogue: Page 15, No. 143.
Paris Catalogue: Page 106, No. 375.
London Catalogue: Page 29, No. 182.

(183). **Furnace, Nocturne** W 183
Boston Catalogue: Page 15, No. 144.
London Catalogue: Page 29, No. 183.

(184). **Quiet Canal** W 184
London Catalogue: Page 29, No. 184.

(185). **Salute: Dawn** W 185
Boston Catalogue: Page 15, No. 145.
Paris Catalogue: Page 106, No. 376.
London Catalogue: Page 29, No. 185.

(186). **Lagoon: Noon** W 186
Boston Catalogue: Page 15, No. 146.
London Catalogue: Page 29, No. 186.

(187). **Murano, Glass Furnace** W 187
Paris Catalogue: Page 106, No. 378.
London Catalogue: Page 29, No. 187.

(188). **Fish-Shop, Venice** W 188
London Catalogue: Page 29, No. 188.

(189). **The Dyer** W 189
Boston Catalogue: Page 15, No. 147.
Paris Catalogue: Page 106, No. 379.
London Catalogue: Page 29, No. 189.

(190). **Little Salute** W 190
 Boston Catalogue: Page 15, No. 148.
 London Catalogue: Page 29, No. 190.

(191). **Wool Carders** W 191
 Paris Catalogue: Page 106, No. 380.

(192). **Regent's Quadrant** W 192
 London Catalogue: Page 30, No. 192.

(193). **Islands** W 193
 Boston Catalogue: Page 15, No. 149.
 London Catalogue: Page 30, No. 193.

(194). **Nocturne, Shipping** W 194
 Boston Catalogue: Page 15, No. 150.
 London Catalogue: Page 30, No. 194.

(195). **Old Women** W 195
 Grolier Club. No. 197.

(196). **Alderney Street** W 196
 London Catalogue: Page 30, No. 196.

(197). **The Smithy** W 197
 Boston Catalogue: Page 16, No. 152.
 Paris Catalogue: Page 106, No. 381.
 London Catalogue: Page 30, No. 197.

(198). **Stables** W 198
 Boston Catalogue: Page 16, No. 153.
 London Catalogue: Page 30, No. 198.

(199). **Nocturne, Salute** W 199
 Boston Catalogue: Page 16, No. 154.
 London Catalogue: Page 30, No. 199.

(200). **Dordrecht** W 200
 Boston Catalogue: Page 16, No. 160.
 Paris Catalogue: Page 106, No. 382.
 London Catalogue: Page 30, No. 200.

(201). **A Corner of the Palais Royal** W 201
 London Catalogue: Page 30, No. 201.

(202). **Sketch at Dieppe** W 202
 London Catalogue: Page 30, No. 202.

(203). **Booth at a Fair** W 203
 London Catalogue: Page 30, No. 203.

(204). **Cottage Door** W 204
 Boston Catalogue: Page 16, No. 161.
 Paris Catalogue: Page 106, No. 383.
 London Catalogue: Page 30, No. 204.

(205). **The Village Sweet-Shop** W 205
 Boston Catalogue: Page 16, No. 162.
 Paris Catalogue: Page 106, No. 384.
 London Catalogue: Page 30, No. 205.

(206). **The Seamstress** W 206
 London Catalogue: Page 30, No. 206.

(207). **Sketch in St. James's Park** W 207
 London Catalogue: Page 30, No. 207.

(208). **Fragment of Piccadilly** W 208
 London Catalogue: Page 30, No. 208.

(209). **Old Clothes Shop** W 209
 London Catalogue: Page 30, No. 209.

(210). **The Fruit-Shop** W 210
 London Catalogue: Page 31, No. 210.

(211). **A Sketch on the Embankment** W 211
London Catalogue: Page 31, No. 211.

(212). **The Menpes Children** W 212
London Catalogue: Page 31, No. 212.

(213). **The Steps** W 213
London Catalogue: Page 31, No. 213.

(214). **The Fish-Shop: "Busy Chelsea"** W 214
Boston Catalogue: Page 17, No. 163.
London Catalogue: Page 31, No. 214.
 (Wrongly called the "Fruit Shop" in London Cat-
alogue.)

(215). **T. A. Nash Fruit Shop** W 215
Paris Catalogue: Page 106, No. 385.
London Catalogue: Page 31, No. 215.

(216). **Furniture-Shop** W 216
London Catalogue: Page 31, No. 216.

(217). **Savoy Scaffolding** W 217
Paris Catalogue: Page 107, No. 386.
London Catalogue: Page 31, No. 217.

(218). **Railway Arch** W 218
London Catalogue: Page 31, No. 218.

(219). **Rochester Row** W 219
Boston Catalogue: Page 17, No. 165.
London Catalogue: Page 31, No. 219.

(220). **York Street, Westminster** W 220
Boston Catalogue: Page 17, No. 166.
London Catalogue: Page 31, No. 220.

(221). **The Fur Cloak** W 221
London Catalogue: Page 31, No. 221.

(222). Woman, Seated W 222
London Catalogue: Page 31, No. 222.

(223). Steamboat Fleet W 223
London Catalogue: Page 31, No. 223.

(224). Mother and Child, Cameo No. 1 W 224
Boston Catalogue: Page 17, No. 167.
Paris Catalogue: Page 107, No. 387.
London Catalogue: Page 31, No. 224.

(225). Sketch of Battersea Bridge W 225
London Catalogue: Page 31, No. 225.

(226). Putney, No. 3 W 226
Boston Catalogue: Page 12, No. 115.
London Catalogue: Page 31, No. 226.

(227). F. R. Leyland's Mother W 227
London Catalogue: Page 31, No. 227.
(Not in Grolier Club's exhibition.)

(228). Wild West W 228
Grolier Club. No. 239.

(229). The Barber's W 229
Boston Catalogue: Page 17, No. 170.
Paris Catalogue: Page 107, No. 388.
London Catalogue: Page 31, No. 229.

(230). Petticoat Lane W 230
London Catalogue: Page 32, No. 230

(231). Old Clothes Exchange, No. 1 W 231
Boston Catalogue: Page 20, No. 202.
Paris Catalogue: Page 107, No. 389.
London Catalogue: Page 32, No. 231.

(232). **St. James's Place, Houndsditch** W. 232
 London Catalogue: Page 32, No. 232.

(233). **Fleur de Lys Passage** W. 233
 London Catalogue: Page 32, No. 233.

(234). **Cutler's Street** W 234
 London Catalogue: Page 32, No. 234.

(235). **The Cock and the Pump** W 235
 Boston Catalogue: Page 17, No. 171.
 London Catalogue: Page 32, No. 235.

(236). **Sandwich: Salvation Army** W 236
 London Catalogue: Page 32, No. 236.

(237). **Visitor's Boat** W 237
 Boston Catalogue: Page 17, No. 172.
 Paris Catalogue: Page 107, No. 390.
 London Catalogue: Page 32, No. 237.

(238). **Troop Ships** W 238
 Boston Catalogue: Page 18, No. 173.
 Paris Catalogue: Page 107, No. 391.
 London Catalogue: Page 32, No. 238.

(239). **Monitors** W 239
 Boston Catalogue: Page 18, No. 174.
 Paris Catalogue: Page 107, No. 392.
 London Catalogue: Page 32, No. 239.

(240). **Dry Dock, Southampton** W 240
 Paris Catalogue: Page 107, No. 393.
 London Catalogue: Page 32, No. 240.

(241). **Bunting** W 241
 Paris Catalogue: Page 107, No. 394.
 London Catalogue: Page 32, No. 241.

(242). **Dipping the Flag** W 242
Paris Catalogue: Page 107, No. 395.
London Catalogue: Page 32, No. 242

(243). **The Fleet—Evening** W 243
Boston Catalogue: Page 18, No. 175.
Paris Catalogue: Page 107, No. 396.
London Catalogue: Page 32, No. 243.

(244). **Return to Tilbury** W 244
Boston Catalogue: Page 18, No. 177.
London Catalogue: Page 32, No. 244.

(245). **Landing Stage, Cowes (Ryde Pier)** W 245
Paris Catalogue: Page 108, No. 397.
London Catalogue: Page 32, No. 245.
(In the London Catalogue on Page 18 it is stated
that No. 245 is "incorrectly described by Wedmore as
Ryde Pier.")

(246). **Chelsea** W 246
Paris Catalogue: Page 108, No. 401.

(247). **Windsor** W 247
Paris Catalogue: Page 108, No. 402.
London Catalogue: Page 32, No. 247.

(248). **Canal, Ostend** W 248
Grolier Club. No. 266.

(249). **The Church, Brussels** W 249
London Catalogue: Page 32, No. 249.

(250). **Court-Yard, Brussels** W 250
Boston Catalogue: Page 18, No. 178.
Paris Catalogue: Page 108, No. 403.
London Catalogue: Page 33, No. 250.

(251). **Grande Place, Brussels** W 251
 Boston Catalogue: Page 18, No. 179.
 Paris Catalogue: Page 108, No. 404.
 London Catalogue: Page 33, No. 251.

(252). **Palace, Brussels** W 252
 Boston Catalogue: Page 18, No. 180.
 Paris Catalogue: Page 108, No. 405.
 London Catalogue: Page 33, No. 252.

(253). **The Barrow, Brussels** W 253
 Paris Catalogue: Page 108, No. 406.
 London Catalogue: Page 33, No. 253.

(254). **The High Street, Brussels** W 254
 Boston Catalogue: Page 18, No. 181.
 Paris Catalogue: Page 108, No. 407.
 London Catalogue: Page 33, No. 254.

(255). **The Market Place, Bruges** W 255
 London Catalogue: Page 33, No. 255.

(256). **Passages de L'Opéra** W 256
 Boston Catalogue: Page 18, No. 182.
 London Catalogue: Page 33, No. 256.

(257). **Carpet Menders** W 257
 Boston Catalogue: Page 19, No. 184.
 Paris Catalogue: Page 108, No. 408.

(258). **Sunflowers, rue des Beaux-Arts** W 258
 Boston Catalogue: Page 19, No. 185.

(259). **Mairie, Loches** W 259
 Boston Catalogue: Page 19, No. 186.
 Paris Catalogue: Page 108, No. 409.
 London Catalogue: Page 33, No. 259.

(260). **Steps, Amsterdam** W 260
 Boston Catalogue: Page 19, No. 187.
 Paris Catalogue: Page 108, No. 410.
 London Catalogue: Page 33, No. 260.

(261). **Square House, Amsterdam** W 261
 Boston Catalogue: Page 19, No. 188.
 Paris Catalogue: Page 108, No. 411.
 London Catalogue: Page 33, No. 261.

(262). **Balcony, Amsterdam** W 262
 Boston Catalogue: Page 19, No. 189.
 Paris Catalogue: Page 109, No. 412.
 London Catalogue: Page 33, No. 262.

(263). **The Little Drawbridge** W 263
 Paris Catalogue: Page 109, No. 413.
 London Catalogue: Page 33, No. 263.

(264). **Pierrot** W 264
 Boston Catalogue: Page 19, No. 191.
 Paris Catalogue: Page 109, No. 414.
 London Catalogue: Page 33, No. 264.

(265). **Nocturne: Dance House** W 265
 Boston Catalogue: Page 19, No. 192.
 Paris Catalogue: Page 109, No. 415.
 London Catalogue: Page 33, No. 265.

(266). **Long House—Dyer's, Amsterdam** W 266
 Boston Catalogue: Page 19, No. 193.
 London Catalogue: Page 33, No. 266.

(267). **Bridge, Amsterdam** W 267
 Boston Catalogue: Page 19, No. 194.
 London Catalogue: Page 33, No. 267.

(268). **Zaandam** W 268
 Boston Catalogue: Page 20, No. 197.
 Paris Catalogue: Page 109, No. 416.
 London Catalogue: Page 34, No. 268.

(269). **Speke Hall, No. 2** S 269
 London Catalogue: Page 34, No. 269.

(270). **Church Doorway, Edgemere** S 270
 London Catalogue: Page 34, No. 270.

(271). **Double Doorway, Sandwich** S 271
 Grolier Club. No. 298.

(272). **Doorway, Sandwich** S 272
 Paris Catalogue: Page 109, No. 418.

(273). **Butcher's Shop, Sandwich** S 273
 Grolier Club. No. 300.

(274). **Ramparts, Sandwich** S 274
 Boston Catalogue: Page 20, No. 198.
 London Catalogue: Page 34, No. 274.

(275). **Portsmouth Children** S 275
 Paris Catalogue: Page 108, No. 399.
 London Catalogue: Page 34, No. 275.

(276). **Tilbury** S 276
 Paris Catalogue: Page 108, No. 400.
 London Catalogue: Page 34, No. 276.

(277). **Windsor** S 277
 Grolier Club. No. 264.

(278). **Little Putney, No. 2** S 278

(279). **Battersea Bridge, No. 3** S 279
 (Numbers 278 and 279 do not appear in the cata-
logues of the Memorial Exhibitions or in that of the
Grolier Club exhibition.)

(280). **Under Battersea Bridge** S 280
London Catalogue: Page 34, No. 280.

(281). **Melon Shop, Houndsditch** S 281
Boston Catalogue: Page 20, No. 199.
Paris Catalogue: Page 109, No. 419.
London Catalogue: Page 34, No. 281.

(282). **After the Sale, Houndsditch** S 282
Grolier Club. No. 303.

(283). **Steps, Gray's Inn** S 283
Grolier Club. No. 304.

(284). **Gray's Inn Babies** S 284
London Catalogue: Page 34, No. 284.

(285). **Gray's Inn Place** S 285
Boston Catalogue: Page 20, No. 201.
London Catalogue: Page 34, No. 285.

(286). **Seats, Gray's Inn** S 286
Grolier Club. No. 308.

(287). **Exeter Street** S 287
London Catalogue: Page 35, No. 287.

(288). **Abbey Jubilee** S 288
Grolier Club. No. 262.

(289). **Bird Cages, Drury Lane** S 289
London Catalogue: Page 35, No. 289.

(290). **The Bucking Horse.** S 290
London Catalogue: Page 35, No. 290.

(291). **Rag Shop, Milman's Row** S 291
Boston Catalogue: Page 17, No. 164.
Paris Catalogue: Page 109, No. 420.
London Catalogue: Page 35, No. 291.

(292.) **Clothes Exchange, No. 2** S 292
Boston Catalogue: Page 20, No. 203.
London Catalogue: Page 35, No. 292.

(293). **Charing Cross Railway Bridge** S 293
Boston Catalogue: Page 20, No. 204.
London Catalogue: Page 35, No. 293.

(294). **Shaving and Shampooing** S 294
Boston Catalogue: Page 17, No. 169.

(295). **Jubilee Place, Chelsea** S 295
Boston Catalogue: Page 20, No. 205.
Paris Catalogue: Page 109, No. 421.
London Catalogue: Page 35, No. 295.

(296). **Justice Walk, Chelsea** S 296
Boston Catalogue: Page 21, No. 206.
London Catalogue: Page 35, No. 296.

(297). **Bird Cages, Chelsea** S 297
Boston Catalogue: Page 21, No. 207.
London Catalogue: Page 35, No. 297.

(298). **Merton Villa, Chelsea** S 298
Boston Catalogue: Page 21, No. 208.
London Catalogue: Page 35, No. 298.

(299). **Little Maunders** S 299
Paris Catalogue: Page 109, No. 422.
London Catalogue: Page 35, No. 299.

(300). **Custom House** S 300
(Not in the catalogues of the Memorial Exhibitions or in that of the Grolier Club exhibition.)

(301). **Nut Shop, St. James's Place** S 301
Boston Catalogue: Page 21, No. 209.
London Catalogue: Page 35, No. 301.

(302). **Old Clothes Shop, No. 2** S 302
 London Catalogue: Page 35, No. 302.

(303). **Model, Stooping** S 303
 London Catalogue: Page 36, No. 303.

(304). **Nude Figure, Reclining** S 304
 Grolier Club. No. 330.

(305). **Binding the Hair** S 305
 Grolier Club. No. 331.

(306). **The Little Hat** S 306
 London Catalogue: Page 36, No. 306.

(307). **The Little Nurse Maid** S 307
 London Catalogue: Page 36, No. 307.
 (Not in the Grolier Club exhibiton.)

(308). **Baby Pettigrew** S 308
 Grolier Club. No. 333.

(309). **Miss Lenoir** S 309
 Grolier Club. No. 334.

(310). **Swan and Iris** S 310
 Boston Catalogue: Page 21, No. 210.
 London Catalogue: Page 36, No. 310.

(311). **Mother and Child, Cameo No. 2** S 311
 Boston Catalogue: Page 17, No. 168.

(312). **Marbles** S 312
 Grolier Club. No. 341.

(313). **Bébés, Luxembourg Gardens** S 313
 Boston Catalogue: Page 23, No. 229.

(314). **Terrace: Luxembourg Gardens** S 314
 Paris Catalogue: Page 109, No. 423.

(315). Boulevard, Poissonnière S 315
 Boston Catalogue: Page 21, No. 211.

(316). Rue Rochefoucault S 316
 Boston Catalogue: Page 21, No. 212.
 Paris Catalogue: Page 109, No. 424.
 London Catalogue: Page 36, No. 316.

(317). Quai de Montebello S 317
 Boston Catalogue: Page 21, No. 213.
 London Catalogue: Page 36, No. 317.

(318). Quai, Ostend S 318
 Grolier Club. No. 267.

(319). Railway Station, Vovés S 319
 Boston Catalogue: Page 21, No. 214.
 Paris Catalogue: Page 109, No. 425.

(320). Rue des Bons-Enfants, Tours S 320
 Paris Catalogue: Page 110, No. 426.
 London Catalogue: Page 36, No. 320.

(321). Hôtel Croix Blanche, Tours S 321
 Grolier Club. No. 358.

(322). Market-Place, Tours S 322
 Boston Catalogue: Page 21, No. 215.

(323). Hangman's House, Tours S 323
 Boston Catalogue: Page 21, No. 216.
 London Catalogue: Page 36, No. 323.

(324). Little Market-Place, Tours S 324
 Boston Catalogue: Page 22, No. 217.

(325). Cellar Door, Tours S 325
 Grolier Club. No. 362.

(326). **Place Daumont** S 326
 Grolier Club. No. 363.

(327). **Château** S 327
 Grolier Club. No. 364.

(328). **Château, Touraine** S 328
 Grolier Club. No. 365.

(329). **Doorway, Touraine** S 329
 Grolier Club. No. 366.

(330). **Court of the Monastery of St. Augustine at
 Bourges** S 330
 Boston Catalogue: Page 22, No. 218.

(331). **Hotel Allement, Bourges** S 331
 Boston Catalogue: Page 22, No. 219.
 Paris Catalogue: Page 110, No. 427.

(332). **Windows, Bourges** S 332
 Grolier Club. No. 369.

(333). **Windows Opposite Hotel, Bourges** S 333
 Paris Catalogue: Page 110, No. 428.
 London Catalogue: Page 37, No. 333.

(334). **Chancellerie, Loches** S 334
 Boston Catalogue: Page 22, No. 220.
 Paris Catalogue: Page 110, No. 429.
 London Catalogue: Page 37, No. 334.

(335). **Market Women, Loches** S 335
 Grolier Club. No. 373.

(336). **Hôtel Promenade** S 336
 Grolier Club. No. 374.

(337). **Théâtre, Loches** S 337
 Grolier Club. No. 375.

(338). **Tour St. Antoine, Loches** S 338
Grolier Club. No. 376.

(339). **Market-Place, Loches** S 339
Grolier Club. No. 377.

(340). **Renaissance Window, Loches** S 340
Boston Catalogue: Page 22, No. 221.

(341). **Chapel Doorway, Montresor** S 341
Boston Catalogue: Page 22, No. 222.
London Catalogue: Page 37.

(342). **Château, Amboise** S 342
Grolier Club. No. 382.

(343). **Clock Tower, Amboise** S 343
Boston Catalogue: Page 22, No. 223.

(344). **Gateway, Chartreux** S 344
Grolier Club. No. 384.

(345). **Under the Cathedral, Blois** S 345
Boston Catalogue: Page 22, No. 224.

(346). **A Guild House, Brussels** S 346
London Catalogue: Page 37, No. 346.

(347). **Gold House, Brussels** S 347
London Catalogue: Page 38, No. 347.

(348). **Butter Street, Brussels** S 348
Grolier Club. No. 388.

(349). **House of the Swan** S 349
Grolier Club. No. 389.

(350). **Archway, Brussels** S 350
Boston Catalogue: Page 18, No. 183.
London Catalogue: Page 38, No. 350.

(351). **Courtyard, Rue P. L. Courier** S 351
Grolier Club. No. 391.

(352). **Brussels Children** S 352
Grolier Club. No. 392.

(353). **Little Butter Street** S 353
Grolier Club. No. 393.

(354). **Château Verneuil** S 354
Grolier Club. No. 394.

(355). **Church, Amsterdam** S 355
Grolier Club. No. 288.

(356). **The Embroidered Curtain** S 356
Boston Catalogue: Page 20, No. 195.
London Catalogue: Page 38, No. 356.

(357). **Jews' Quarters, Amsterdam** S 357
Grolier Club: No. 290.

(358). **The Mill** S 358
Boston Catalogue: Page 20, No. 196.
Paris Catalogue: Page 109, No. 417.

(359). **Little Nocturne, Amsterdam** S 359
Grolier Club: No. 291.

(360). **The Hole in the Wall—Ajaccio** S 360
Boston Catalogue: Page 23, No. 234.
(The same as "Bohemians, Corsica.")

(361). **Venice** S 361
Grolier Club. No. 202.

(362). **Seymour, Standing** S 362
Grolier Club. No. 25.

(363). **Opposite Lindsay Row** S 363
London Catalogue: Page 38, No. 363.

(364). **A Lady Wearing a Hat with a Feather** S 364
Grolier Club. No. 120.

(365). **A Girl with Large Eyes** S 365
Grolier Club. No. 121.

(366). **A Sketch of Heads** S 366
Grolier Club. No. 122.

(367). **Nora Quinn** S 367
Grolier Club. No. 231.

(368). **The Traghetto** S 368
Grolier Club. No. 157.

(369). **An Eagle** S 369
Grolier Club. No. 395.

(370). **Jo—Bent Head** S 370
Boston Catalogue: Page 8, No. 58.
London Catalogue: Page 39, No. 370.

(371). **Young Woman, Standing** S 371
Grolier Club. No. 102.

(372). **Nude Figure, Standing** S 372
Grolier Club. No. 109.

(373). **Au Sixième** G 4
Grolier Club. No. 4.

(374). **Sketching No. 2** G 72
Grolier Club. No. 72.

(375). **Court Yard, Venice** G 203
Boston Catalogue: Page 16, No. 156.

(376.) **Gondola Under a Bridge** G 204
Boston Catalogue: Page 16, No. 157.

(377.) **The Steamboat, Venice** G 205
Boston Catalogue: Page 16, No. 158.

(378). **Venetian Water Carrier** G 206
Boston Catalogue: Page 16, No. 159.

(379). **Shipping, Venice** G 207
Grolier Club. No. 207.

(380). **The Towing Path** G 217
Grolier Club. No. 217.

(381). **Wild West—Buffalo Bill** G 241
Grolier Club. No. 241.

(382). **Turret Ship** G 261
Boston Catalogue: Page 18, No. 176.
Paris Catalogue: Page 108, No. 398.
London Catalogue: Page 18, No. 139.

(383). **The Beach, Ostend** G 268
Grolier Club. No. 268.

(384). **The Little Wheelwright's** G 294
Grolier Club. No. 294.

(385). **Little Dordrecht** G 295
Grolier Club. No. 295.

(386). **Boats, Dordrecht** G 296
Grolier Club. No. 296.

(387). **The Greedy Baby** G 306
Grolier Club. No. 306.

(388). **Babies, Gray's Inn** G 310
Grolier Club. No. 310.

(389). **Children, Gray's Inn** G 311
Grolier Club. No. 311.

(390). **St. Martin's Lane—Rag Shop** G 315
Grolier Club. No. 315.

(391). **King's Road, Chelsea** **G 323**
Grolier Club. No. 323.

(392). **The Hansom Cab, or Wimpole Street** **G 324**
Grolier Club. No. 324.

(393). **Wood's Fruit Shop** **G 326**
London Catalogue: Page 40, No. 378.

(394). **Resting by the Stove** **G 336**
London Catalogue: Page 40, No. 381.

(385). **Little Nude Figure** **G 337**
London Catalogue: Page 39, No. 376.

(396.) **Model Number 3** **G 388**
Grolier Club. No. 338.

(397). **The Bonnet Shop** **G 339**
Grolier Club. No. 339.

(398). **The Mantle** **G 340**
Grolier Club. No. 340.

(399). **Dray Horse** **G 347**
Grolier Club. No. 347.

(400). **Marchand de Vin, Paris** **G 348**
Boston Catalogue: Page 23, No. 230.

(401). **Rue de Seine** **G 349**
Boston Catalogue: Page 23, No. 233.
London Catalogue: Page 40, No. 379.

(402). **Atelier Bijouterie** **G 350**
Boston Catalogue: Page 23, No. 231.
Paris Catalogue Page 110, No. 432.
London Catalogue: Page 39, No. 373.

(403). **Café Luxembourg** **G 351**
Boston Catalogue: Page 23, No. 232.

(404). The Terrace, Luxembourg Gardens G 352
 London Catalogue: Page 40, No. 377.

(405). J. L. Druez's Fruit and Flower Shop G 353
 London Catalogue: Page 39, No. 375.

(406). The Wine Shop G 354
 Grolier Club: No. 354.

(407). The Picture Shop G 355
 Grolier Club: No. 355.

(408). Hotel Windows, Bourges G 370
 Grolier Club: No. 370.

(409). Notre-Dame, Bourges G 371
 Boston Catalogue: Page 23, No. 227.

(410). Hôtel de Ville, Loches G 379
 Boston Catalogue: Page 22, No. 226.

(411). From Agnes Sorell's Walk, Loches G 380
 Boston Catalogue: Page 22, No. 225.
 Paris Catalogue: Page 110, No. 433.

(412). A Market, Ostend L 380
 London Catalogue: Page 40, No. 380.

(413). Coast Survey L 400
1854-55. *Paris Catalogue:* Page 101, No. 289.
 London Catalogue: Page 46, No. 400.
 (The London Exhibition contained two of these
Coast Survey subjects. In No. 400 only a part of the
plate was etched by Whistler.)

(414). The Silk Dress L 382
 London Catalogue: Page 41, No. 382.

(415). Luxembourg Garden L 383
 London Catalogue: Page 41, No. 383.

(416). **Sailing Boats off Battersea** L 384
 London Catalogue: Page 41, No. 384.

(417). **Nude Model** L 385
 London Catalogue: Page 41, No. 385.

(418). **Two Young Girls** L 386
 London Catalogue: Page 42, No. 386.

(419). **Female Figure** L 387
 London Catalogue: Page 42, No. 387.

(420). **Portrait of Mr. Leyland** L 388
 London Catalogue: Page 42, No. 388.

(421). **Coast Survey No. 1** L 401
 London Catalogue: Page 46, No. 401.

(422). **Polichinelle—Jardin du Luxembourg** P 434
 Paris Catalogue: Page 110, No. 434.

(423). **Marchand de Meubles Rue du Four** P 435
 Paris Catalogue: Page 110, No. 435.

(424). **Fruiterie, Rue de Seine** P 436
 Paris Catalogue: Page 110, No. 436.

(425). **Café Corazza, Palais-Royal** P 437
 Paris Catalogue: Page 110, No. 437.

(426). **The Bushy** P 438
 Paris Catalogue: Page 110, No. 438.

INDEX

INDEX